From *Folk Art* to Modern Design in Ceramics

Ethnographic Adventures in Denmark and Mexico
1975-1978 updated 2010

Also by Robert Anderson

The Vanishing Village: A Danish Maritime Community (with B.G. Anderson), 1964

Bus Stop for Paris: The Transformation of a French Village (with B.G. Anderson), 1965

Traditional Europe: A Study in Anthropology and History, 1971

Modern Europe: An Anthropological Perspective, 1973

Denmark: Success of a Developing Nation, 1975

Conservative Care of Low Back Pain, (Editor, with Arthur H. White), 1991

Magic, Science, and Health: The Aims and Achievements of Medical Anthropology, 1996

Alternative and Conventional Medicine in Iceland: The Diagnosis and Treatment of Low Back Pain (monograph), 2000

The Ghosts of Iceland, 2005

The Labyrinth of Cultural Complexity: Fremont High Teachers, The Small School Policy, and Oakland Inner-City Realities, 2008

Headbutting in Academe: An Autoethnography, *2010*

The Backdoor to Medicine: An Embedded Anthropologist Tells All, 2010

From Folk Art to Modern Design in Ceramics

Ethnographic Adventures in Denmark and Mexico
1975–1978 — Updated 2010

ROBERT ANDERSON

AND

EDNA MITCHELL

iUniverse, Inc.
Bloomington

From Folk Art to Moderin Design in Ceramics
Ethnographic Adventures in Denmark and Mexico 1975-1978
updated 2010

iUniverse books may be ordered through booksellers or by contacting:

iUniverse
1663 Liberty Drive
Bloomington, IN 47403
www.iuniverse.com
1-800-Authors (1-800-288-4677)

*Because of the dynamic nature of the Internet, any Web addresses or
links contained in this book may have changed since publication and
may no longer be valid. The views expressed in this work are solely those
of the author and do not necessarily reflect the views of the publisher,
and the publisher hereby disclaims any responsibility for them.*

ISBN: 978-1-4502-6742-7 (sc)
ISBN: 978-1-4502-6743-4 (ebook)

Printed in the United States of America

iUniverse rev. date: 12/08/2010

Table of Contents

Dedicated to

our grandchildren

. . . a new generation

already shaping the future

Alec Sun
Chelsea Mitchell
Dylan Anderson
Emily Morell
Jack Mitchell
Kara Sun
Kyle Anderson
Luke Anderson
Maya Sun
Sophia Anderson
Taran Sun

Acknowledgments

First, our appreciation goes to those ceramists, artists, and informants interviewed in the course of our research in Denmark and Mexico; although some are not individually named in the book. Their generosity in giving time, sharing their hopes and dreams, telling us intimate details of their lives and work relationships, and allowing us to use them for the purpose we explained: to write a book. We regret we delayed so many years keeping the promise.

Our appreciation also includes friends and colleagues in Denmark who shared our love of Danish traditions in art and our interest in ethnography. Especially to be thanked are Holger and Inge Rasmussen (both now deceased) who introduced us to the Kähler factory in Naestved, and to George and Karen Nelleman who befriended us for years in Denmark. (George and Bob were fellow students of ethnology at the University of Copenhagen, 1949- 1951). In the 1970s, Holger was director, and George, curator of ethnography of the section of the National Museum of Denmark located in Brede at the old textile factory by the mill stream. For many years, Holger and George allowed us to store our car in the museum during the winter months. George always arranged for it to be ready to drive when we arrived at the beginning of summer. Their loyalty and friendship is beyond compensation, and our appreciation immeasurable

Family members important to our research included Bob's parents, Stella and Victor Andersen, both Danish-American. Although speaking only English at home, the Danish atmosphere permeated the lives of Bob and his brother Stan, inspiring them both to study in Denmark, to learn to speak, read and write Danish fluently, and as professors to focus their university research on issues related to Denmark and Scandinavia. Stan, recently deceased, gave lifelong loyalty and patient support to Bob and our extended family of six children and eleven grandchildren,

remembering each one at birthdays and sharing with them his stories of the Danish family.

The extended family, just mentioned, is the reason for reviving and revising this manuscript. We have different but multiple reasons to appreciate our children and their partners and to value their opinions: Andrea, lived in Denmark as a child and shares a love of adventure with her partner, Jim; Robin, born in Denmark, has made ceramics herself and spent time with potters on Samsø Island in Denmark; Scott and Camille, did research in Tzintzuntzan, Mexico; Debra and Dave visited Denmark with us and met our friends the Nellemans; Tom and Debbie encourage their children to speak Spanish and will one day visit our favorite places in Mexico and Denmark; Kristin and Yao are committed to providing global experiences for themselves and their children as opportunities permit, and are always supportive of our writing efforts.

For our eleven grandchildren, each one beloved, admired, and treasured, we want to document and share the experience of doing this research. We list in love from eldest to youngest: Kyle and Dylan Anderson, Emily Morell, Chelsea Mitchell, Jack Mitchell, Taran Sun, Maya and Kara Sun, Sophia Anderson, Luke Anderson, and Alec Sun. We hope they will view this story against the broad spectrum of our other ethnographic work and will see it as a model for reflecting on the cultural contexts of their own lives. It was a time for us well spent in research, adventure, and even in writing and re-writing. We hope they will each have a reason to keep and enjoy our narrative.

A note reflecting our appreciation for each other, offered as an explanation to our grandchildren seems appropriate here.

The authors met at Mills College in 1973, Bob already a professor there, Edna just arrived in late summer from a faculty position at Smith College in Massachusetts to reorganize and rejuvenate a troubled education department as the new department head. Each was divorced, each had three children ranging in age from mid-twenties to ten. Bob had quickly decided Edna was his soul-mate having seen her when she visited the campus for her interviews in April and having surreptitiously read her resume. His criteria for a partner included one who was an academic by profession in order to understand his compulsive work-style, a woman with children who (he assumed) would be less likely to be egocentric, and an attractive but mature woman. She seemed

well qualified. Struggling with overwhelming new administrative responsibilities, she was too busy for courting, but he won her attention by bringing coffee and college conversation to her when she was unable to break away from her desk for lunch.

For Bob, getting to know Edna's children was a critical factor, so he took them all—his and hers—to an Oakland baseball game. The children passed inspection by enjoying it thoroughly, but this was a once in a lifetime experience. It was a test. Bob actually is not interested in baseball. By October in the fall semester, he sent a telegram to Edna saying something like this: "On this day Columbus discovered America, and I discovered you! I have our tickets for a concert and dinner. Will you join me?" From there the relationship matured, and by winter break, it was off to Mexico to get married. For Edna, it was too quick, too soon, and she got "cold feet" in Mexico. They postponed the official marriage for nearly 20 years, until they "got to know each other."

Summer of 1974 was already committed to Edna's work in Nepal where Bob joined her to pursue his research interests in ethnomusicology. But winter of '74 permitted a second trip to Mexico. Denmark was the destination the following summer. Although the authors were then working on separate research projects, the attraction of the arts in both countries planted an idea that blossomed by the winter of 1975 to become this project. As Edna explored Danish early childhood services, children's playgrounds, and play materials, the initial search for unique toys turned shopping into a genuine ethnographic investigation of ceramics.

Our first project working together, now also becomes perhaps our last shared product. We have, over these years, supported each other's separate interests and respected each other's work styles, but never co-authored a major study. This book, in its early stages, resulted from the October "discovery" of new love, and, in its final stages, is the product of a deep but more mature love, sustained and nurtured by mutual appreciation.

Epigraph

The Challenge

from the pen of Warren d'Azevedo

"It is clear that a new approach is needed in the study of the arts of our own society as well as in comparative studies—one that would concentrate on artists and their public. This is the most neglected of the four primary tasks for the comparative study of art that have been singled out.

". . . These tasks are mutually dependent but have been carried out very unevenly. Efforts to understand the artist as producer and as a member of society have been given the least attention. The problem, rather than one of 'biography', however, is essentially one of identifying a type of individual behavior and a type of social action that can be designated as the loci of artistry.

"This is the crux of the matter, at least for the social scientist. As long as art is conceived only in terms of its results, no social theory of artistry is possible."

The Traditional Artist in African Societies. (1973)

Prologue:
The Manuscript—Abandoned and Lost

Oh Time, thou must untangle this, not I;
It is too hard a knot for me to untie.
—William Shakespeare, *Twelfth Night*

Indeed, this may seem a tangled knot with many entwined threads. To untangle them, we need to thread our way back to the beginning. To explain the origins of this book, and its emergence into print, the authors need to take you back in time more than three decades. It was December,1974, we were spending our second winter-break in Mexico but this time with a purpose other than a romantic holiday. We had found a new research romance: the potters in the area of Guadalajara, specifically Tonalá. We were a husband-wife team, an anthropologist and an educator, both professors at a small liberal arts college in northern California. What intrigued us in that winter were the similarities between the work of potters in Mexico and ceramists in Denmark whose work we had appreciated during long summers in Denmark doing research on other subjects of separate interest. It occurred to the anthropologist side of the team than it would be interesting, unique, and perhaps important, to do a comparative study of these two cultures focusing on the fate of folk art traditions in the face of industrial forces and a shift to modern designs. Thus began a four year study that absorbed our energy and time during Danish summers and our intense focus on Mexico during the six week winter interims between fall and spring semesters. The fact that the anthropologist, Bob Anderson, was fluent in both Danish and Spanish made the study and observations possible without the aid of translators; this ease of communicating with peasant workers as well as designers and managers led to amicable relationships. We conducted interviews and observations in workshops, studios, factory settings, stores, and in many cases in the homes of the artists/ceramists/potters who were the subjects of the study. The core of the manuscript was completed and ready for editing by 1979, but stalled due to the need for approvals to use professional photographs to illustrate the artwork described in the book. Soon, the authors turned

to other projects, put the manuscript in a file to be abandoned and forgotten for three decades. In the spring of 2010, the box in which it lay moldering, was opened and the manuscript was read once more.

The narrative seemed too interesting merely to send to the trash. The stories of intrigue, family quarrels, theft, and drunkenness along with amazing talent arising in surprising places, experimentation, innovation, imagination, determination and other human experiences confronted by social and technological changes were described for both societies. The study was not about art, but about the expression of human minds as individuals in both settings tried to blaze new paths in their craft while also trying to make merchandise to sell. They were craftspeople and artists creating a life while trying to make a living.

The stories seemed useful as an historic ethnographic record; the theoretical underpinnings that gave structure to the collection of data and its analysis are perhaps of less interest. What was most troubling was the passage of time and the challenges of a thorough follow-up. We would like to have re-traced our steps, checked in personally on people and places we had written about, but given other priorities in our lives, we reluctantly put aside that hope. Through other sources, however, we have been able to track down individuals we interviewed long ago... those still living, and like sleuths we found information about the fate of ceramic and porcelain factories we had studied. As we uncovered bits and pieces of information, several surprises confronted us. Factories we had expected to survive had failed; some operations we thought were fragile are now not only surviving, but are thriving. We met many individual artists and entrepreneurs who gave us interviews in the 70s who are still pursuing their craft, many with outstanding success. Other key figures moved from the scene but left behind legacies that continue to inspire others.

In the Epilogue, we open ourselves to criticism and include some raw self-criticism: not about our ethnographic methodology and reporting, but about our inability to foresee the forces of globalization affecting the fate of folk art in village communities. We also did not anticipate the commercialization of modern design leading to the implosion of long established factories. The business of wide-scale corporate "buy-outs" was yet to come. The amazing amalgamation into conglomerates controlled by stockholders interested in bottom line profits was on the horizon but not within our scope of vision. Our original fantasy of bringing together

the Danish methods of organized pottery production to the context of Mexican pottery production, linking folk art to modern design, is thwarted by the socio-political-economic changes both nationally and globally during the past three decades.

Nevertheless, we believe the resuscitation and publication of this study has merit. The stories told to us are unknown or forgotten. Many stories of these artists will never be told, and many voices now are silenced. In this study, the communities of ceramists and the individual artists are viewed in a unique cross-cultural perspective. Their common problems are exposed; their contextual differences compared and appreciated. Their life patterns, in a thirty-year retrospective, show the influences of fate, fortune, and in many instances brilliant talent, with patient persistence and fluid flexibility. We have taken the position of social scientists and academics, not novelists, as we weave these stories together in a theory of paradigm change. The important point to remember is that what was written is now history, even though the narrative is in the present tense.

We leave to the reader the task of weighing the evidence; separating history from updated reports of current status; and enjoying the effort to juxtapose these two different cultures under a common theme. Those readers, who are collectors of Mexican folk art or of Danish modern design, will undoubtedly find their collections enhanced in value, at least in their own eyes, through the reading. All readers will find elements of interest or intrigue, and will be informed in new ways about the old ways of changing dirt into dishes — clay to porcelain—and tradition into art.

Chapter 1 explains the original structure of the book. The eleven chapters are the historical record of our ethnographic analysis, with almost no changes from the original manuscript except for an occasional italicized note to indicate a death or a significant event. We hope the chapters between the Prologue and the Epilogue will be viewed as voices from the past; the thoughts and stories are written as though in the present, but it is all now history. We have tried to preserve the integrity of that fieldwork and the respect for our informants, while having the unique challenge of putting it into perspective after a 30-year hiatus. Updated information to the extent we could extract it is in the final Epilogue.

Chapter One
An Uneven Jigsaw: Fitting Denmark with Mexico

An artist is someone who produces things that people don't need to have but that he - for some reason - thinks it would be a good idea to give them.

—Andy Warhol

Denmark as a Model—1975

It was the time of the winter break at Mills College in December 1975. We returned to Mexico to enjoy the culture and learn more about Pre-Columbian civilizations, as well as to pursue our separate research interests related to ethnography and education. We detoured into the community of Tonalá near Guadalajara, studied fifteen years earlier by an anthropologist colleague. We were interested to see for ourselves the community she had described. Not unlike countless others coming as tourists or with an interest in folk art we browsed in the marketplace, wandered around the central plaza and shopped in stores both large and small. As we chatted with salespeople and potters and examined objects on display, we began to be aware of enormous changes that had occurred. Our curiosity aroused, we sought out individuals who could tell us of these changes, and immediately found we were documenting a sequel to the earlier study, not merely in the small town of Tonalá, but more widely in urban and suburban Guadalajara, including the municipality of Tlaquepaque. Above all, we found we were documenting the human and aesthetic components of a serious problem, a problem of economic development in which peasant potters and craftspeople are struggling to survive in competition with modern factories and stores.

Our explorations in and around Guadalajara would have come to nothing more than a personal experience were it not for recent

anthropological work of one of the authors in Denmark. Denmark is so distant and so different from Mexico, both in geographical space and in culture, that its relevance may strike the reader as somewhat forced. Yet Denmark has potential relevance for any nation struggling to modernize. The high standard of living and social system characterizing Denmark today grew out of pervasive poverty and social inequality in the not too distant past. In the nineteenth century, Denmark was a developing nation. If Denmark could succeed as well, perhaps it could serve as a model for nations not yet so successful. That was the hope that lay behind the book *Denmark: Success of a Developing Nation,* (Anderson, 1975) recently published at the time we first visited Tonalá.

We felt, in short, that we might use an approach in anthropology much like that used by psychologist Abraham H. Maslow (1971) when he coined the term "growing-tip statistics." Maslow was interested in the human potential for successful living. "Of what are human beings capable?" became his basic question. To find answers, he rejected the assumption that statistics about ordinary populations would be germane. If you study ordinary people you learn how to live an ordinary life, was his argument. Rather, to learn about human success you need to study truly successful individuals who have developed ahead of others. The term "growing-tip statistics," then, is an analogy from the fact that in plants the greatest genetic action takes place in the small part that is newly emerging (Maslow 1971, 5-7).

It is a weakness of Maslow's method that it requires the investigator to identify successful, self-actualized people, a largely subjective process susceptible to some judgmental error. The same weakness applies to the selection of a nation as a model for what a human society may be capable of achieving. It is impossible to eliminate ethnocentric bias completely. Is Denmark really a good model, or does it only appear so to those with a certain political and cultural bias? We are prepared to argue that our potentiality for ethnocentrism, a danger even for those trained to guard against it, is reduced because, in addition to our training as behavioral scientists, we are Americans, and therefore outsiders in Scandinavia as well as in any developing nation we might study. While the element of bias or potential bias must be acknowledged, it is not sufficient to prevent Denmark from serving here as a growing-tip statistic. Denmark has its own problems and imperfections, as many of its own

citizens would be the first to point out. Yet, for all of its shortcomings, it is a nation providing individual opportunity and freedom on an extraordinary scale in human history. Its success in numerous ways is a matter of objective measure. To this, it has an advantage over other equally successful nations: Denmark is small, comprising only five million people and sixteen thousand square miles of territory. Further, it does not interfere with the freedom of outsiders to carry out research. As nations go, Denmark is more manageable for study than most other technologically advanced nations.

Why Mexico as the Partner?

The book *Denmark: Success of a Developing Nation* serves as a basic orientation for those who might chose to look to Denmark as an economic and social model. It attempted to identify fundamental cultural processes in history that perpetuated a traditional, agrarian life style for peasants, burghers and aristocrats from the Middle Ages into the eighteenth century. It then examined the nineteenth century as a period when, as a developing nation, the expression of those processes changed. Ultimately, it dealt with the twentieth century as a period when the processes became those of a complex, urban-industrial nation. In offering a view of such global dimensions, we can only sketch roughly the concrete difficulties of modernizing particular aspects of life. Yet it is precisely in such particulars that the final application of method is carried out: how to provide justice, improve education, minister to personal needs, provide health care, build homes or give meaning to life. These are issues that can provide a test for the utility of Denmark as a model.

We wanted to follow up that earlier work in Denmark by focusing upon a single problem area. Mexico suggested itself as the nation for comparison since it has been slower than Denmark to develop, but is modernizing as rapidly as it can. We could handle interviewing in Spanish, although not with the same fluency as in Danish.

We elected to carry out an investigation of problems affecting utilitarian and popular art. As a topic for investigation, the subject is important. Although it may not be apparent to those who have not given thought to the matter, art is fundamental to successful human living. No society exists without it. Art also constitutes an important sector of

the economy. As a subject sadly neglected by anthropologists, it is even more worthy of study.

Balance and Equity—the Traps of Labyrinths and Matrices
Putting Success into Perspective

The approach advocated and explored here needs a word more of explanation. We attempt in what follows to examine one aspect of culture—craft and factory ceramic arts—as a function of a whole way of life. It has long been customary for anthropologists to take a holistic approach to the study of human behavior. To extend holism from a local community to a nation is perhaps difficult, but not revolutionary. If nations as units have enjoyed only limited popularity, it is because the complications of size and complexity make them unwieldy. We innovate in a modest but significant way, however, insofar as we extend the holistic approach to encompass the developed nation—the cultural donor, as well as the population seeking techniques that can improve social life—the cultural recipient. Within anthropology, it has been the practice to study recipient cultures holistically, but to leave donor cultures unexamined except to describe certain institutions or technological systems or techniques. We attempt here to elaborate. We advocate Denmark as a model because we can examine Danish institutions comprehensively as part of a whole way of life. Therefore, we sought contrasts and comparisons using Denmark as the example of a donor culture and Mexico as a potential cultural recipient.

It is a difficult and cumbersome procedure to take as a model an entire modern nation. Would it not be simpler and more direct to follow the usual procedure, identifying useful social or cultural techniques in the donor society and then examining how they may be transplanted to a nation such as Mexico? *Den Permanente*, a large elegant cooperative store in Copenhagen, supports art by providing a sales outlet for independent artists. It offers a case in point. Why not simply study the operation of this store and then bring these findings to concerned individuals in Guadalajara? Why insist upon a holistic assessment within Denmark?

The answer, as what follows will indicate, is that the success or failure of an institution such as *Den Permanente* depends upon a complex labyrinth of inter-related circumstances, even though it appears to an

4

inexperienced observer as a clear-cut socio-economic matrix in the form of a discrete building and staff with its own organizational procedures. The idea behind *Den Permanente*, that of the cooperative endeavor on an urban scale, works in Denmark because it is adapted to circumstances that include a complex array of studio artists and factories, training institutes, moral and legal codes, consumer preferences, international tourism, and national experience in making cooperative enterprises succeed. Looked at as an isolated institution, *Den Permanente* is likely to be misunderstood, and not the least, we might add, by being over-evaluated.

Perhaps the most important single advantage of the balanced approach advocated here is that it puts success into perspective. Too often in the past we have examined the problems of developing nations in the light of isolated success in the West, forgetting that a proper perspective must go beyond pilot projects and special programs to enduring, work-a-day kinds of success. Den Permanente, to return to our example, is an admirable institution, but from talking with many different craftspeople and from learning about other aspects of the world of contemporary design we find that it is also an institution with serious shortcomings and ultimately with an uncertain future. To extrapolate from this, and to anticipate our findings somewhat, we find that in taking a nation as our ultimate term of reference we find the success of Denmark far less dazzling than certain examples of isolated achievement would suggest. We also find Mexico, the less highly developed nation, less dismal than earlier comparisons might suggest. If Mexico makes mistakes, so too does Denmark. If Denmark can boast of areas of success, so too can Mexico. On the whole, Denmark has progressed further than Mexico in making the good life possible for ordinary citizens and, more specifically, in providing a support system for artistic accomplishment. It does make sense to take Denmark as a model. It makes the best sense, however, to keep the realities of complex circumstances in view. This is the organizing principle for this book. It is an organizing principle fundamental to an anthropological approach to the study of culture change. If we amplify upon it, it is to apply that principle to the advanced nation as well as to the less advanced.

Circular Comparisons
Anthropological Field Methods Modified

Building on the well-established anthropological method of comparative analysis, we found we needed to modify somewhat the accepted approach to field work. Anthropologists traditionally spend at least a full year in the community selected for study. It is felt that a year is minimal if the investigator is to witness first-hand the complexity of a culture that includes an annual cycle of social and economic practices, ritual traditions, family and community customs, and other activities. We do not take issue with that approach when the goal is to do ethnography of an otherwise unknown or little known society. Nor do we deny the need to know the basic ethnography of the population under investigation. We do find, however, that long-term field residence can be inappropriate for many kinds of research, and that it was inappropriate for ours. An abundant literature already describes the basic dimensions of culture in both Denmark and Mexico. We could build upon that.

Fortunately, international travel is now rapid and relatively inexpensive. This makes possible a program of repeated short visits with decided advantages over the large-scale expeditions that formerly were integral to field work not located in one's home area. It means that summer and winter academic breaks offer time for distant research. This offers an advantage to university students who will find their professors more available than when taking sabbatical breaks or long leaves of absence. It offers the advantage to the anthropologist, as well, with less disruption to family and private life. In addition, short periods in the field are less strenuous and involve less the problem of culture shock while providing the advantage of time between sessions for analysis, double-checking information, reviewing and reflecting on notes.

The latter advantage included, in addition, a modification of field procedure making more accessible certain kinds of data difficult to acquire when following the customary leave-of-absence/year-in-the-field approach. Because we traveled back and forth between the two nations, we were able to improve the extent to which our evidence on the two societies was indeed comparable. We were able to follow up on new leads and incomplete observations. We were able to probe beneath and beyond early impressions. Under the traditional system,

it is necessary to anticipate while on the scene every question one may ultimately wish to ask perhaps months and even years after leaving the field. That is, of course, nearly impossible to accomplish, and probably not an anthropologist among us has escaped, while analyzing data and writing, the frustration of finding gaps in the documentation. Actually, we find that we have gaps too, for the time came when we had to terminate fieldwork and begin writing. But these gaps are minimal, and on the other side of the ledger, we were able to ask questions in Denmark based upon findings in Mexico, just as we asked questions in Mexico based upon findings in Denmark. Therefore, carrying out the research in an alternating schedule produced more complete and comparable information.

In gathering data in the field, anthropologists employ a technique known as *participant observation*. The purpose of the technique is to gather data as widely and as deeply as possible by living among people, working with them, and being open to every kind of information that may come along. This is the technique we used, but necessarily much less intensively than is possible when research involves a long period of temporary or permanent residence. We interviewed potters, factory personnel from directors, designers, and skilled artisans to unskilled laborers, storekeepers and sales persons, museum and school or academy employees, local residents and others. We watched people at work, shopped in local stores, and met people informally in every way we could. The emphasis was more on open-ended interviews and less on personal involvement, however, and participation had to be limited.

Anthropological Ethics in the Field

Fieldwork for comparative analysis carried out as alternate visits to the two areas under study had implications of an ethical and practical nature. Potters in both places were interested in what we were learning about others. Because personal reputations as creative artists are involved as well as commercial success in marketing a product, we faced the ethical dilemma of confidentiality. We had to decide what information in our possession was confidential. Normally this was resolved very simply. When told that the information given us was privileged, we kept it to ourselves and let it serve as background material but not as publishable or repeatable to others. Much that we learned, however, was not secret

and yet had value for others, particularly across national boundaries. A factory in Mexico having difficulty with the loading of shuttle kilns was greatly interested in solutions to this problem previously worked out in Denmark. Mexican potters are interested in how Danes shifted from poisonous lead glazes to non-lead types. Danes do not feel that they are in competition with Mexicans to sell ceramic products, and we never discussed our project with a Dane who did not wish to be of service to Mexican ceramists, so we have had no hesitation in telling Mexicans what we could, little though it might be.

Our findings in Mexico did not have comparable utility for Danish ceramists, a finding consistent with the idea that Denmark may serve as a model. Danes tended to be more interested in what we had learned about other Danish ceramists. In one case, we found ourselves serving as spontaneous consultants for a factory involved in selecting a new designer. Ethics became an immediate torment. The dilemma was in our desire to help a factory director do what would be best for his enterprise as well as for staff that earned a living under his direction even though the right decision might hurt the career of a person with serious personal and professional deficiencies. The dilemma was in the fact that we knew of those deficiencies only because we were invited generously and openly for an interview with the individual under review. In this case, we told the facts as we knew them without, of course, betraying any promise of confidence; but we did so with reluctance and a sense of uncertainty. Perhaps we should have declined to become involved. Ethical problems are sometimes easier to solve days and weeks later than at the decision-making moment.

It is interesting to speculate on these illustrations of Heisenberg's uncertainty principle that, very simply, the more precisely one property is measured, the less precisely the other can be measured. Applying this principle to our anthropological research, we were cautious not to advise. Our presence influenced the field of study in minor ways. It is easy to imagine a situation in which our influence could have had a major impact, thus making us part of the subject under investigation. This happens increasingly to applied anthropologists concerned with finding solutions to human problems.

Ethical considerations intrude again in considering the way in which we have written this book. We found in doing our background

reading for this project that journalists, art historians and others who write about folk art and modern design tend consistently to distort their findings. We found most of the people we visited and interviewed far less glamorous and gifted than they seemed from published reports. Even museum displays and publications tended to resemble public-relations propaganda. We should not have been surprised. Anthropologists often do the same, except that occasionally they may be inclined to vilify rather than laude. Many anthropologists feel that it is a betrayal of their trust to describe unsavory, immoral or criminal behavior. Sometimes, of course, it would be, for a variety of reasons. It can happen that an anthropologist agrees as a condition of his acceptance as an investigator that he will not publish findings unacceptable to his research subjects: in effect an agreement to accept censorship. That kind of prior agreement is perhaps itself unethical, but the point is that the ethics of fieldwork are so complex and difficult that intelligent, well-intentioned scholars at times are tormented by uncertainty.

In what is written here, we take a position that we feel is correct, but which will undoubtedly seem incorrect to some. Fully aware that the careers of individual people are involved, and willing to be helpful rather than harmful when we can, we feel it is our obligation to provide an honest, objective, and well-rounded description, and that means describing weakness and failures as well as strengths and successes. We never said or implied to anyone who agreed to talk with us that we would do otherwise. Everything we describe is openly accessible to an inquiring reporter. We expect our findings to have an impact on the people we describe. We believe that to have a beneficial impact, our findings must be truthful. We do not assume that a beneficial impact protects every individual or organization from criticism. *(Note: a thirty-year delay in publishing our findings made these ethical considerations moot.)*

Purpose, Problems, and Paradigms

Two goals shape our intent. It is difficult in writing about them to keep them separate. The one purpose is to develop and test an approach to the analysis of culture change. While elaborating that purpose, however, we need to refer to the other, which is to identify a process of change within the specific areas of art that we explored. We hope, in

other words, that our findings in this comparison of two nations will suggest as a goal valuable in itself, possible regularities applicable more widely to development influencing the future of certain kinds of art. We find that Denmark is a high achiever in the field of contemporary crafts and factory-produced design. We believe that if we can identify critical factors that facilitated, encouraged or shaped that achievement we will have identified something of value to those involved in and concerned about industrial and craft arts in other nations. We believe that an important initial measure of the meaningfulness of these critical factors can come from an examination of how they actually emerge in a balanced comparison of Denmark with Mexico.

To achieve this goal we must begin with a brief survey of the achievement of modern design in Denmark. Though brief, this survey is of key importance, because it provides the basis for defining what Anthony F. C. Wallace (1972) terms a *paradigmatic process*. The concept of paradigmatic process—of a paradigm—provides an organizational tool for describing what appear to constitute the basic ingredients of success, from innovation to culmination. We propose to identify this paradigm initially from historical sources, but our emphasis is entirely upon the present and our interest is in the future. We shall explore the working out of this paradigm today, using the approach of balanced comparison.

The seminal work of Thomas Kuhn (1962) frames the discussion of paradigm change in science, although he rejected its use in social science. He proposed these principles for understanding paradigm change.

- Science undergoes periodic "paradigm shifts" instead of progressing in a linear and continuous way.
- These paradigm shifts open up new approaches to understanding what scientists would never have considered valid before
- Scientists can never divorce their subjective perspective from their work; thus, our comprehension of science can never rely on full "objectivity" - we must account for subjective perspectives as well

He explains in his preface to *The Structure of Scientific Revolutions* (1962) that he concocted the concept of paradigm precisely in order to distinguish the social from the natural sciences. Kuhn's term "paradigm

shift" referred to the necessity of *revolution over evolution* in changing scientific thought and practice. Despite his protests the paradigm process (Wallace) or paradigm shift (Kuhn) has interesting applications for our study of change in a social science/anthropological context. We use the now standard definition for paradigm shift: a dramatic change in methodology or practice. It often refers to a major change in thinking and planning, which ultimately changes the implementation of projects. In applying paradigms to changes in folk art and the production of ceramic artifacts, we had to cope with concepts of change including evolutionary, revolutionary, or other. This is the focus of our research in *From Folk Art to Modern Design: Denmark and Mexico*.

Because folk art and modern design are very broad and ill defined as areas of human endeavor, we employed an investigative strategy focusing in-depth upon a single kind of art. We concentrate upon ceramics. Even that remains more than we can cope with. Within each nation we focus upon the following major centers: in Mexico, the area around Guadalajara. In Denmark, the focus was on the old peasant pottery areas around the town of Sorring on the peninsula of Jutland; Naestved on the island of Sjælland, plus a major center for modern ceramics, the island of Bornholm.

Strategies for scientific research always sound very carefully programmed when described in textbooks: one begins with a question and a definition of a problem, moves on to reformulation in the guise of an hypothesis, then tests the hypothesis, and ultimately redefines the problem in terms of what was discovered. In fact, scientists rarely are that completely organized. As Kuhn clearly observed, research is not linear and researchers are not free from subjectivity. They may depend heavily upon intuition, serendipity and opportunities not always foreseen. At times, reversals occur in procedural sequences. It makes good sense to take ceramics for in-depth study, but, of course, that focus came early rather than late in our research. Intuition, serendipity and a chance opportunity in part lay behind that decision. At one time we thought that furniture would be more suitable for special attention, but gave that up when we discovered that it was more than we could handle with the time and resources at our disposal. It was only after we were committed to ceramics as our central concern; however, that we learned that it was probably a superior choice. Historically, the paradigm

of modern design first became evident in ceramics, and thus it exerted a shaping influence on modern design as a whole. It is also superior because the relationship to folk art is clearer in ceramics than in any other field and because the variety of endeavor in ceramics ranges from numerous studio artists to enormous factories to give a widest possible spectrum to observe. This investigation is empirical, then, in structure. The approach belongs to the subculture of behavioral scientists, who explore what anthropologists designate as "real" rather than "ideal" culture.

Next, we turn to designing a paradigm, as a structure for theory, based on the emergence in Denmark of an early pottery-to-porcelain industry.

Chapter Two
Poking Around In Paradigms:
Wading Through Theory

Art... does not take kindly to facts,
is helpless to grapple with theories,
and is killed outright by a sermon.
—Agnes Repplier, *Points of View*, 1891

The Royal Copenhagen Paradigm

Before delving into the juicy parts, or the messy clays, of our story, we want to set the stage by providing some structure for analysis. We have chosen to look at the development of the pottery-ceramic-porcelain industries in these two nations through the framework of paradigms. In simple terms, a paradigm may be defined is an example that serves as a pattern or model for something, especially one that forms the basis of a methodology or theory. As the term is used more academically in this study, we apply a definition from the philosophy of science: paradigm —"a generally accepted model of how ideas relate to one another, forming a conceptual framework within which scientific research is carried out." In order to make meaning out of the chaos of our comparisons, we created and applied the paradigm concept to contemporary ceramic production using the Royal Copenhagen Porcelain Factory as the initial paradigm design. First, let us discuss the elements of the paradigm.

Modern Design and Paradigmatic Analysis

What do we mean by the expression *modern design*? According to Victor Papanek, "Design is the conscious effort to impose meaningful order." (Papanek, 1971, 3) "Modern" qualified that order as being recent or contemporary. So defined, the designation remains vague and unclear.

13

It recognizes no boundaries of place or loyalty. It cannot be identified as a "school" of art or as a unified aesthetic philosophy. The broadest relevance of our inquiry, then, is amorphous. We deal with recent and contemporary styles in two countries. We will be interested in a large range of products that fit this uncertain definition, but we shall, before this chapter is concluded, identify the defining characteristics of one specific version of modern design, that of Denmark.

In customary usage, the concept of paradigm is equally ill defined. It refers to a pattern or model. In our effort to identify a paradigm of modern design, however, we will use the concept elaborated by Anthony F. C. Wallace. In his formulation, a paradigm of changing culture is includes five essential components: (1) innovation, (2) paradigmatic core development, (3) exploitation, (4) functional consequences, and (5) rationalization (Wallace, 1972. 468).

Paradigm innovation occurs when a sharp break takes place in the way behavior is organized or understandings conceptualized, making identifiable a new model or pattern. For example, a paradigmatic innovation in science took place when the oxygen theory replaced the phlogiston theory of combustion. The oxidation paradigm consisted of a complex set of principles and procedures that led to the creation of modern atomic chemistry. In industry, the invention of machinery, the harnessing of powerful sources of energy and the strict organization of workers became a paradigm we speak of as the *industrial revolution*. In anthropology, the method of fieldwork for eliciting the facts of ethnography constituted a paradigm that led to the growth of anthropology as a modern social science. In the present chapter we shall identify a new model for the creation of modern design. We call it the *Royal Copenhagen Paradigm* sometimes shortened by us to RC.

Paradigmatic innovation merges at times indistinguishably into Wallace's second essential component, paradigmatic core development. This elaborates on the ideas that constitute the original paradigm. Thus, if the paradigm of fieldwork originated with Franz Boas, Bronislaw Malinowski (1915) modified it substantially in what he called the method of *participant observation*. As long as the original paradigm remains identifiable, such changes are core development rather than the creation of a new paradigm. In chapter five, we identify this type of elaboration as the Royal Copenhagen (RC) Paradigm.

Before dealing with elaboration of the RC Paradigm, however, we devote two chapters to an investigation of the exploitation of the paradigm. By *paradigmatic exploitation* (Wallace's third essential component of paradigm change), we refer to the economic, military, religious, or political organizations that exploit a new model to further their own purposes. Specifically, we will examine in chapter three the extent to which the RC Paradigm remains largely missing in Mexican factories. In chapters four and five we see how its implementation in Danish factories of our time.

A new paradigm need not replace earlier models, but may stimulate responses that direct a changing culture in unintended directions toward unintended consequences. These Wallace has designated *functional consequences*. In subsequent chapters we will investigate the ways in which the response within ceramics has taken place. We shall find in chapters six and seven what precipitated the paradigm shift in pottery production from utilitarian ware to art style. Emerging technology and changing socio-economic circumstances leading to the demise of folk pottery in both Mexico and Denmark were the precipitants. In chapters eight and nine we will evaluate the changing traditions of Mexican folk art and the potential functional consequences for Mexican peasant potters based upon our findings in Denmark. Our observations and generalizations focus on the region of Guadalajara. Finally, in chapter ten we will identify on the island of Bornholm, Denmark the appearance of a new paradigm, one that emerged as a functional consequence of the Royal Copenhagen Paradigm. In the study of the Bornholm studio artists clear traces of the RC Paradigm may found, but the paradigm shifts again and circles back to a new type of pottery production echoing that of the old folk patterns of peasants. However, the new form reveals an independence and sophisticated awareness of moral choice in life and artistry.

People are inclined to justify their commitment to a paradigm in moral and rational terms. *Paradigmatic rationalization* is the process of explaining or justifying adherence to a particular paradigm. We examine in chapter ten how people evaluate and rationalize their commitment to every paradigm we encounter in this research, from that of the peasant potter to that of the factory designer and the studio artist.

Anthony F.C. Wallace points out what is apparent in the preceding paragraphs. The five components of a paradigm do not necessarily follow each other in strict order. On the contrary, they may well blur into each other or be out of order. However, in principle they begin with innovation, the creation of a new model or pattern for achieving some purpose. That purpose may be to produce aesthetically satisfying objects for practical use or for enjoyment.

Our own rationalization for persisting in presenting 0ur research materials in a structure of evolving paradigms is to give the reader a framework for tracking the changes we identified in moving from folk art to modern design in these two countries. The use of the language of the paradigm may be off-putting at times, but bear with us as we attempt to show its usefulness for predicting and perhaps influencing change in more successful directions. The stories of shifting allegiances within communities of potters and by individual potters themselves make intriguing background drama.

Danish Modern Design

The Danish reputation for modern design, with its clean and simple characteristics, emerged over a period of years. It all began with furniture. All viable movements in art have sprung from the embryo of protest and provocation. The revolt of the mid-1920s was no exception. It directed the development of Danish design into a narrow path of self-criticism, a route that a generation later— to the surprise of many— was to lead to the broad highway of international acclaim.

The young rebels who set the ball rolling and gave Danish design its fertile image— later to crystallize as "Danish Modern"— included people like Kare Klint (1888-1954), Kay Bojesen (1886-1958), Poul Henningsen (1894- 1968), and others whom we will discuss.

It was not, we must stress, a purely national development. Sweden, Germany, other nations in Western Europe, Japan and the United States all contributed. Yet Denmark was always in the front ranks, contributing at least as much, especially in proportion to its size and wealth, as any other single nation. Although we ultimately will focus primarily on the transformation of clay into different forms, it is worthwhile to take time to look at the ubiquitous spread of design concepts across differing forms. Ultimately, the central focus of this

study is the transformation of ceramics from strictly functional uses to products valued for their aesthetic qualities. The rich history of Danish design principles combining form and function emerged and cut across all areas of folk art and modern design providing common themes. We will review some of the major areas to demonstrate common themes. It will also become apparent that artists, even those who specialized, had skills they used experimentally across many artistic forms and with different media. One area in which Danish design excels is that of furniture.

Furniture. Contemporary Danish furniture sells throughout the world. It has the ambiguous honor of being widely imitated, even by some of the furniture makers of rural Mexico. Yet it oversimplifies to refer to these products as though they represent a solitary style or a single approach. Several distinctive characteristics are present.

First, a deliberately functional approach appeared in the work of Kaare Klint in the 1920s. His basic principles were two-fold. First, a piece of furniture ought to serve its function as effectively as possible in a direct and unencumbered way. If it is a chair, it ought to hold a person comfortably and fit into a room easily. Secondly, in form and decoration it should be simple, serving as a vehicle of expression for the natural woods and other raw materials used in its construction. It should be built in a manner unobtrusive enough for the piece to fit in with furniture already in the possession of the purchaser. It should be timeless: a piece independent of period and fashion.

In 1926 Klint demonstrated the effectiveness of these principles in his design of a buffet. Furniture at that time tended to be large and heavy. Often the tiny dining room of an urban apartment, or the relatively undersized room of a suburban villa, was crowded by the positioning of a massive buffet, the chief practical function of which was to store dishes and silverware when not in use. Klint designed his buffet to function more efficiently by undertaking a statistical study of what people customarily possessed for setting a table with glassware, porcelain, silverware and tablecloths. He then experimented with space and its application to the storage of these possessions. Based on these studies he developed a buffet that held the tableware of an average family satisfactorily in only half of the space required by models then on the market. In appearance it offered straight lines and the appeal

of grained wood. In short, it became the prototype of a functional approach to furniture design.

Dramatically opposed to the functional approach of Kaare Klint is the artistic orientation of Finn Juhl. He fully agreed with the idea that a piece of furniture ought to serve its function effectively, and with the idea that the essential beauty of a piece of furniture resided in the potentialities of the materials of which it was constructed. However, Juhl differed in his belief that an item of furniture ought to be a work of art, on a par with a piece of sculpture. Rather than subordinate to its surroundings, it should dominate them, or give focus to them. For example, he liked, to place a chair next to a large piece of standing sculpture so that the massiveness of the one balanced the light, airy quality of the other. His furniture as a result is highly distinctive, with more of a sculptured quality and an artistic presence than is the case with the "anonymous" furniture of Kaare Klint and his followers.

However, if Klint and Juhl represent two contrasts integral to modern Danish furniture, others syncretize these trends. Many of the outstanding creations of Hans Wegner are as much *objets d'art* as are pieces developed by Juhl. Both join their skills as designers to the expertise of experienced cabinetmakers to produce well-constructed pieces of distinctive beauty. Wegner, however, strives for pure, precise lines that give his work something of that timeless quality sought by Klint. Often his goal is essentially aesthetic, as when he explores, for example, the potentialities of a basic shape of chair. Yet he is imaginative and inventive in functional design, engineering chairs that in addition to their aesthetic appeal also are comfortable and, in some cases, stack easily for storage or shipping — another acknowledgement of the Danish need for space–saving furniture.

Børge Mogensen found an alternative way of assimilating the two approaches. Early in his career he produced pieces as art objects. To furnish a hunting lodge, for example, he created a chair of oak wood and heavy ox hide leather prominently fitted with metal buckles. It was as much a piece of sculpture as was any chair developed by Finn Juhl or Hans Wegner. However, after working for a time as an assistant to Kaare Klint, he turned to designing for factories with high volume sales. Ultimately he exercised an enormous influence on Danish consumers, since he created sturdy, low-priced, useful pieces by developing the

concept of sectional furniture. With these designs, people of ordinary means and with growing families could furnish their homes to begin with by purchasing very little. Gradually they could add matched and fitting pieces as their resources and needs increased.

Klint, Juhl, Wegner and Mogensen are internationally known exponents of a variety of approaches that share a fundamental commitment to the idea that furniture should be honest. It should be honest in the sense that it serves its purposes well, that it reflects the beauty of the materials of which it is constructed, and that it gives fair value, whether as a low-priced piece of utility ware or as an expensive object of art. Contemporary with these names and subsequent to them are many others, a few equally well known (e.g., Arne Jacobsen and Poul Henningsen) and many not as well known, yet all part of that complex industry that lies behind the designation "Danish Modern" furniture.

Textiles. Modern design in textiles grew primarily out of efforts to coordinate woven fabrics with contemporary furniture and with new trends in interior decoration. This is not to downplay Danish achievements in other aspects of textile art, such as printed fabrics of the sort currently bringing attention to Finnish factories such as Marimekko, but it does reflect the extent to which Denmark gained recognition for excellence in the production of architectural textiles.

Gerda Henning, who began her career as a painter in the Royal Copenhagen Porcelain Factory, but eventually turned to weaving rugs and fabrics, set the trend. Her husband Gerhard Henning, a sculptor, at times worked with her in designs, but so too did others including the furniture designer Kaare Klint, who frequently collaborated in designing rugs. Her preference for earth colors and rugged Islandic wool to produce rugs covered with geometric designs in muted tones was consistent with the feeling Klint had for a subdued but natural beauty in furniture design. So, too, was her preference for design in broad stripes of pure color inspired by Balkan folk weavers.

Lis Ahlmann, who collaborated with Gerda Henning for many years, was particularly influential in setting standards for the weaving of fabrics that harmonized well with the natural wood of contemporary furniture. She, too, brought out the inherent beauty of woven wool and earth colors in subdued but contrasting stripes or checkered work. For more than twenty years, working closely with Børge Mogensen,

she produced textiles, which, like the furniture they were meant to complement, are nearly timeless in their capacity to fit into a room and to please.

When Gerda Henning died in 1951, one of her students, Vibeke Klint, inherited her studio. Young Kim Naver studied under Vibeke Klint, and thus was trained in the tradition of Henning and Ahlmann. She designs for factory production, and has been particularly successful with striped cotton fabrics that exploit a wider range of colors than was characteristic of her predecessors. They show the influence of Henning, Ahlmann and Klint in their restraint and honesty. That is, she does not attempt to create fabrics that will give an appearance of being hand-woven but prefers to exploit the aesthetic potentialities of machine technology. She remains loyal, however, to the belief that simple raw materials and muted colors can be beautiful. Though happily wed to large-scale weaving machinery, she has not accommodated herself completely to modern chemistry. She prefers not to design fabrics made of artificial fibers.

Silver. More than a generation before style-conscious Americans began to furnish their homes with imported Danish furniture they learned to appreciate the well-crafted sturdiness and imaginative design of Danish silver, particularly as produced by Georg Jensen.

The new movement in silver can be said to have taken its start in the 1890s, although to assign even an approximate date is an arguable matter. As early as 1850 A. Michelsen produced a delightful little silver teapot that has an appearance in some ways one hundred years before its time in its sculptured, unadorned body, in the simple curvature of its spout and handles, and in its cover topped by a simple floral knob. It displays a timeless beauty. It draws attention to the innate aesthetic potential of silver. It was produced at a time, however, when Michelsen otherwise manufactured objects that fully expressed mid-nineteenth century notions of contemporary style. The little teapot is exquisite; and while it bears witness to an extraordinary talent in silversmithing, it did not begin a new era in design.

The firm of A. Michelsen, founded in 1841, did, however give this early indication of a capacity for innovation and leadership that came to fruition in the time of Carl Michelsen, son of the founder. It helped to introduce a new era. Between 1889 and 1900, the firm employed several

of the most known artists of the period. Hans Wegner, whose works of sculpture now stand freed from time in a museum of open fields north of Copenhagen, was one of these. Another was N. G. Henriksen, who was especially skilled in combining silver with porcelain, and who designed a silver beaker of pure, smooth metal embossed with leaves and flowers that betray sensitivity for ageless values in art. Most famous at the time was Thjorvald Bindesbøll, a man of wide-ranging talents among Danish designers.

Other firms, including those of C. Christensen, Carl M. Cohr, Mogens Ballin and Holger Kyster also employed skilled designers as part of this transformation in silversmithing. Throughout the industry, the influence of Bindesbøll was pervasive. He designed for Kyster as well as for Michelsen. His influence is detectable in the designs of Cohr and Ballin.

These firms were pathfinders, but the true pioneer was Georg Jensen. Like Ballin, and unlike the others, Jensen was himself a trained artist as well as a silversmith. After earning his journeyman's papers as a goldsmith, Jensen apprenticed as a sculptor. He turned briefly to designing for a terracotta factory in Copenhagen where he created more than a score of ceramic designs from around 1899. None were outstanding, but he was still young. In 1904, he established Georg Jensen's Silversmith Shop (*Georg Jensens Sølvsmedie*) and set immediately to producing the wares that made him famous, his broaches of silver and semi-precious stones from as early as 1906.

The elegant simplicity, sculptured suppleness and striking texture of these designs are well known. What is not so well known is that many of the products that later confirmed the high reputation earned by Georg Jensen were in fact designed by others. Of the many who collaborated with Jensen, the one who contributed the most was a trained painter and experienced furniture designer, Johan Rohde. Rohde's first silver spoons were manufactured by Mogens Ballin in 1903, but in 1906 Rohde began an association with Jensen that lasted a quarter of a century. It resulted in a large number of models. His style was different from that of Georg Jensen, tending to be tighter and less curvaceous.

Some of the most magnificent products of the firm were designed a decade and more after 1935, the year in which both Georg Jensen and Johan Rohde died. Their creator is Henning Koppel who came

to the Jensen shop at the end of World War II. In Sweden he worked for Svensk Ten where he developed his skills in cast metals, and in glass with Orrefors. He was 27 when he came back and, although his education was neither in design nor in jewelry, he joined Georg Jensen as a designer for jewelry, hollowware and cutlery. Many of his best-known works were first modeled in clay, which shows in the sculptural quality of his work. His love for sensual forms was not limited to products and sometimes linked to his reputation as a womanizer. Some of his finest achievements are in stainless steel, for the company also specializes in factory-produced wares aimed at a larger market than can be reached with silver and semi-precious stones.

We interviewed Henning Koppel and his wife in 1976 in his studio in Copenhagen and had the opportunity to share a glass of wine while we admired and discussed some of his new designs and work in progress. His famous stainless steel pitcher already had been copied and mass-produced and held a place of honor in the California home of Anderson's (co-author) mother, herself a Danish immigrant.

According to some sources his work is credited with achieving the pinnacle of Danish Modern Design. (*Koppel died in 1981at age 63. We insert here an updated review of his work.*)

Henning Koppel is responsible for what we have come to think of as "Danish design". Koppel was an earlier pioneer of functionalism in design: his mission was to make everyday life products beautiful as well as practical. He was trained as a sculptor and began collaborating with Georg Jensen in 1946.

Henning Koppel is born to a wealthy Jewish family and showed an early talent for art, leading him to train in both drawing and aquarelle early on. He continued studies in sculpture at the Royal Danish Academy and later in Paris. His superb drafting skills, developed as a child, helped him in to produce outstanding product renderings of his designs. Even on their own, they form an exceptional body of work.

Like many Danish Jews, Koppel fled to Sweden during the Second World War. At 27, he returned and began working at Georg Jensen, which marked his start in jewelry, hollowware and flatware design. His first works – a series of necklaces and linked bracelets resembling whale vertebrae and microscopic

organisms - were small masterpieces in imaginative modeling. Henning Koppel was in every way groundbreaking and his jewelry was unlike anything ever created at the silversmithy in its first 40 years. *(http://www.georgjensen.com/global/Designers/ Henning-Koppel.aspx) 2010*

Although his work earned many prizes and accolades, perhaps his most famous piece is the silver pitcher (named the Pregnant Duck) made for Georg Jensen in1952. His designs for Torben Orskov, a pitcher, tumblers and bowls in melamine are an exception of his reluctance to make affordable products. He was always openly critical toward functionalism and unmoved by those critics who encouraged him to design more affordable products. "Functionalism has nothing to do with the art of forming silver" was said to be one of his favorite expressions. Koppel also designed for Bing & Grøndahl (Form 24, better known under the name Koppel White), ceramics for Saxbo, lighting and clocks for Louis Poulsen, Glass for Kastrup and the Swedish Orrefors. Kvetny & Sonner produced his furniture. He won the Lunning Prize in 1953, gold medals at the Milan Triennale in 1951, 1954 and 1957 and the International Design Award of the American Institute of Interior Designers in 1963.

Woodcraft. Cheese plates, trays, salad bowls and animal figures are exported throughout the world from Denmark. Some of the most recent were created by Henning Koppel; however, of older designs probably anyone who will read these lines has seen the wooden monkey with beady eyes, flat face and undershot jaw that hangs by long arms or short legs and seemingly begs to be stroked around his polished tummy of light-colored wood. The monkey often hangs in a chain of identical monkeys dangling from each other, hand to foot. Although other designers produce similar models in wood, and these humorous creatures now are copied cheaply and imported from Asia, the originator of the monkey (and of numerous other products of a richly imaginative mind) was Kay Bojesen. Until his death in 1958, he worked out of a basement shop in the nineteenth century atmosphere of the street on which the Museum for Industrial Design is located in Copenhagen. His shop still looks the way it did: small, crammed to the ceiling. The designs he made famous include rocking horses, wooden autos, painted wooden officers of the Royal Guards, bears, elephants, and rhinoceroses, as well as bowls,

trays, salad servers and small boxes in profusion. Also on display is flatware in silver and stainless steel, for Kay Bojesen was one of the first apprentices as a silversmith with Georg Jensen. Bojesen, born to a Danish bookseller turned publisher, first trained as a grocer, but in 1906 at the age of 20 he came under Jensen's tutelage. As a highly skilled and truly talented silversmith, Kay Bojesen introduced simple, straightforward and, most important of all, usable handicraft at a time where ornate was standard. Some disapproved, others applauded. In 1913 he opened his own workshop where he worked with silver, later with steel, and in time with the wooden products that made him internationally famous. It was for his own son that he created the Noah's Ark in his basement shop, translating into wood ideas about good design. He avoided unnecessary details, but liked friendly designs that avoided sharp edges. Always a child at heart, with a ready sense of humor, he said, "Lines have to smile. There has to be life, blood and heart in things you let go. They have to be human, warm and alive." He loved making the wooden animals and toys, but the most famous of his animals, his monkey, was not made until 1931. When he eventually applied for the monkey to be accepted by the Danish committee that ruled on national souvenirs, the monkey was denied admission because it was not a Danish animal. Now a coveted collector's item, it seems to have become a naturalized Danish citizen.

In 1930 he sold his shop and started working for Bing & Grøndahl as artistic leader. However, probably for traits similar to those of other artists in our story, independence and non-conformity to profitable production demands, he soon was on his own again and in 1932 opened a shop at Bredgade 47 in Copenhagen. It included a workshop for silversmithing and for woodturning. Although Bojesen designed the models for the marketable products, they were made by a number of different manufacturers in Demark. One of these was Langeskov Legetojsfabrik, near Nyborg, on the Danish island of Fyn. This firm made a wide selection of his toys including cars, trains, horses and soldiers. Some of his toys were also made in Holland and Sweden as well as the in the USA under the name Boysen Toys. Unfortunately a number of Bojesen's toy designs were illegally copied by other companies and he spent much time trying to protect his patents.

Bojesen was one of the founders of the annual exhibit for Danish arts and crafts called *Den Permanente* (The Permanent). He commented when the first exhibit was established, "We are sliding into a time of simplification where the practical design of everyday things will be an important demand to consider." These were the views of a practical yet whimsical man who began his career as a grocer, in contrast to Koppel who was supported by a wealthy father but who had faced the dangers of the Nazi hunt for Danish Jews. For Koppel, practical considerations were subsumed by the imagined beauty of the object. Yet, both artists were compatibly contained in a consistent stream of ideas, dialogue and products now often referred to as Danish Modern. Boyesen died in 1958, but his workshop and sales shop at Bredgade 47 were still jammed with his wooden toys when we visited it below the street in 1975 through 1978.

Glass. Most of the Scandinavian glass that foreigners admire is produced in Sweden, where environmental conditions support fifty glassworks, forty of which are located within a twenty-kilometer radius in the province of Småland. They continue a tradition dating from the seventeenth century. In comparison, the Danish glass industry was small and weak. It was not launched until the nineteenth century, when thirteen factories were established. Of these, only one survives, Holmegaard, founded in 1825. (Kastrup, which dates from 1847, was dismantled as this book was written (1978).) Holmegaard's Glassworks Ltd. is a large, modern operation which produces enormous quantities of sturdy container glass in a fully automated factory, but which also maintains a production of handcrafted domestic ware.

Modern design got underway rather late in Danish glass. It began when the Royal Porcelain factory contracted with Holmegaard to develop glassware that would fit well with their dinnerware and with contemporary flatware such as that of Georg Jensen. To this end, they employed a trained designer, architect Jacob E. Bang (1899-1965). Some of Bang's designs are still in production, as are those of his son Michael. The present art director is the well-known Per Lütkin who, like his predecessors, designs pieces that serve their function effectively and please aesthetically because they build upon the capability of handcrafted fine glass to assume shapes, which are sensual in form and brilliantly reflect light. Danish glass, in our time, is limited in

quantity but is high in quality. *(Inserted update: Per Lütkin worked for Holmegaard until his death in 1998, and is considered one of the world's finest glass artisans and a Danish treasure. The Holmegaard Glass Factory merged with Royal Copenhagen in 1985. However, again on the verge of bankruptcy it was closed in 1999, sold again and reopened in 2006 as an adventure park called The Living Glassworks.)*

Danish Modern Design. From this brief survey of utilitarian art we gain a preliminary impression of what the Danish paradigm of modern design represents. It appears to be shaped by two main principles: (1) that the object produced should serve its function as well as possible, and (2) that the form of the object should be honest, fitting well with both the use to which it will be put and with the materials of which it is constructed. Even if the object is purely decorative, a new figurine or a necklace for example, it should be conceived in terms of these principles, since a figurine needs to sit well without tipping and a necklace needs a lock that will not unfasten accidentally. Both should reflect an appreciation of the inherent beauty of the materials of which they are made.

Beyond these broad principles, the approach is eclectic and variable. Objects may be handcrafted or mass-produced, they may be intended to stand out as distinctive art pieces or merge almost unnoticed into their surroundings. Although the aim is to be timeless, they do in fact reflect passing styles. Georg Jensen silver is clearly *art nouveau,* for example, while that of his successor Henning Koppel is not. With his designs in expansive, beautiful shapes in hollowware, cutlery and jewelry, Koppel was breaking new ground for Georg Jensen.

We gain an impression, too, of how Denmark succeeded in the effort to produce objects of modern design. Consistently, we find that modern design appeared when two kinds of skills were joined, (1) those of the trained craftsperson or well-managed factory with (2) those of the artist or architect trained in principles of modern design. To elaborate more precisely these findings, however, we need to turn to the area of modern design that we will examine in depth.

Danish Porcelain. Porcelain originated in China where it was anticipated by high-fired stoneware around the third century of our era. The first porcelain as such dates from the ninth and tenth centuries. Marco Polo brought examples to Italy several centuries later, but imported

pieces remained rare in the West. The first true porcelain factory to be built in Europe dates from 1709. In subsequent decades a large number of factories were constructed in various parts of the continent, among them two latecomers, The Royal Copenhagen Porcelain Factory in 1775, and much later, the Bing and Grøndahl factory in 1853, both located in Copenhagen.

For more than a century, Danish porcelain remained imitative and unexceptional. Royal Copenhagen did produce fine original dinnerware in the so-called *Flora Danica* pattern, each plate reproducing a unique example of the delicate lines and accurate colors of flowers printed in a contemporary set of books decribing Danish plants. Painting over the glaze, *Flora Danica* artists worked with a rainbow of colors, since the low temperature of the final firing is highly permissive in this regard. Not until 1889, however, did the company stand out on the international scene. In that year Royal Copenhagen won the *Grand Prix* at the World Fair in Paris. The product that earned them this prize was a type of porcelain known as "underglaze." It was produced by a technique of painting in a blue-dominated palette of a few colors able to tolerate firing at high temperatures. In applying paint under the glaze rather than over it, the number of colors that remain true and clear after firing is enormously collapsed, but the resultant texture and refraction are stunning. The style developed by Royal to exploit this technique was essentially *art nouveau*, with a decided preference for genre scenes, particularly of the Danish countryside.

Striking success in modern design normally proves on investigation to be very limited as far as true originality is concerned. In his general analysis of creativity in culture change, anthropologist Homer G. Barnett concluded that innovation is a process in which ". . . there is an intimate linkage or fusion of two or more elements that have not been previously joined in just this fashion. . . ." The elements exist in advance, but because they were never united before, the result becomes something qualitatively new, ". . . a true synthesis in that the product is a unity which has properties entirely different from the properties of its individual antecedents." (Barnett1953, 181).

As concerns this first internationally acknowledged triumph in Danish modern design, the element of underglaze decoration was old. It was practiced in China for centuries. Royal Copenhagen knew of it

and learned by experimentation and industrial espionage to duplicate it. They gave it a special effect by diluting the colors. This adoption and adaptation is essentially the process termed *stimulus diffusion* by anthropologist A. L. Kroeber (1948, 691). As for the painting style, as a local expression of *art nouveau*, it was a synthesis of European and Japanese styles that became possible only after Japan opened up to the West in the second half of the nineteenth century. Exhibitions of Japanese art in Copenhagen and Paris in 1886 provided a direct stimulus for a syncretism of French, Japanese, and Danish elements. A style so eclectic in origins might have led to dismal artistic failure but for one critical matter: stimulus diffusion and eclecticism took place in the hands of a person of extraordinary ability, the artist Arnold Krog.

A person with great natural talent cannot be creative in a cultural vacuum. The success of Arnold Krog was inseparable from the success of the Royal Copenhagen Porcelain Company in creating a milieu in which the potentiality of a creative individual could be actualized. Margaret Mead speaks of such a milieu as an "evolutionary cluster" made up of "...*the small group of interacting individuals* who, together with the most gifted among them, can . . . set about the task of creating the conditions in which the appropriately gifted can actually make a contribution." (Mead, 1964, 266, her italics).

Mead found that a key problem for those who want to see culture change (micro-evolution) made into a rational process in which human genius can be applied, is that of learning how, ". . . we can purposefully produce the conditions we find in history, in which clusters are formed of a small number of extraordinary and ordinary men, so related to their period and to one another that they can consciously set about solving the problems they propose for themselves." (Mead, 1964, 267).

To establish an evolutionary cluster is to surmount a "double bind", if we may borrow the felicitous expression of Gregory Bateson, another esteemed anthropologist. The double bind derives from the need to tie down the soaring imagination and unfettered aspirations of an original thinker without hindering cerebral flight, to make the individual free to create even though the restraints of cooperation with others must be imposed. Based upon the study of a number of creative individuals, Abraham H. Maslow concluded that it could be very difficult to find a way out of this bind. To work effectively in an organization requires a

capacity for conformity. Yet Maslow's creative person tends to be non-conformist. (Maslow 1971, 81-85).

"They tend to be unconventional; they tend to be a little bit queer; unrealistic; they are often called undisciplined; sometimes inexact; 'unscientific,' that is, by a specific definition of science. They tend to be called childish by their more compulsive colleagues, irresponsible, wild, crazy, speculative, uncritical, irregular, emotional, and so on. This sounds like a description of a bum or a Bohemian or an eccentric. And it should be stressed, I suppose, that in the early stages of creativeness, you've got to be a bum, and you've got to be a Bohemian, you've got to be crazy." (Maslow, 1971, 93).

This characterization is based upon studies of creative individuals. It is more than a stereotype. Yet, it has in it the qualities of a stereotype and must be accepted with caution. It does characterize extremely well one Danish artist, Jean Gauguin, who worked for years in uneasy alliance with Bing and Grøndahl.

The present factory director, son of the director in Gauguin's time, still recalls with a shudder the tribulations of harnessing the artist's enormous creative potential to the realities of a large organization. Gauguin was given a studio at the factory, where hundreds of other employees punched time clocks and followed company procedures, but where Gauguin, perhaps more a child of his French father than of his Danish mother, openly defied company regulations and often made inordinate demands upon company executives. When doing a ceramic sculpture that included the figure of a horse, for example, he installed a horse in his studio. A beer drinker himself, he taught his horse to drink beer. Gauguin produced some highly original artwork, including large *chamotte* pieces, but he also hosted some equally original drinking parties. What does the manager of a large concern do when order and authority are threatened by tipsy people and an inebriated horse making merry in the middle of a working day?

Jean Gauguin fits the Maslow characterization of how difficult it can be to bring a creative individual into an organization without dampening creativity. Not all artists or designers with the personality type of Gauguin are equally creative, however. We closely investigated one person whose relationship with a factory was at least as stormy as

that of Gauguin, and in which the company and the artist nevertheless managed to cooperate over a period of years. The missing ingredient in that relationship was talent: neither the management nor artist displayed very much. However, these are later situations. Let us return to the creation of a paradigm of modern ceramics in the 1880s.

At Royal Copenhagen, Arnold Krog was responsible for coping with artistic problems from 1885 until 1916. He came to the company after training in the Danish Art Academy, an apprenticeship to an outstanding architect, and one year in Italy where in part he studied old faience. Krog came to the company far more conventional and realistic, far less the lone wolf, than many of the people Maslow identified as creative. Yet he was a path-maker, an innovator, a breakaway from accepted patterns. For him to be creative in the Royal Copenhagen factory, however, required the creation of a new kind of organization. For Arnold Krog to succeed as he did there had to be Philip Schou.

Philip Schou was a businessperson with experience in ceramic factories. The large faience company, Aluminia, which later amalgamated with Royal Copenhagen, came under his direction in 1868. In 1882 he took over the leadership of Royal itself. Related to his period, as Mead might phrase it, he was committed to the concept of industrial art. The idea had grown as a reaction in the second half of the century to the ugliness of industrial products manufactured in the first half. Equally responsive to the philosophy of Romanticism, with its ideas about ethnic identity, Schou wanted to see Denmark create a national style. Dedicated to commercial success, but also to artistic goals, he brought Krog into the company and encouraged him in his efforts to develop the underglaze style. Schou was also the main organizer of the Great Nordic Exhibition held in Copenhagen in 1888. That exhibition served as the first forum for the new underglaze decoration.

A third key person in the Royal Copenhagen cluster was Adolphe Clément. To develop underglaze decoration required the skills of a chemical engineer experienced in working with porcelain. A gifted person in his own right, Clément collaborated closely with Krog in developing the technique, and within a few years added chrome green and gold-red to cobalt blue to create the basic three-color palette that characterized the style.

An appraisal of this evolutionary cluster must take us beyond the factory not only to identify influential ideas and concepts such as those concerning national identity and industrial art. It must also acknowledge three other factors apparently essential for success. First, for individuals to acquire basic technological skills and humanistic orientations, training institutions are necessary. The success of Krog, Schou and Clément grew at least to some extent out of their training in an art institute, a university, and a technical college.

Second, an audience of buyers and appreciators is essential for artistic success. A growing middle class of consumers became the new patrons, to supplement and replace the royal family, which earlier supported the company and kept it alive. By the turn of the century an effective feedback loop of producer and consumer had emerged. A then new element in the system was the appearance of new merchandizing techniques based upon specialty shops, department stores (then an innovation), and more extensive advertising.

Equally important in this feedback loop were art and industrial exhibitions. They began with an industrial exhibition organized in Paris in 1798, when it was decided to hold a big folk festival for crafts and industry. Exhibited wares were not for sale as in a marketplace; but rather were on display so that designers and manufacturers could exchange experiences and earn public attention. The idea worked so well that the industrial exhibition became an annual event. In time, other cities took up the practice, including Copenhagen in 1810. With the International Crystal Palace exposition in London in 1851, the concept was enlarged to feature displays from countries throughout the world. Exhibitions became permanent when museums of industrial art were established. The museum in Copenhagen serves both to preserve historical specimens for study and to provide galleries for the exhibition of current work. The success of Danish porcelain grew in part, then, out of international exhibitions held in 1888 and 1889 initiated by interests of a wider social structure supportive of creativity in the industrial arts.

Third, competition was important. Competition and the presence of an audience are implicit in the custom of holding international exhibitions and exhibiting in craft and industrial art museums. More directly, however, the establishment of the Bing and Grøndahl factory,

as well as of smaller faience factories, stimulated Royal Copenhagen, just as RC stimulated the others. The development of underglaze decoration in porcelain provides a case in point. RC failed to keep the process a secret. By 1886, almost simultaneously with RC, Bing and Grøndahl also experimented with the" new" technique. They, too, set up a creative cluster in which Pietro Krohn at B&G was the counterpart to Arnold Krog at RC. Krohn used the underglaze palette to design a blue on white service called *Heron* after the bird it featured in a variety of poses and scenes. *Heron* got good reviews in 1889 at the World Fair in Paris even though the *Grand Prix* went to RC. To this day, neither RC nor B&G can rest long on old laurels, for each is determined to outdo the other in a highly competitive market in which they are the Danish giants. (Royal Copenhagen today, 1976, employs approximately 1800 people; B&G, approximately 1200.)

(Update: *B&G fell to the ownership of RC, merging with its competitor in 1987, with both taken over by a Scandinavian conglomerate in 2008. See Epilogue.*)

The Royal Copenhagen Paradigm. The evolutionary cluster at Royal Copenhagen around 1885 possessed as its central feature the cooperation of several individuals who among themselves shared the skills of artistic ability, business ability, and engineering ability. At least one of them possessed ability to an extraordinary degree. (We avoid Mead's use of the term "genius" as possessing an uncertain but stereotyped meaning.) For these individuals to work together it was essential that they share central goals, and that the goals included artistic as well as technological and commercial dimensions. It was clearly of special importance that the business head attached importance to artistic goals as such.

For the cluster of key individuals to function creatively an understanding of, and a commitment to, a current ethos or philosophy of industrial design was essential. This, in turn, required institutions to develop and transmit that ethos: educational centers (which also communicate skills), institutions to function in the feedback loop between producers and consumers (i.e. stores, exhibitions, museums), and systems to maintain a feedback loop among producers (competition).

While innovation is an essential element for the success of this paradigm based on the evolutionary cluster, a second essential

component in the process is that of paradigmatic core development, "…
the continuous elaboration of the ideas which constitute the original
paradigm …" (Wallace 1972, 469). From our survey of Danish modern
design in general we can identify one additional idea of this nature. The
artistic goal from the beginning anticipated, if it did not completely
express, the preference we find in Denmark today for earth colors and
rich textures, for nature and natural materials, in short, for honesty in
design. In the 1920s the artistic goal was extended to include, as we saw
in our discussion of furniture, the concept of functional integrity. The
product should perform elegantly the use for which it was intended.
More recently, core development incorporated as well a change in the
role of the designer. That is relatively recent, and will be described in
chapter five.

Now, we turn our attention to Mexico and to the near absence of
a clear paradigm in El Palomar — a pottery factory near Guadalajara
with a shaky beginning, uncertain purpose, meager resources, and
the emergence of an inconstant creative cluster of individuals. As in
Denmark, the pottery traditions in the area of Guadalajara (old folk
practices for making and decorating utilitarian-ware) gave way in the
face of a deluge of factory manufactured utilitarian goods. Efforts to
sustain the folk traditions and pottery vessels addressed the need of the
peasant potter to retain a livelihood, but did not address the fact that
the usefulness of those products was obsolete. The transformation to
factory models of production and to production pieces with utilitarian
purpose for a contemporary market failed miserably. Ignorance and
amateur experiments took precedence over planning, expertise, and the
paradigm of a diversified but creative cluster.

Chapter Three
Paradigm Absent—Paradise Lost
El Palomar in Tlaquepaque, Jalisco, Mexico

Life beats down and crushes the soul
and art reminds you that you have one.

—Stella Adler

The Case of the El Palomar Factory
Traditional Products to International Markets
Establishment of the Factory—Mid 1960s. When the President of Mexico needed a ceremonial gift to offer the President of the United States of America, he commissioned El Palomar to produce tableware of high-fired stoneware, a type of ceramic not manufactured in Mexico until recent years. Inscribed "LBJ Ranch," the ware was decorated in one of the old pottery styles of the peasants of Tonalá. A similar set was commissioned by the next President of Mexico with the monogram "RP" for "Richard and Pat." Commissions by two presidents of Mexico constitute credentials for El Palomar comparable to those of Royal Copenhagen or Bing and Grøndahl. Both RC and B&G at times have been selected to produce tableware considered outstanding as contemporary industrial art, yet distinctive enough to serve as ritual objects symbolic of a nation. Royal Copenhagen traditionally marked its pieces with the statement: *"Purveyor to Her Majesty the Queen of Denmark since 1775"* thus identifying itself as the provider of dinnerware for Danish Kings and the royal family. Royal Copenhagen was for generations identified as the provider of dinnerware for the Danish king and the royal family; and Bing and Grøndahl, more recently, created a large ceramic eagle as a gift to the United States on the occasion of the American bicentennial celebration

The stoneware of El Palomar, including dinnerware and collectibles, while contemporary and international in style and market orientation, remains distinctively Mexican in decorative detail. A Mexico folkloric quality is most apparent in a wide assortment of small bird and animal figurines, which duplicate in three-dimensional stoneware the shapes, and surface designs of terracotta figurines originating in Tonalá. Equally Mexican are certain painted designs of flora and fauna, which also originate in Tonalá, but are adapted to the contemporary shapes of vases, lamp pedestals and dinnerware. Such Mexican innuendos in sturdy utilitarian objects have proved for over a dozen years to appeal to middle and upper class consumers in the United States, Europe and Mexico. Approximately eighty percent of total sales of El Palomar are in dinnerware, most of it to Americans.

The mass production of distinctively Mexican stoneware by El Palomar is ironically non-Mexican in origins. It grew out of the meeting in Mexico of two ex-patriot Americans, Ken Edwards and Arthur Kent. Ken Edwards, a hulking, six-foot-two survivor of beatnik ideals, Greenwich Village and the sculpture studios of the Kansas City Art Institute, arrived in Mexico in the mid-1950s to follow the bull fights, much as Ernest Hemmingway did a generation earlier in Spain. A rugged individualist with an unquenchable need to find expression for artistic urges, the early 1960s found him converted from sculpture to ceramics, a new field for him. He taught English at the North American Language Institute in Guadalajara as a way to finance his kiln. Arthur Kent met Ken at the Institute where Kent enrolled to learn Spanish. We will return to their association after a brief detour to an earlier, and important, association.

Not long after arriving in Guadalajara, Ken, as everyone knows him, went into partnership with Jorge Wilmot, whom many regard as Mexico's most outstanding contemporary ceramist. Before long, the two found the relationship incompatible and dissolved their partnership. It was then that Ken found work teaching English in Guadalajara to finance his kiln. He simultaneously acquired a plot of land near a small village (Tonalá) over thirty miles away. Displaying the kind of Yankee ingenuity and dogged determination that characterizes him, he hired a village boy to help him build an adobe kiln in which he fired the bricks he needed to build a high-temperature kiln. Learning as he

improvised, because he was not trained as a ceramic engineer, when his first high-temperature kiln exploded he began all over again to build a second kiln, this time with success. He was ready to begin his commute between teaching English in the beautiful city of Guadalajara, and experimenting with porcelain and stoneware in a cornfield many miles away.

At about that time, still the early 60s, a very different sort of American arrived in Guadalajara. We now return to Arthur Kent. Kent, suffering from heart disease, sold his business in Los Angeles to enter what he thought was early retirement. He was not quite sixty years old. Enrolled in the North American Institute to learn Spanish, he met Ken Edwards the English teacher, and while he knew absolutely nothing at the time about ceramics, he was increasingly impressed with the wares Ken showed him. Friendly interest grew precipitously into intense involvement when the village where Ken had his kiln did away with electricity and immobilized all further experimentation. By the time that Arthur Kent learned of the problem, Edwards had already signed a contract to build new kilns on the premises of a ceramics factory owned by José Palacio Norman in nearby Tlaquepaque.

Without so intending, Kent converted his new station wagon into a prematurely aged truck as he volunteered it to serve as moving van. Because he was an experienced businessman, he also offered to look over the contract Ken had signed. Reading the contract became a turning point in Mexican ceramics, because he found that Ken, who tends to be careless in business matters, had signed away the profits of his business before it was even established.

Concerned for his new friend, and attracted to a business opportunity like a bear to honey, Kent bought the land next to the Palacio Norman factory and proposed that he and Ken establish a partnership that would join the artistic talents of the one with the business skills of the other. The contract with Palacio Norman would run out within the year. Meanwhile, if Edwards would produce samples, Kent could take them to Los Angeles and attempt to find customers and backers for their enterprise. They entered a marathon because Kent's tourist visa required that he leave the country by the end of six months, and his time was nearly gone. To prepare his samples, Edwards worked night and day, sleeping by his kilns and taking his meals at his bench.

The results pleased both men. In Los Angeles Arthur Kent contacted Fred and Barbara Meiers. Artists as well as business people, Fred once taught art in a southern California community college. At the time that Kent approached him, the Meiers were in the business of distributing Mexican products for sale in the United States. They liked the samples Kent showed them, but were uneasy about buying from a producer who might not be able to meet commitments. Their fears eased, however, when informed that Kent would personally guarantee quality and delivery. Within the year, they were placing large orders for wares that proved popular with their clients.

The contract with José Palacio Norman expired and the neighboring El Palomar factory became a reality. It seems, however, that Ken Edwards remained a careless businessman. Before long, Arthur Kent (75%) and Fred and Barbara Meiers (25%) owned El Palomar. Eventually, Ken Edwards found himself working at El Palomar for an hourly wage.

Although owned and operated by Americans, the factory is a Mexican enterprise. It is successful in part because it employs painters from peasant families in which decorating pottery is a traditional skill. The treatment of workers was, during this study, a familiar one for the local potters whose responsibilities were limited to making, painting, and firing pots in the age old way, with little role in the manufacturing process as such. Imported clay and high-temperature kilns are remote from village materials and equipment. The ware is painted by locals, however, using village motifs executed in a largely traditional manner posing problems, both predictable and unexpected.

Inconsistent Art Management

Involving peasant artisans successfully in factory production requires technical and interpersonal skills of a high order. Ken Edwards exercises these skills. He created and maintains a stable work force through personal ties established as a generous patron to village families. Through his friendships in the village, steady workers were recruited, including some of the most talented in the community. Absenteeism is low, a tribute to Ken's managerial approach as well as to the adaptability of the painters. Rural people accustomed to pace themselves by family, farm and ceremonial routines do not easily adjust to clocks and calendars.

In assisting village painters to adapt traditional techniques to factory circumstances, Ken developed a formula for thickening the paint so that it would feel the same to the artists as the materials with which they grew up. Even so, stoneware painting requires adjustments, since the way colors change when fired is different. Paint also runs or spreads differently under high temperatures. It always takes time for a new painter to master these differences, but Ken is patient.

Ken resisted the American tendency to place workers in rows at tables. Instead, he allows them to sit helter-skelter in their area of the plant, exactly as they do when working at home. Naturally, the environment remains a factory. The workday is devoid of the distractions of family, neighbors, and the household routine. However, painters do assume the comfortable positions they are accustomed to, and may proceed at their own pace.

Pacing utilizes the familiar factory technique of payment by the number of pieces completed rather than by the hour. On this basis, money incomes are earned which are high by village standards, and extraordinarily regular. Production is steady enough so that the factory can meet delivery commitments on time without harassing the artists. Advantages are offset, however, by the implications of a system in which the more workers are able to produce the bigger their paychecks become. Being paid on a piecework basis encourages one to paint as fast as possible and therefore to reduce the care given to fine detail and careful composition. The system also encourages one to put in long, hard hours beyond those required by the factory. Long hours result in fatigue, which further increases the tendency to be less careful with the painting.

These repercussions from the system of remuneration can be controlled by subjecting all work to careful inspection. Here Ken encountered another unintended consequence of the system he created. Hiring village artists based on personal contacts, he created an art staff permeated by the intimate ties of kinship and neighborhood. Brothers, cousins and fellow villagers relate to one another in the plant in terms of life-long loyalties. The senior painter, selected by Ken to inspect all painting, is asked to perform an impossible task. He cannot reject much unacceptable work because he is subject to interpersonal pressures that permeate the workplace. As a result, quality varies greatly from one bowl or plate to another. Many pieces are poorly done. The company is deeply

concerned about this aspect of the broader problem of maintaining standards.

Uncertain of how to proceed, Kent let matters drift along and become worse in recent years. Mr. Kent now favors installing a full-time painting inspector, since it weakens quality control to have the inspector divide his attention by also undertaking piecework painting himself, as presently is the case. Kent is also considering the advisability of finding an inspector who is not himself a painter. This, it is hoped, will bring to the firm an administrator who will not be influenced by the conflict of family and village loyalties. Will the painters work well with such a person? Will their morale remain high? It is apparently easier to let the problem drag on than to attempt forcefully to answer such questions.

El Palomar built its reputation on a line of dinnerware known as "Tonalá." The original idea is Ken's. His prototypes were painted on semi-finished bisque ware purchased from the Losa Fina Company. However, since Losa Fina specialized in sturdy pieces for restaurant use, the dinnerware forms were heavy and uninteresting,

Ken's inspiration was to hire village potters to paint. The way he went about it resulted in designs that remain quite traditional. Years ago, in the days when he was sleeping by his kiln, Ken took a dozen blank (bisque) plates, gave one to each of a dozen painters, and said, "Paint this." He then designated those he liked as prototypes for the line. In the process, he suggested that they paint perhaps a bird or some flowers, and he did not hesitate to suggest modifications in composition. Fundamentally, he let the painters use their own techniques, design elements, and organization. Later, new forms and more carefully composed designs were worked out for the Tonalá pattern by Fred Meiers in southern California, but the painting style remains that of Tonaltecan artisans.

Ken, it should be recalled, is a sculptor, not a painter. It should also be pointed out that he is philosophically committed to accepting peasant potters as colleagues, and more generally, to the implementation of a managerial style that is as nondirective, tolerant, and accepting as possible. Part of the problem in quality control reflects this easy-going attitude. The company at times has been too tolerant of careless work and they pay a hidden price for that, but Ken's managerial style was

also supportive of a peasant contribution to creative elements of product design.

El Palomar built its reputation in part on a line of figurines that especially appeal to travelers who want to bring home something Mexican that is less bulky and expensive than dinnerware. Figurines also sell abroad, since they have an aesthetic appeal that makes them more than mere souvenirs. Ken came to the new factory with many of these designs already in hand. The painting on them incorporates motifs from old Tonalá pottery along with some new elements. The forms are essentially new. The first pieces were created by Jorge Wilmot, a modern designer with whom we will become better acquainted in chapter five. Additional designs based on the Wilmot idea were created by Edwards, both earlier in his association with Wilmot, and subsequently in association with Kent and Meiers.

As an artist, Ken Edwards has achieved far less than he is given credit for in the public eye and in company advertising. His renown, like that of Georg Jensen in the world of Danish silver, is based substantially upon the work of others. Edward's main artistic achievement was to propose the idea of the Tonalá line over a dozen years ago, a line that remains basic to the appeal of El Palomar. Nothing he has created for the company since can match that achievement.

The company recently expanded its offerings by introducing a brown pattern called Vera Cruz, a green pattern termed *Chapalita* and a dark blue one designated Guadalajara. The first two resemble the Tonalá pattern in featuring flowers and birds while the latter departs from company tradition in reducing the composition to a centered geometric daisy, which has no ancestry at all in local art. All three were designed by Fred Meiers of Rolling Hills Estates near Los Angeles. Limited artistic initiative in El Palomar reflects the fact that the company did not employ a qualified artist-designer. It did not even employ Ken Edwards truly as a full-time designer, since his time was spent almost entirely in supervising production. El Palomar, it is clear, failed to recruit the equal of Royal Copenhagen's Arnold Krog to serve as art director.

Poor Engineering Management

Ken's forte in production is trouble-shooting; plugging holes in dikes. Untrained in ceramics, he is weak in dealing with overall

efficiency and day-to-day routine as well as in chemical engineering. In terms of what he wants out of life, these weaknesses make sense for him, if not for the factory. He works for fun. Making money is an irksome though recognized necessity. When he designed and built the kilns, he thought of them in terms of effectiveness for firing ceramics. The factory was allowed to grow more or less spontaneously around them. Preparing clay, pouring or pressing molds, moving pieces in and out of the smaller bisque kiln, to the painters, through the glazing operation, to the large kilns and on through the various other processes of manufacture took place with an inordinate amount of unnecessary movement and inefficient technique. In the end, a factory employing 105 people attempted to compete internationally using homemade equipment based as much on innate Yankee ingenuity as on sound engineering principles.

The problem of engineering, overall efficiency and smooth daily operation permeates the plant, but centers upon kilns, since they are the largest and most expensive items of equipment and cannot be moved. Shortly before Ken left the firm in 1973, a tunnel kiln was installed to reduce inefficiency in firing plates. Stacking plates in the old kiln was wasteful because each plate was loaded with a slab under it, leaving the kiln as full of slabs as it was of salable items. Because plates are so simple in form, a tunnel kiln may be expected to result in efficiencies. The one installed under Ken's direction, however, never worked quite right, primarily because it proved impossible properly to control oxygen reduction. Only eighty percent of plates fired passed inspection in the first quality category while the figure was ninety percent for the old kiln. The tunnel kiln was dismantled, but perhaps prematurely. The number of first quality dinnerware fell as low as sixty percent at times after that in the old kiln. Yet it is reasonable to conclude that whether or not the kiln was salvageable, the more fundamental error was to construct a tunnel kiln without the services of an experienced engineer. Tunnel kilns work very well in the porcelain factories of Denmark, particularly in the Bing and Grøndahl factory.

Around the time that Ken terminated his association with El Palomar (1973), an American artist trained and experienced in ceramic design was brought in to serve as consultant on glazes. He was also asked to participate broadly in the problem of improving production.

This man was Richard Petterson, Professor of Art at Scripps College and a specialist on Chinese and Latin-American ceramics. The tunnel kiln was under construction when he arrived, so Petterson was asked to turn his attention to the remaining kilns. Under his direction, a large bell kiln was constructed and the foundation laid for a second such kiln. Called a bell kiln because of the shape of its top portion, it offers efficiencies that result from hoisting the cover and loading through the top.

As designed, Petterson's kiln should have worked quite well. He left, however, before construction was complete. For unaccountable reasons, the final work of completing the chimney was never carried out. The result was serious dissatisfaction, because plant personnel on the second floor found the air exceedingly hot. One worker complained of faintness. It is little wonder. The kiln was venting carbon monoxide fumes into their area. The second story of the factory is itself an expression of the ineptitude of plant engineering. In spite of the expense involved, Mr. Kent concluded that more space was needed if the plant was to operate efficiently. The upper floor was planned as an area in which pouring clay into molds could be done. An engineering analysis after construction was completed revealed that the second floor was not sturdy enough to support the weight of barrels of liquid clay. Pouring continues to be carried out in a confined space on the first floor where the pourer must walk across the room every time he needs to fill his bucket from a standing barrel.

The expensive second story space was turned over to the seamstresses of the small dress-making division of the factory, who for a time worked in the heat and fumes of the bell kiln. Next, the space was used by Ken for making new molds. Ken rejoined the firm in 1976 after a three-year separation. The bell kiln, meanwhile, was dismantled.

The permanent replacement for Ken was to be a trained chemical engineer brought in on a trial one-year contract. It became clear that he was not working out well. He was let go when his contract expired. He was it seems the opposite of Ken in his approach to the job. Whereas Ken kept things going by improvising, the new man attempted to do so by rigidly following certain limited procedures with which he was familiar. Since these did not include experience with the new kilns, on

that basis alone, it now appears, he ordered both the tunnel kiln and the bell kiln dismantled.

He also ordered the glaze spraying booths dismantled, in that instance without realizing that he would not be able to replace them with new purchases. (After several weeks of tying up production because no one could glaze and fire, Edwards was asked to design replacements to get things moving again.) Kent now regrets that he allowed the new engineer to involve the company in such heavy expenses, but at the time, he felt that a qualified technician ought to know what he was doing. What the technician apparently knew was that he did not like equipment he did not already know or that was not purchased from a known equipment manufacturer. His training was faulty.

In order to cover the heavy losses involved in expanding the factory building and dismantling the kilns, it became imperative to increase production and reduce inefficiencies. To this end, five new shuttle kilns were installed. They are in use today *(note: remember this is written in 1976.)* More efficient than the old front-loading kilns, it became clear after they were in use that they remain less than perfect although their efficiency is better than that of the original kilns. Items to be fired are loaded upon a cart that rests on iron rails outside of the kiln. It can be reached from all four sides. The original kilns could only be loaded through an opening in the front, a much more restrictive procedure. When the shuttle cart is loaded, it is pushed into the kiln and the door is sealed. In unloading, however, the cart has to be pulled backwards to where the loading took place. This means that the cart of fired ware has to cool and be unloaded before a new load can be stacked on the same cart. In the more efficient shuttle kilns of the Søholm factory in Denmark, a railway switching system allows an empty cart to be loaded while the full cart is in the kiln or is cooling. Therefore, while the new El Palomar kilns fire well, they are bottlenecks. Kent is seriously considering the possibility of replacing them in the near future.

A number of engineers followed Ken's original replacement. The present man is a twenty-two year old graduate of the University of Guadalajara. He is qualified as a chemical engineer, but came to the factory with no experience at all in ceramics. Unfortunately, Mexican universities do not train people in this specialty. Technicians trained in other countries can earn much higher wages than Kent is able or willing

43

to pay. Therefore, Kent feels he must develop local talent. He plans to send his young engineer to the United States for a month of visits to the Heath factory in Sausalito near San Francisco and to other factories.

Meanwhile, Ken Edwards is back. Ostensibly, he is working on a small number of new designs. Above all, he is caught up again in production problems. He is doing what he does superbly, plugging holes in dikes with daily repairs and improvisations.

Fortunately, for El Palomar, Ken Edwards needs cash once again to finance his own private kiln. He is willing to work for a small salary compared to what he might earn in the United States. Even with Ken Edwards and the university graduate, however, it is clear that El Palomar failed to recruit the equal of Royal's Adolphe Clement to serve as production engineer.

The *Buen Gusto* Debacle

Lead has been widely used since antiquity as a glaze for cheap terracotta objects. They can be fired under low-temperature firing and yet attain a smooth, glossy finish. The solubility of lead glazes, however, is now known to constitute a serious health hazard for anyone eating or drinking anything acidic from such surfaces. Because of this danger of lead poisoning, federal law now prohibits the importation of lead-glazed utilitarian ware into the United States. The new law closed off a rich market for peasant potters throughout Mexico. At El Palomar, this was seen as an opportunity for the factory. They proposed to develop a lead-free line of low-priced kitchenware to fill the market vacuum. The pattern name was to be *Buen Gusto* .

In design, *Buen Gusto* was to incorporate the rustic shapes and painting of traditional Mexican terracotta with its proven market appeal; it was to be modernized to extend that attractiveness. It was also to be produced very inexpensively. First, it was to involve very little hand painting. Second, it was to employ painters on a cottage-industry basis. Third, by using cheap local clays it would save the expense of importing foreign materials.

The idea was under consideration just before Ken left the factory but after Richard Petterson came on the scene. The two ceramists collaborated in working it out. For reasons, which are not clear, singly nor together, did they come up with shapes and patterns acceptable

to the company. These were created later by Fred Meiers. At this later stage of development, Kent and Meiers departed from their original intent by separating the ceramic forms, under the name of *Buen Gusto*, from the painted design, which was designated as *Lal Jalma*. The latter follows the original plan in being quite simple to paint. It consists of a wide brown line along the border. The shapes also follow the original plan, since Meiers designed informal rectangular plates rather than round ones and coffee mugs rather than cups and saucers. When they went into production, however, it was decided to produce the shapes of *Buen Gusto* in any of the existing patterns, including Tonalá. All of these patterns require extensive painting, which eliminates the savings of simple painting, of course. Ken wanted the ware to be manufactured on a cottage-industry basis. The idea derives out of his Peace-Corps-like desire to help peasants. Factory-made pieces would be delivered to the community to be painted and would be returned to the factory for glazing. Ken felt that cottage industry would bring employment to additional members of Tonalá and yet work out well for the factory. Such a system would allow individuals to paint in a congenial atmosphere, since they could work, according to age-old custom, in their homes, surrounded by their families. It would provide employment for those who need part of their time for farming or other responsibilities. It would save individuals the time and expense of commuting to the factory in Tlaquepaque. It would benefit the factory by providing a lower overall unit cost.

Arthur Kent found the idea attractive, but impractical. The savings in piecework payments would be overbalanced by the costs of transporting unpainted pieces to the village, distributing them to painters, and collecting them again when painted. So much movement of goods would involve high breakage rates. Under cottage-industry arrangements, the factory would not be able to rely upon delivery dates. Tonalá potters are well known for how difficult they find it to fill orders on time in producing their own traditional wares. Finally, it would be nearly impossible to supervise quality, since it would be very hard to reject imperfect work when a family's whole production batch, rather than individual pieces, were turned in at any one time. *Buen Gusto*, as a result, is produced entirely in the factory. It involves no savings in labor management costs. Producing marketable kitchenware at low prices,

above all, required shifting to cheap local clays, this in turn required a replacement for the old lead glaze. Petterson had one that worked with the clays of Oaxaca in the south of Mexico, but it crazed (cracked) when tried locally. Joint experimentation with Ken yielded repeated frustrations. When both Ken and Petterson left El Palomar in 1973, the search was abandoned. It was not seriously pursued again until Ken returned in 1976.

Intermittently between 1973 and 1976, Ken experimented in his own kiln, but the need to produce goods to earn a living left little time for this kind of investment in future products. Meanwhile, El Palomar resolved the problem by producing *Buen Gusto* in the imported clay that is utilized for their other patterns. With that, the last of the hoped-for economies evaporated. What remained of the original plan was no more than some additional variety in the established line of wares.

Poor Business Management

Our last visit found the company financially optimistic after half a decade that included several years when bankruptcy threatened. It was a half decade of general economic recession that was hard on many businesses. Yet El Palomar seemed to suffer more than it needed because it was poorly administered. When Harry Truman was President of the United States, he kept a small placard on his desk that read, "The Buck Stops Here." It is certainly true that the ultimate responsibility for making decisions lies with the president, not only in a nation, but more directly and completely even in a small company. It can clearly be unfair at times to lay blame for failure on a president. We do not want to be unfair in assessing the effectiveness of Arthur Kent. It must not be forgotten that there would be no company today had Arthur Kent not taken hold and carried on. It should also be pointed out that despite the fact that he looks and acts fifteen years younger than is normal for his seventy-plus years, he suffers greatly at times from the heart problems that led him to Guadalajara years ago to retire. (*Note: he lived to be 101.*) Yet, when all is considered, the president proved ineffective at key times in the history of the company.

Mr. Kent must be held responsible for a series of costly errors in judgment. At least in retrospect, it was clearly a mistake to let an inept engineer order the demolition of perfectly useful kilns. It was equally serious to invest heavily in

plant expansion only to learn that the work was improperly carried out with serious consequences that were avoidable. It was wasted effort to develop a line of low-priced kitchenware that ended up selling at higher prices. It is mere procrastination to let the problem of quality control drag on without forceful resolution. Lingering indecision allowed price schedules to fall behind general inflation for three years before they were hiked up to where they belonged. It is inexplicable that after hiring efficiency experts from Texas a couple of years earlier to search for ways to improve efficiency, no recommendations were carried out.

El Palomar, it is clear, failed to develop a business management model equal to that of Royal Copenhagen's when Philip Schou was business manager. The difference may be rooted in experience, personalities, understandings and misunderstandings of job requirements and resources available, but also in cultural contexts, which are dramatically different.

El Palomar in a National Context

The company is financially optimistic as this is written, *(1978)* but primarily because a big order recently was paid in dollars at the very moment the peso was devalued. This yielded a momentary infusion of funds. In fact, the firm will need to display skilled leadership if it is to survive, because it is caught, suddenly, in a market squeeze.

Until 1975, El Palomar competed in the international market with the advantage of cheap labor by skilled peasant potters. This allowed them to offer hand-painted products at prices competitive with good stoneware from nations which could no longer afford handwork.

That advantage evaporated with minimum wage laws that forced the company to raise wages by forty-three percent in 1975 and by an additional twenty-three percent in 1976. Comparable wage hikes are anticipated for subsequent years. Factory success until recently was subsidized, in effect, by a staff of impoverished worker-peasants. That subsidy will now end if the labor laws are enforced.

One major way for the company to remain competitive is to become more efficient. This is exactly the problem faced by factories in the more industrialized nations with which they compete, yet the record of El Palomar is poor in efficiency and their options are limited. They cannot presently afford to build more cost-efficient kilns, since they

already suffer financially from the kiln investments of recent years. They cannot speed up other operations by investing in machinery to replace costly handwork, because devaluation of the peso makes it impossible to buy certain key equipment at this time. They seriously need a German jiggering machine, for example, but whereas the peso has fallen low, the German mark has reached undreamed of heights. To acquire German equipment is out of the question at this time. As long as the nation cannot produce its own equipment at prices the factory can afford, El Palomar is at a disadvantage in competing with the factories of other nations. The same observation applies as concerns skilled designers, engineers and managers. Specifically, our investigation revealed that El Palomar is frustrated in its efforts to recruit a qualified ceramic engineer because the requisite training is not provided in Mexico, and foreign-trained experts are too expensive to hire.

Finally, the nation fails, not necessarily through any fault of its own, to provide a rich internal market for high-fired ceramic products. El Palomar is forced to produce for an external market. As a result, quality and imagination are ineptly stimulated. Mexico lacks the well-developed feedback between producers and public which in Denmark gave sophisticated, middle-class consumers and critics a strong voice in product design.

Tourist tastes and purchases count far more than indigenous criticism, and ideas about industrial art remain poorly developed. The interrelationship of form and function rarely challenges the interests of those who manage factories.

In every category, then, the nation is unable at this time adequately to support a creative industry in modern design. Not the least, it fails to provide the stimulation of competition in industrial-artistic achievement.

Copies and Competition

Fine stoneware and porcelain factories abroad are too remote and ties with them are too indirect to permit mutual stimulation or direct imitation. It is evident that European factories, including Danish, exert no influence as models. Locally, a common language, proximity and obvious direct competition could be mutually advantageous, much as athletes in competition drive one another inexorably to new

records. Unfortunately, other ceramic factories offer no challenge in the development of industrial art in Mexico.

Located on property adjacent to that of El Palomar, Ceramica de Jalisco offers the only current local competition in high-fired ware. It began, as did factories like it at a time in the 1930s when Tlaquepaque began to experience growth in the market for tourist wares. Tourists in subsequent decades became as important as peasants in the purchase of water jugs, casseroles, dishes and other cheap utilitarian goods.

José Palacio Norman, the son of a university-trained mining engineer, got involved in tourist sales when he purchased Tonalárt, one of the large, central stores selling local craft products. You may recall he and Ken Edwards worked together briefly, before Arthur Kent read with dismay the contract Palacio Norman had drawn up that would have cheated Edwards out of profits.

The main ceramic attraction of Tlaquepaque at that time consisted of small human figurines and local low-fired pottery. Looking for ways to increase profits and ensure supplies, Palacio Norman established *Ceramica de la Jalisco* at Tonalárt in Tlaquepaque in1932, moving to its present location a few years later. For two decades the factory functioned by employing a score of local potters to produce their traditional wares. Other similar factories grew up in the area, including *Alfarera Aldana* in Tonalá (Diaz, 1966, 167-169). All were similar. Products did not deviate from those of independent peasants except in artistically disappointing ways. The work tended to be less carefully done than was characteristic of the best potters, and innovations were inspired by a storekeeper response to tourist tastes, resulting in ashtrays and brightly painted souvenirs along with older forms.

Ceramica de Jalisco entered a new phase around 1943 when it shifted to finer clays and better kilns to produce tin-glazed, unleaded, earthenware (faience). Some of the older pottery was lead-glazed. When tin oxide is added to the lead and fired under higher temperatures, it produces an opaque, white, porcelain-like surface which can be painted in lively colors and refired to produce a glossy, colorful finish. With faience, Tonalárt expanded its offerings to capture the rapidly growing tourist trade of the post-World War II era. British-type beer mugs, painted Venuses, colorful platters and the inevitable ashtrays became the seedbed for a large assortment of objects, nearly all of which had

nothing Mexican about them. Even painting a sleeping peon in his sombrero was an artifact of the tourist impact upon local art.

Similar faience factories grew up to compete with *Ceramica de Jalisco*. One of the most modern and efficient was *Ceramica Artistica Tonalá* (CAT), established in the village of Tonalá around 1960 by Manuel Garay, a professional engineer with no background in ceramics but with an eye for business opportunities. Colorful, porcelain-appearing faience not only promised continuing sales in the tourist market, but by 1960 promised to sell as well in a middle-class Mexican market that suddenly began to swell. Mexico began to fill the socioeconomic gap between a small and wealthy internationally oriented elite and a mass of peasants and workers. This new, fast-growing, middle-class population needed goods, including tableware and household ceramics. Here we caught a glimpse of a possible Danish-like transition from folk art to modern design for a potential future market in Mexico.

The Mexican middle-class was not at all interested in filling their homes with beautiful examples of village arts and crafts. Anthropologist Oriol Pi-Sunyer recalls from the town of Zamora how stunned were his Mexican urban friends to find that he and his wife had decorated their flat with folk art. They referred to the Pi-Sunyer apartment as a museum (Pi-Sunyer 1973, 32, 102). Middle-class patrons wanted household wares that were international in concept. Sensing this, Garay established CAT to produce vases, mugs, ashtrays and flowerpots for tourists, but also to produce tableware and vases for Mexicans. Operating four petroleum kilns, Garay employed Tonalá potters to paint, but not as Ken was to do a few years later. Garay asked his potters to paint designs which he provided for them, designs they had never tried before, in order to produce colorful yellow or blue on white and green on green floral patterns of the sort that crept into Mexico through Sears stores and the Woolworth chain. It was superior ware for what it was, but it was not a product of skilled artistic design and was unrelated to folk art motifs, even though hand painted by locals.

Recently, CAT adapted the figurine line of El Palomar to faience. Attempting to tap the market for small ceramic sculptures, they now produce the animals and birds originally designed by Jorge Wilmot and Ken Edwards. In faience they look different for being porcelain-white with rainbow-bright colors, but otherwise they are exact copies.

Garay is also taking a string out of Ken's bow to produce vases and plates on which traditional Tonalá designs are painted, again in bright colors that contrast sharply with the muted colors hitherto employed. Other faience factories in the area, including *Ceramica Artistica "Gomez"* in Tlaquepaque, manufacture products nearly identical with those of CAT,

Meanwhile, *Ceramica de Jalisco* (CAT) shifted to quite different wares again. It will be recalled that when Ken moved his kiln from its location in a cornfield in which the electricity was cut off, he moved into the partially unused factory of José Palacio Norman. When Ken joined Arthur Kent to set up El Palomar, he left his high-temperature kilns with Palacio Norman. He also trained men to produce stoneware for his former landlord. This he did, not because his contract required it, but because Ken Edwards is extraordinarily helping and sharing. He created his own competition. It has not mattered. Consequently, *Ceramica de Jalisco* has produced stoneware since the early 1960s. The basic concept of their tableware is identical with that of the Tonalá line produced by their neighbor El Palomar. The pattern differs in including more painting, with figures drawn against a background of sprays of green leaves. Rather than painting birds and butterflies on everything, these pieces portray fish, deer or birds.

(**Insert:** *A description of Palacio Norman's shop in its early days showed a dynamic business in the 1940s:*

Two of Tlaquepaque's most important shops catering to the tourist trade were El Arte Tonalteca owned by J. Palacios Norman and a shop belonging to Joséfina Arias. Norman was a master potter himself and a very perceptive businessman. His shop was a rambling Spanish house built around a central courtyard, filled with studios, showrooms and bougainvillea draped patios. Artisans worked in full view of the shop's patrons, which proved to be one of Norman's best selling techniques. A tourist could sit, relax and have a cold drink in one of the many patios—all the while observing and chatting with the potters and artists at work. With such camaraderie and a better appreciation for the talented artists, it was difficult to leave without buying a few pieces of pottery. *(www. donnamcmenamin.com, 2010)*

In 1978, José Palacio Norman is old. He is content to allow the factory to continue without growth or change. Only three people remain to manufacture painted faience tiles and stoneware sets of dishes. The two painters are superb. Their tableware painting is consistently freer and more complex that that of the El Palomar line. With some exceptions, the fauna are portrayed more in the lively brush strokes of a Chinese painting than in the Disney-like style that tends to shape El Palomar birds and butterflies. However, if the painting is more interesting, the product a decade later is an almost unbelievable failure.

Palacio Norman is a former potter-cum-businessman who does not directly concern himself with production methods. Factory management is left in the hands of the former village potters trained fifteen years ago by Ken. With the passage of time they have lost control of the technical process. They fail to maintain kiln temperatures and glaze mixtures at standards accurate enough to produce uniform background colors. The best of their recent work, seen in a dining-room display at Tonalart, includes plates that are mismatched and coffee pots and teapots with lids several shades lighter than the bottoms. We spent an afternoon going through stacks of dishes. We found only a few that were not seriously blemished.

Crazing, which probably results from errors in mixing the glaze, was nearly universal. Some displayed crawling, which is caused by poor adhesion of the glaze during melting and which could result from applying the glaze too heavily or, alternatively, from allowing dust to settle before the glaze was applied. Still others suffered from pin holing and bubbling, which may be attributed either to problems in mixing the glaze or to errors in setting the temperature of the kiln. Nearly every piece was so dark and smoky in appearance that the painting was heavily obscured. It is understandable that wares of such poor quality are not widely distributed. They may be obtained only in *Tonalart* as seconds and in a store owned by the brother of Mr. Palacio Norman. *Ceramica de Jalisco* provides no competitive basis to challenge EI Palomar to produce new and more interesting products. When the products of El Palomar are displayed for sale next to those of any of the other factories of the area, including *Ceramica de Jalisco, Ceramica Artistica Tonalá,* and *Alfarerla Aldana,* the only predictable reaction can be one of self-satisfaction. The comparison encourages a tendency to forget that higher

standards are set in international competition. It seems clear that one of the reasons why El Palomar does not achieve more is that the area of Guadalajara does not force the factory to compete with an energetic competitor the way Royal Copenhagen was forced to compete with Bing and Grøndahl.

The Misplaced Paradigm.

El Palomar, beyond dispute the finest ceramics factory in the Guadalajara area and perhaps the best in all of Mexico, falls short of standards set in the nineteenth century by the Royal Copenhagen Porcelain Factory. In the solution of business, engineering, and design problems the company failed to put leadership in the hands of a cluster of creative individuals. The company has been plagued by the costs of human error and inadequacy. Failures and mediocrities can also be attributed to inadequacies in the infrastructure of supportive institutions, especially in the areas of professional training, the mechanisms of feedback loops, and the stimulation of competition. The concept of industrial art is only weakly developed. The situation, of course, is one of relative standards. El Palomar does well. At issue is the fact that, in a worldwide competitive market, it is not one of the very best. It is precisely at this point that the method of balanced comparison becomes essential if we are to be accurate in our appraisal. In comparing El Palomar to Royal Copenhagen of the nineteenth century, are we making an unfair comparison: the very best of Danish history versus what is ordinary at this moment of time in Mexico? To a striking extent this is exactly so, as the following chapter will reveal.

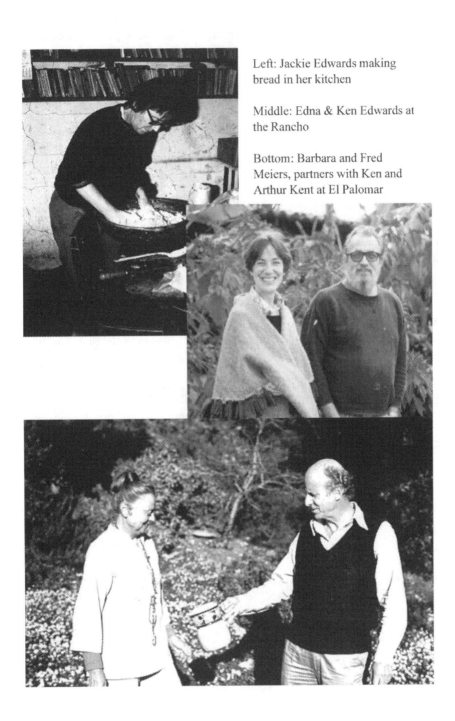

Left: Jackie Edwards making bread in her kitchen

Middle: Edna & Ken Edwards at the Rancho

Bottom: Barbara and Fred Meiers, partners with Ken and Arthur Kent at El Palomar

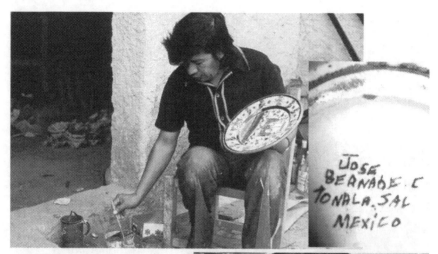

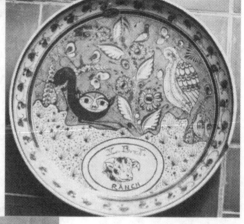

Jose Bernabe at work,
1975

Upper right: his signature,

A Petatillo plate designed for
a gift to the President of
the U.S., LBJ, from the President
of Mexico

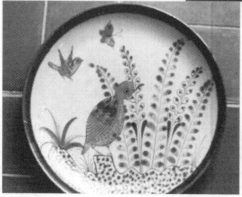

Bottom left:
a quail design
ala Ken Edwards
and Jorge Wilmot

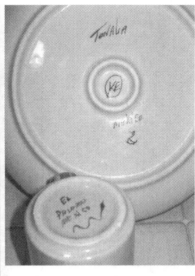

Above: Ken's initials, KE, with painters' signatures

Below: Jorge Wilmot's signature. (*authors' collection*)

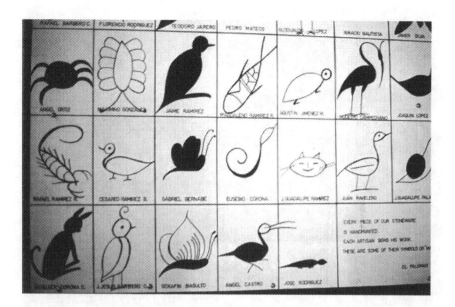

Above: a chart of village painters' signs, often used instead of a signature.
Below: another list of painters and their signs.

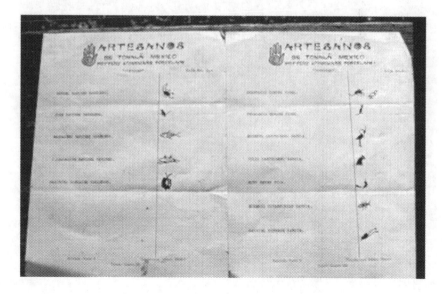

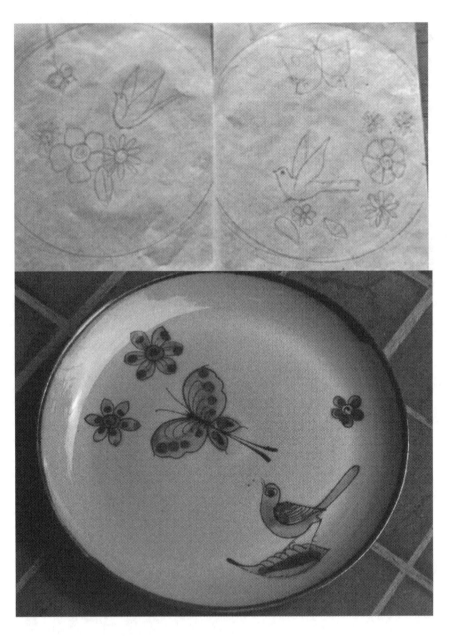

Patterns to guide the painter. Below: a plate using a similar pattern with a variation. El Palomar, Tonalá

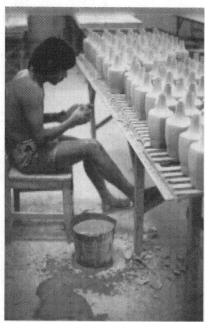

Upper left: 1976, El Palomar,
preparing bisque-ware for
painting

Upper right: a poorly made copy
of Wilmot's owl from a renegade
potter

Right: A boy painting and
repairing the fired pieces.

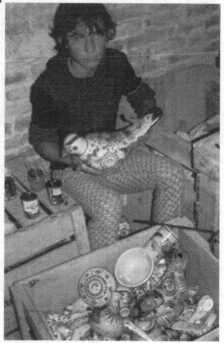

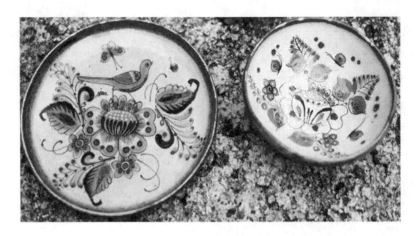

El Palomar plates poorly painted, different colors, don't stack in dishwasher.
(below) one pattern, variations in designs and in quality.

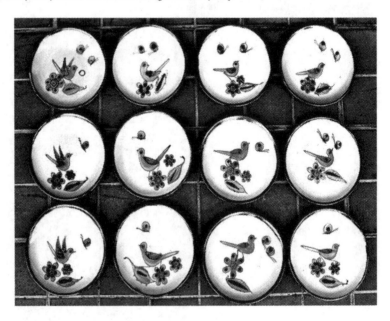

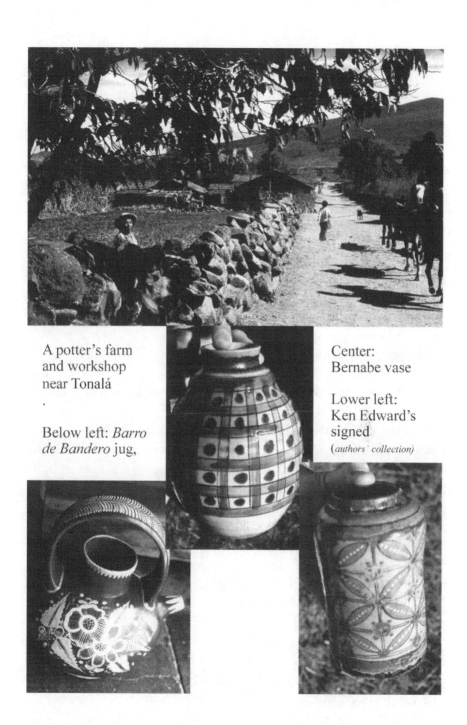

A potter's farm
and workshop
near Tonalá
.

Below left: *Barro
de Bandero* jug,

Center:
Bernabe vase

Lower left:
Ken Edward's
signed
(*authors' collection*)

Chapter Four
Denmark—the Old Potters of Bornholm and Sjælland

Art at its most significant is a distant early warning system that can always be relied on to tell the old culture what is beginning to happen.

—Marshall McLuhan

The Family Paradigm Evolves — From Folk Art to Modern Design

The Royal Copenhagen Paradigm has existed in Denmark for nearly a century. It is a paradigm for rational development of the industry, but exactly how rational is the industry as we find it today? To answer this question, let us examine a region of Denmark that corresponds to that of Guadalajara. In the Baltic Sea the Island of Bornholm serves our purpose exceedingly well. Like Guadalajara, it is known nationally as a center for contemporary ceramics. Like Guadalajara, it is a center both for individual potters and for large-scale production. Four factories provide a focus for the industry. All are located in the island capital, the town of Rønne.

Bornholm has long been famed for its beautiful ceramics. The unusual geology of Bornholm includes deep veins of clay that potters have appreciated for many generations. Since the 1700s, hundreds of island residents have produced large numbers of unusual pots, plates, and cups — many of which are whimsical and highly idiosyncratic reminders of another way of life. In 1858, a small-scale factory, Hjorth's Ceramics, was established to make pottery from the island's rich deposits of clay. The business was a small family operation. It provides a paradigm model to compare and contrast with the development of an urban factory model (The Royal Copenhagen Paradigm) as well as to

use later in examining the successes and failures of similar strategies in potteries around Guadalajara.

The Family Paradigm: from the Folk Art of Daily Life to Modern Art as Commerce

Until the end of the nineteenth century, the organization of ceramic production in Denmark was patterned as a family paradigm. Small potters in peasant villages and preindustrial towns characteristically managed their shops as family undertakings, which were passed on in inheritance to their children. The result in some cases was a firm that remained in the hands of a single family for as many as six or seven generations. In places, family shops functioned in an extended family network. They were frequently located in a village, parish or town in which many potters working independently in small shops were relative of one another.

Factories constructed in the last century, frequently were organized on a family paradigm. Although the family paradigm is less rational in an industrial society than is that of modern design, it offers some advantages. Where local politicking and intrigue are a factor, families often succeed in maintaining solidarity better than do congeries of unrelated individuals. Where labor problems intrude, families may offer advantages of mutual reliance based upon non-commercial considerations. In the face of rising wages and expensive fringe benefits, family members often are induced to work without the constraints of labor contracts.

The advantages of the family paradigm often outweigh the disadvantages, however. As a model for clustering creative individuals in a commercial enterprise, the family paradigm proves comparatively limited and rigid. Factories organized as voluntary associations recruit in terms of training and ability. Family businesses are under pressure to employ relatives, regardless of talent, who may be ill suited to their tasks. Of course, families do possess some flexibility. Not all members need stay in the business. Outsiders can be attached to the core group through marriage or informal adoption. Non-family members are also hired for pay. Yet only with difficulty can a family organization free itself completely from the deadweight of unneeded or counterproductive members. In contrast with the Royal Copenhagen Paradigm, the family

paradigm is ill suited to organize the collaboration of skilled and talented individuals in a ceramics factory.

The shortcomings of a family paradigm in the industrial age are offset, at times superbly, by minimizing reliance upon family members. When that occurs, principles of hiring may become very similar to those of the Royal Copenhagen Paradigm. If remaining family members possess the necessary skills and ideals, operation of the enterprise may appear identical to that of the paradigm that produced modern design. The appearance can be deceptive, however. The resultant paradigm is a syncretism, a pattern that shares features of each of the parent paradigms. This is so because, although non-relative artists and specialists may be recruited, it continues to incorporate families as integral to its structure, and therefore is under pressure to revert, eventually, to a familistic syndrome in which disadvantages are greater than advantages.

The Johgus Factory—a Partnership of Friends

All of the factories we studied in Bornholm began as family enterprises. One is Johgus. Founded in 1945, it is the youngest of the Bornholm factories. The unusual name is a contraction from the names of the founders, Johannes Pedersen and Gustav Ottosen, both of whom were journeymen potters employed by Søholm the largest of the island factories. Petersen suffered a stroke in 1952 and sold out to Ottosen who still owns and manages the firm. The name sounds peculiar, even ugly, to the Danish ear. Its creation suggests aesthetic insensitivity and lack of imagination.

Johgus products resemble in general quality those of Mexican faience factories such as *Cerámica Artistica Tonalá* (CAT) and *Cerámica Artistical "Gomez"*. The factory is technologically well run. Mr. Ottosen commands the necessary expertise. It is artistically impoverished, however. Catering primarily to a tourist market that combines vacationing on the island with visits to ceramics shops and factories, the best of the wares may be imitative and featureless. The worst include crude ceramic miniatures of local tourist attractions and other bric-a-brac destined for souvenir shops. Pieces are formed by pouring fluid clay into slip molds. An unskilled worker whose job demands no drawing of figures or completion of designs more complex than simple lines and loops carries out hand painting.

In contrast to comparable faience and souvenir novelty factories in and around Guadalajara, Mexico, only this one exists on Bornholm, even though the influx of tourists is large in both areas (mainly American and Mexican in the Guadalajara region; German, Swedish and Danish on Bornholm).

The factory is small. Earlier, the staff totaled twenty-two. The number fell to twelve in the mid-fifties and to seven in recent years. A decline in staff is the owner's response to inflationary increases in wages and fringe benefits combined with dissatisfaction over worker productivity. In discussing these problems with us, Mr. Ottosen disclosed that he is considering further reductions that will leave the firm essentially limited to himself, his wife and their son. Although such a move would reduce the volume of sales, it would not decrease the Ottesen's income because of savings in the expenses of employee's wages and benefits. Further, this step will eliminate the fatigue and frustration of managing personnel and meeting payrolls. Even without this projected reduction in staff, the factory operates basically as a family undertaking. It follows a family paradigm rather than the one we have identified as a paradigm of modern design.

The Hjorth Factory, Successive Generations in Dispute

Two factories inevitably are mentioned in any discussion of fine, old enterprises in Denmark. One is Kähler on the island of Sjælland. The other is Hjorth on Bornholm. Both have existed for well over a hundred years as factories organized based on a family paradigm. Hjorth is of interest in the present analysis because it made efforts at times to syncretise with the paradigm of modern design, but did so without much success.

The Industrial Arts Museum (*Kunstindustrimuseet*) in the impressively restored King Frederick's Hospital in Copenhagen recently *(1976)* hosted a retrospective exhibition on Hjorth. In conjunction with the exhibition they published two small books, one on the factory and the family, the other on the artistic achievements of seven family members. As with El Palomar for Mexico, Hjorth brings distinction to Denmark.

With so much current national awareness of the factory, we fully expected to be put-off by secretaries and clerks when we approached the

plant in Rønne. Here again we encountered a parallel with El Palomar. In both places we received full cooperation. Erik Hjorth, like Arthur Kent of El Palomar, showed us around his factory and arranged for us to talk with whomever we wished.

Established in 1859 by Lauritz Hjorth, the grandfather of the present owners, with commercial vision the founder successfully defied advice from his mid-nineteenth century contemporaries in the trade by taking up the production of a new kind of earthenware. Town and peasant potters of that time devoted themselves to kitchen and table products thrown on the potter's wheel, and to small figurines formed in press molds, generally made as coin banks. Lauritz Hjorth introduced items calculated to appeal to bourgeois tastes. He designed cigar and matchstick holders, fruit containers and vases, all objects that were useful, yet shaped and styled differently from current products. Like his contemporaries, he worked in low-fired, fragile earthenware.

After the earliest years Lauritz began a line of vases decorated with oil paintings applied to the finished pottery surface. Executed by trained painters in the formal manner of the art academy, they were far removed from the simple line painting peasant and town potters routinely added to their better pots. The painting did not hold up well, however, since it was not "fixed" by firing.

Encouraged by a good market response, Hjorth developed new clays and techniques. He began to manufacture vases and figurines shaped as miniature reproductions of Greek and Egyptian antiquities as well as the sculptured works of a famous Dane, Thorvaldsen. It was a time when educated people throughout Europe were enthralled with Heinrich Schliemann, the discoverer of ancient Troy. They also thrilled to the neoclassic statuary of Thorvaldsen. Hjorth catered to those tastes.

These products of the nineteenth century brought good profits and an excellent reputation to the factory, yet they were little more than well-made memorabilia. Buying from Hjorth in those years, a middle-class family could afford to possess a fine, small reproduction of an antique red-on-black Greek vase. Objects of this sort had more to do with curios than with living art.

In our exploration into the history of the firm we looked in particular to the decades after 1885 to see if we could detect any reaction to Royal Copenhagen and the products they exhibited in international exhibitions.

By that time the factory was in the hands of a second generation of Hjorths, two sons Peter and Hans and a daughter Thora. We found an artistic, but not an organizational response to the Royal Copenhagen Paradigm. The Hjorths continued to function as a family enterprise dependent upon the caprices of nature to provide capable individuals, and the intrigues of family politics to maintain production

Fortunately, the caprices of nature provided a man of talent, Hans Hjorth. In collaboration with his brother, Peter, he was instrumental in developing an all-black-ware by a process that employed smoke rather than the use of ferrous clays fired in a reduction atmosphere. The all-black-ware proved marketable and Hans enjoyed some success in designing for it. Perhaps his finest work was an 1898 vase formed as a bouquet of poppies in the *art nouveau* style. On display in the museum, it still evokes an appreciative response.

At the turn of the century the ceramic skills of Hans Hjorth moved the company for the first time into the production of a different kind of ceramics. The international exhibition in Paris in 1900 made it clear that stoneware could compete with porcelain as a strong, beautiful material. Hans began efforts to make stoneware at the Hjorth factory. By 1902 he could display his first success in the new medium. By 1905 stoneware was in regular production, well ahead of both Royal Copenhagen and Bing and Grøndahl. Today, stoneware serves as the keystone of the Hjorth reputation.

The sister, Thora, also possessed artistic talent. During the first half of the 20th century the company based its reputation in large part upon a range of smooth-surfaced tan stoneware decorated in soft, muted colors with Japanese-inspired flowers, fruit, and birds. Until 1955, Thora headed the painting studio and did much of the finest painting. The design itself was developed anonymously in the factory by making copies of Japanese designs.

Also imitative was the design of another line that added to the company reputation, pharmacy jars. Created around 1930 for the local drugstore in Rønne, they are still in production. Their original use became obsolete long ago, but their simple, harmonic shape gives them an appeal that seems timeless.

The reputation of the factory is based almost entirely upon family talent. Erik Hjorth of the third generation added a few simple but

elegant designs to the factory inventory. The finest pieces introduced in recent years are produced by his daughters Marie and Ulla.

The family has done well. At times, syncretism was facilitative. Over the years from as far back as 1870, artists and sculptors were brought to the plant to collaborate with the family and other employees. The imitation Greek vases and Thorvaldsen reproductions were done with the assistance of a painter and sculptor. In the 1930s a local sculptor, Gertrud Kudielka, was employed to create a series of figurines, which for a time made up a significant part of the factory inventory. Nothing, however, came of efforts a dozen years ago to bring Per Lütken to the firm. He went instead to the Holmegaard Glassworks where he exercised a powerful influence. It has been a decade now since an outsider last was employed to add to the company line. The success of the factory is essentially based, then, upon exploitation of the family paradigm.

Because the family paradigm does not consistently work well, Hjorth has suffered shortcomings of organization as serious in their way as those that later befell El Palomar. The factory was shaken by a family dispute when the gifted Hans and his brother Peter found they could no longer work together. Hans withdrew. That happened over forty years ago, but the family remains divided and bitter, one lineage the owners, the other the disinherited. Descendents in the line of Hans include four of the finest ceramists in all of Denmark, but they contribute nothing to the factory and derive no benefits from it. It is tempting to imagine how much more the firm might have achieved had these gifted individuals not been cut out by a problem that can arise in a family business.

The younger generation includes Marie and Ulla whose creative skills are already in evidence. Now in their mid-thirties, they have never been included in the deliberations of their elders. In important questions of policy they generally are not even consulted. In particular, discussions concerning the future of the factory are restricted to their father, uncles and aunt while they separately ponder the consequences for themselves.

Not only are they excluded from direct participation in the planning of their own futures, they are sidelined as decision-makers concerning daily matters. While they spend their time at their benches and throwing wheels, their father is in direct charge, assisted by his brother and

sister. The young women are gaining no experience in either long-range planning or day-to-day management.

The personalities of the two women reflect their roles. They seem to be essentially compliant and withdrawn. Will they change suddenly if they are given control? Will they be able to provide dynamic leadership? Maybe, but this situation is very reminiscent of Irish peasant families in which parents frequently delay retirement until high old age. Men as far into their years as the half-century mark may be treated still as "boys" because they have not yet come into their inheritance. When they do take over, they are characteristically unsuited for aggressive farm and family management because they were kept as boys for much too long a time (Opler, 1957, 105). It is not a mode of family interaction calculated to breed strong, independent individuals.

The problem of transition involves still additional complexities. The two young women may find their ambitions shattered by yet another consequence of family ownership: the division that takes place on inheritance. For years Marie and Ulla have worked in the factory, but their cousin Jens Westh is also a ceramist. He has equal claim to the estate, even though he has been employed elsewhere for many years. Will it lead to another family dispute if he is brought in to collaborate with the women who have been there so long? Worse, it appears likely that if the factory is retained by the family rather than sold, Jens will be appointed to manage as the only trained man in the line of inheritance.

These speculative predictions find support in what we know of the history of the family. Women have traditionally been relegated to subordinate positions. The wife of the founder, acclaimed now for her skills and dynamism, lived out her life behind the scenes, a helpmate to her husband. Thora of the second generation was confined to the painting room while her two brothers sat in the head office. Third generation Inger Hjorth Westh manages the retail store and does some bookkeeping while her brother Erik is the person in charge. She insists she would have it no other way and that her talents are less than his. It is her son, however, who may be expected to displace the daughters of Erik when the fourth generation takes over. Not to be overlooked are other renowned artists coming through this family in recent years,

especially two granddaughters of Hans Hjorth, Lisbeth Munch-Petersen *(deceased, 1997)* and Ursula Munch-Petersen.

Success in modern design is possible when built upon the family paradigm. Hjorth has enjoyed substantial success. Ultimately, however, that paradigm implies the possibility of such serious difficulties that failure is equally possible and mediocrity a persistent likelihood. The factory today is devoid of dynamism. So much do they take pride in their past that they continue the past into the present nearly *en toto.* Workers and family members come to their tasks each morning as though taking seats in a dusty theater to watch an old silent film. There is no liveliness, no excitement.

The staff is down now to fifteen from an earlier 25 to 33. Many of the employees are old, survivors from an earlier generation. The credentials of the firm include medals as awards. However, the last prizes in international competition were won in 1929 and 1935. There is no reason to think at this time that they will ever win a major prize again.

(Insert 2010 - update: after the death of Erik Hjorth in 1982, Marie and Ulla took over the factory. It was closed from 1992 to 1995, but re-opened as a working museum and shop. Fine, individual ceramic pieces are still made here and sold to an international art market.).

A/S Michael Andersen

In comparison with Hjorth, the Andersen firm thrives. (*Note: again this was 1978. By 2010 it was closed.)* With a staff of 35 they are more than double the size of Hjorth. An efficient sales organization keeps production at its maximum. The firm, however, is organized in the same basic way as is Hjorth. Both are family enterprises with tendencies to syncretise.

For 117 years, members of the family of one Jens Pedersen owned a pottery works in Rønne. Numerous small shops of that sort existed in the town between 1750 and 1850 to take advantage of local clay and merchant ship connections to markets beyond the island. The old-fashioned Jens Pedersen shop was merely one among many when it was purchased by Jens Michael Andersen, the grandfather of the present owner and manager of the factory here under consideration. By virtue

of this old use of the site, the Andersen firm advertises itself as the oldest and one of the biggest pottery works on Bornholm. The claim rings false in its implication of unbroken continuity. The family that sold the operation to Jens Pedersen had nothing further to do with him. In addition, it was soon sold to Jens Michael Andersen who broke abruptly with the old craft practices of his predecessors.

The date of the takeover was 1890, a year when the Royal Copenhagen factory was still triumphant in its initial success in modern design. In Rønne it mattered little. In place of the old potter's shop Jens Michael Andersen created a small factory completely imitative of the Hjorth factory on the other side of the town square. Like Hjorth, he manufactured objects to appeal to the new and growing middle class. In factory organization, principles of aesthetics, and kinds of product manufactured, the new firm elaborated upon the tradition created by Lauritz Hjorth. This historical interpretation gains credibility when it is learned that Jens got his training as an apprentice to Lauritz in the Hjorth factory.

Jens Michael Andersen had four sons, all trained potters, working at the factory. At the beginning production was limited to kitchenware, works of associated artists, as well as Greek vases and antiquated pots.

The oldest son Daniel Folkmann Andersen (1885-1959), the most creative and artistic of the four, from 1905 put his stamp on the artistic development in the factory. He introduced decorative animals and plants. Lead majolica glazes in four or five colors were employed, typical of the Art Deco style of the time. In the 1920s his brother Michael Ejner Andersen introduced the Majolica series *Dania* and *Kobolt*, also in the Art Deco style. In 1935 Daniel Andersen's innovation "the Persia Technique" received the gold medal at the World Exhibition in Brussels. The Brussels prize was earned by a female figurine in crackled faience. The crackling technique was discovered by Daniel accidentally when a misfire occurred. In comparison with the crackled wares of other firms, that of the Andersens produced large spaces between the lines. Objects in this style are still produced by the firm.

In 1930 the firm came into the hands of Michael, the youngest son of the founder. As a young man, Michael apprenticed to his father, and thus to the Hjorth tradition. He trained also at the Royal Copenhagen Porcelain Factory where he could see for himself the importance of

bringing skilled specialists into the plant. The biggest influence on young Michael, however, proved to be business school. When he assumed command he gave his attention above all to the development of an effective sales apparatus. His efforts earned for the factory a small, yet substantial part of the Danish market for the first time.

Michael shared factory management with his older brother Daniel Folkmann Andersen, whose education in music and art took him to Czechoslovakia and Austria as a youth. The brothers Michael and Daniel complemented each other in skills and interests enjoying some success, but it was limited. The firm has not won a major prize in over forty years since the 1935 World Exhibition in Brussels. By general consensus, Daniel Folkmann Andersen ranked well below his contemporary Hans Hjorth in the field of ceramics. Further, the Andersen family produced only Daniel as a designer of note. The family paradigm reveals its shortcomings no more dramatically than when genes and fertility fail.

However, while the Andersen family has not produced continuing artistic talent, it has produced talents of other sorts, notably commercial. Sven Michael Andersen of the third generation presently owns and operates the factory. Completely without advanced training in art, aesthetics or ceramics, Sven attended business school to prepare himself to take over from his father. He perpetuates the commercial orientation of his father, but without an artistic brother to direct artistic activities. He is forced to seek outside help.

The family has always employed outsiders. Since the 1930s it has at times used the services of painters and sculptors. Gertrud Kudielka, who designed for Hjorth, also worked for Andersen. Others were also given commissions at times, but as with the Hjorths, the family did not commit itself wholeheartedly to any of them. Nor did they exercise outstanding aesthetic judgment in their commissions. Eventually Daniel retired. An outsider was employed to take responsibility for the day-to-day operation of the plant. The artistic contribution of the new art director was important for the firm, but not for the history of modern design. When he died in 1975, he was not replaced. The factory today employs Marianne Starck as senior artist. Neither she nor anyone else is given authority, encouragement, or collaboration of highly skilled colleagues as was done in the late nineteenth century Royal Copenhagen factory.

The style of the factory today is that of Marianne Starck. Born and raised in Germany, she apprenticed in her homeland to the master of a small shop who taught her to throw and paint pottery. Subsequently, she studied free graphic drawing for two years at an art school in Hamburg. As a young woman she advertised her services in a ceramics newspaper. On that basis she was hired in 1954 to join the Andersen firm.

When we came for our first interview we found her at a kick wheel throwing mugs. It was the busy season for tourist sales, and one of her responsibilities is to replenish stocks when sudden shortages occur. Another time we found her throwing a pot before an appreciative audience of tourists, many of whom were German and very pleased that she could describe her work easily in their language. Her responsibilities include these demonstrations once an hour for the popular factory tour. Her time for the most part is devoted to daily production work, yet over the years she has designed an impressive variety of decorative and utilitarian stoneware. Four designs in dinnerware that are currently advertised as company leaders were created by her. More than half of the wares on display in the company's Rønne salesrooms carry her mark, "M.S.".

Starck is devoted to her craft. She is talented. Yet the company line falls short of true excellence. Her dinnerware looks more the product of a graphics studio than of imaginative design. The hand-painted animals and people of her decorative pieces show close affinities to the art of greeting cards or movie cartoons. The total line is very attractive, but it is artistically lightweight. Why?

One factor is clearly the ability and training of the creator. A successful evolutionary cluster requires at least one individual who is extraordinary. Starck is good, but not extraordinary. Another factor is the organizational structure of the factory. It currently is patterned very differently from the paradigm of modern design. It lacks a talented director of art with the authority to influence company production. It lacks a business head with artistic passions and aesthetic sensitivities. It responds to its clientele in a feedback loop of successful sales that justifies design decisions currently in production. As a syncretism, in short, the company flounders. It operates as a family enterprise.

As a family enterprise it took steps difficult to accomplish that removed nearly all of the advantages of family ownership, but also

some of the most serious disadvantages. Years ago, the brothers Michael and Daniel fell into disagreement, as so commonly occurs in family enterprises. Michael became sole owner. Later, the factory was reorganized as a limited stock company, in Danish an *aktier selskab,* hence the designation "A/S". For a time, outsiders and other family members owned stock. However, Michael feared board meetings in which major stockholders might interfere with his right to make decisions. With considerable difficulty he managed to buy up the stocks and regain complete control again.

The current owner, Sven Michael Andersen, took in a non-family partner to help him finance and manage the firm. When the partner died Sven purchased the partner's stock from his widow, again with difficulty. By these maneuvers, Sven, too, maintains sole control.

Sven has a brother who is a successful dentist with offices in view of the factory. Sven does not work with family members he could possibly turn to for special favors. That disadvantage is clearly outweighed by the advantage of freedom to administer as he sees fit, and freedom from involvement with family employees who do not work well. The result is a firm that is successful as a business, but one that fails to earn high marks in design.

The Kähler Factory in Naestved on the Sjælland Peninsula

In our search for a successful example of the family paradigm we detour to Naestved, a town on the main island of Sjælland. The firm that interests us was established in 1839 by Herman Joachim Kähler. The founder was a traditional potter, distinguished, however, by skills acquired in Germany in the manufacture of tiles for constructing stoves. Indeed, the stove business prospered so well alongside of potting that Kähler acquired a separate building across town in Naestved to house it. When his sons succeeded him in 1872 the firm was divided between them. Carl kept the original establishment with its specialization in utilitarian wares. Eventually it ceased to exist. The other son, Herman A. Kähler, was given control of the new premises with its specialization in the manufacture of stoves.

The 1880s was a decade of transformation in ceramic design as we have seen. It was also a decade when the ceramic stove business fell apart. Building construction declined and cast iron stoves took over the

market. To salvage his business, Herman A. turned the use of his kilns to pottery. In doing so he did not return to the family tradition. He was aware of new trends and sensitive to the appeal to create industrial art. He moved in that direction.

An association known as the Decoration Society was established in Copenhagen in 1887 by individuals responsible for collecting examples of Danish industrial art for the Great Nordic Exhibition to be held the following year. Ceramics was to constitute a big part of the collection. (Recall that the main organizer was Philip Schou, director of the Royal Copenhagen Porcelain Factory.)

These events already had influenced two old pottery shops near Copenhagen: Wallman and Eifrig. G. Eifrig, who took over Copenhagen *Lervarefabrik* in Pimlico in 1890, for years had been the champion apprentice potter at the firm of J. Wallmann on Utterslev Mark. A number of outstanding artists worked with the potters in these two places to produce works for the Decoration Society, among them perhaps the greatest Danish designer of his time, architect Thorvald Bindesbøll, (1846-1908). Also among this group was Sven Hammershøi.

While Arnold Krog was busy at Royal and Pietro Krohn at Bing and Grøndahl, Bindesbøll and several others worked up a ferment of creativity in the two suburban firms, which, until then, produced old-fashioned terracotta. Some of history's finest pieces of Danish ceramics were designed by Bindesbøll between 1887 and 1901 while associated with Eifrig in the suburb of Valby.

Kähler was located in the town of Naestved, an hour or two distant by train, but close enough so that Herman A. Kähler soon was caught up in this creative circle. He decided to produce faience, far tougher than the old earthenware, yet easier to produce than porcelain. He experimented with metallic glazes and hit finally upon a beautiful red luster. He also attached Karl Hansen Reistrup to the firm, an artist trained in Paris and experienced in both glass and porcelain. The pace was rapid. Reistrup joined the firm in 1888. The next year at the international exhibition in Paris, the Kähler factory won a silver metal for wares in red luster designed by Reistrup. From 1888-1914 Karl Hansen Reistrup (1863-1929), painter and visual artist became the artistic leader for the pottery. He had a close cooperation with Herman A. Kähler. The vases and pots that Reistrup designed and Kähler turned

were decorated with modeled animal heads, which in their *art-nouveau* style was a perfect match for the new "Kähler Red" luster glaze. This cooperative work was presented at the World Exhibition in Paris 1889. The public was enthusiastic about "Kähler Red" and with one stroke Kähler was world famous.

Artists can be as competitive as athletes, and may express raw nerves and personalities. Such was the unfortunate situation that emerged between Reistrup and Bindesbøll. Bindesbøll was a prima donna with a dominant personality. In his view there was not room enough for both of them. Kähler did not agree and the message to Bindesbøll was "get along or go along." In the summers of 1890 and 1891, Bindesbøll worked with Kähler in Næstved, and from then on, he worked exclusively with *Københavns Lervarefabrik*, which had been taken over by Wallmann's head craftsman, G. Eifrig. Today, many people are familiar with Bindesbøll's style from the Carlsberg beer label, a label still in use today and one that has decorated literally billions of beer bottles in the intervening years.

(Insert note: A commenter in a recent biography of Bindesbøll says "Bearing the nickname "Bølle" (the Danish equivalent of "lout"), and accompanied by many anecdotes about his somewhat unusual life and behavior, Thorvald Bindesbøll has also inscribed his name in the annals of Danish art as one of the great personalities, a man who gave vent to his opinions without mincing his words, and a man who was loved, feared and hated for his work." Birgit Jenvold, 2010)

Herman A. Kähler committed his firm to a syncretism of the family paradigm with that of modern design. He did not isolate the factory as an enclosed family restricted from contact with outside innovators who took risks with new ideas. Subsequent years saw the factory attach several exceedingly fine artists to its staff, including a long-term association with Svend Hammershøi, a student and protégé of Bindesbøll.

It is difficult at times not to confuse one Kähler with another. They all seem to have Herman as a name. Be not confused, then, to learn that Herman A. was joined by his young son Herman Hans Christian (H.C.) Kähler in the 1890s. H.C., like his father, was one of those gifted individuals who can appear in a family firm. His talent for the family business was enhanced by two years of study at the Danish Art Academy.

Yet his ideas about industrial art were very different from those of his father. Fascinated from childhood by the original old pottery shop with its simple, hand-turned earthenware, he felt that the highly acclaimed works of Reistrup were not true to the family tradition.

Reistrup produced vases and bowls in stylized animal shapes that were manufactured in quantity using slip molds. They were slickly glazed in red luster. They did not have roots in old utilitarian pots. Evidently in youthful rebellion against his father, as well as against a style of art, H.C. accused the family enterprise of pretentiousness. Theirs was not a family of artists, he argued, but of craftspeople. Their new products reflected the artificial standards of the Art Academy. They should base themselves on the honest craft of the simple potter instead. He decided to do something about it and soon became the Kähler in charge.

From 1901 Herman Hans Christian Kähler (1876-1940), the son of Herman August Kähler, took over the leadership. A new era began. The young H.C. Kähler was tired of the "Kähler Red", as we have said, and thought that it was time for a change. It was a stroke of luck when Svend Hammershoi arrived and started his production of slipped ceramics. Hammershoi at times also designed for Eifrig in Valby as well as for Royal Copenhagen. Hammershoi worked together with H.C. Kähler in Næstved and A. Eifrig in Valby, where in addition to their own business, he also was assistant to his friend and teacher, Thorvald Bindesbøll. His ceramic work was characterized mostly by an organic ornamentation, inspired by his teacher and friend Bindesbøll, but unlike Bindesbøll's temperamental expression Svend Hammershøi sought a calm, harmonious effect with lines and design.

In collaboration with a journeyman potter named Lars Peter "Deaf" Olsen, young Kähler experimented. He learned to paint in a traditional folk technique known as "horn painting." The name comes from the use of a cow horn as a painting implement. The utensil is made by hollowing out a horn, severing the tip and inserting a feather quill. Filled with a color slip (fluid clay), it could be used to decorate a piece of pottery much as a pastry cook writes "Happy Birthday" on the frosting of a cake. In traditional use, decorations executed in this manner were characteristically simple. Often no more than a pattern of circular or

wavy lines, on elaborate pieces horn painting could produce flowers, birds and animals as well as more complex design patterns.

It was not the intent of H.C. to duplicate the old designs and recreate them in faience. Rather, his aim was to build upon the old techniques to create a style that would be true to contemporary preferences and yet not untrue to its peasant-burgher ancestry nor to craftsmanship and clay. He succeeded superbly.

H.C. expanded the color palette. He also created an impressive variety of designs by moving away from the technique of trained designers. The latter characteristically did not throw pots themselves. They sketched designs on paper and then worked with a journeyman potter to transform the sketches into pots. Often, it is said, the thrower was as much the creator as the designer, even though he remained a silent partner. The young Kähler felt that this technique perverted the old craft. He preferred to let the decoration grow from working with the slip horn itself rather than from penciled sketches.

H.C. modified horn painting into a wet-on-wet manipulation to which fine brush work was added so that the horn-trailed lines could be drawn out to give new and unusual effects. Together with "Deaf" Olsen he also created new shapes as vehicles for the style of painting they had created. First tested publicly at the exposition in Paris in 1900, they earned kudos.

Horn painting went into production under the leadership of H.C.'s sister Stella, a skilled painter who married one of the finest of the artists attached to the factory, Jens Thirslund. By the turn of the century the Kähler factory was a recognized leader in ceramic design. It accomplished this by organizing in terms of a syncretistic paradigm that clustered a number of individuals with outstanding capabilities, only some of whom were members of the family. It was a triumph for the second and third generations.

The fourth generation was to know both triumph and defeat. Two sons of H.C. shared ownership and management of the factory, another Herman and Nils. The latter contributed fine, new designs in stoneware to replace older red luster and horn-painted wares as the latter gradually were phased out.

In Nils we see the advantages a talented child enjoys when born into a family of achievement. As a teenager he apprenticed to his father

at the factory. In that capacity he 'humming birded" on the edges of a circle of family friends that included some of the best-known figures in the art world. Some artists were known to the family from the days when his grandfather associated with the clique that centered on Bindesbøll. Others were friends of his father from student days at the Art Academy. Most were close friends of his uncle Jens Thirslund. Others were members of the Kähler factory staff.

Out of this apprenticeship and involvement with artists his creative sensibilities developed. They resemble those of his father, and reflect the ethos of modern design then in ascendance: a respect for the innate beauty of raw materials, sensitivity to color, and the goal of leaving the imprint of the craftsman's hand and simple tools upon the final product.

After finishing a customary four-year apprenticeship as a thrower, Nils was forced to forego the traditional journeyman's tour of a year or two of working in shops in Germany and elsewhere on the continent. It was the 1930s. Unemployment and political unrest made it impossible to "go waltzing" in Germany. Instead he became, as he puts it, the "tool" of Svend Hammershøi.

Although his father as a youth opposed in principle the method of designing by use of a sketchpad, the practice was never eliminated. Hammershøi throughout his lifetime came to the factory periodically from Copenhagen to sit with his pencil sketches beside that fine old thrower Olsen to produce designs that were to make him famous. As Olsen aged, young Nils became his collaborator at the wheel. Nils also threw for another fine designer attached to the firm and was given additional assignments to do on his own. The total milieu proved effective in developing the youth as a sensitive and skilled creator of new designs. His teapots in brown stoneware with *sgrafitto* decoration, horn painting, or deeply colored glaze and his dramatic use of bold areas of light blue glaze against the unadorned surface of light bisque clay or an off-white glaze, earned him a reputation to match that of Hammershoi himself.

Family culture and an excellent gene pool produced in Nils a ceramic artist of merit. However, family culture constitutes a total milieu, and the Kähler milieu suffered flaws. Nils served as director of art while his brother, Herman, worked as business manager—a division of labor that

seemed sensible except that it proved a disaster. The brothers found it increasingly difficult to work together. They quarreled with growing acrimony.

The brothers also drank heavily. Our readers in Naestved will find it offensive that we say in print what they mention in low voices. It is equally well known that some of the potters of Tonalá, Mexico destroy their effectiveness with excessive drinking and fighting, but a discrete reference to it in print is considered acceptable, perhaps because the individuals concerned are often illiterate as well as unknown. By convention, however, it should not be mentioned for prominent factory owners, above all because they and their acquaintances may read of it. Yet it is precisely this sort of convention that is offensive to so-called Third World people, when reported about their lives without hesitation yet coyly covered for the elite. We feel obligated to use a single set of standards —- to treat both cultures, the powerful and the unempowered, equally. We also feel it is important to document, as told to us, the likelihood that abusive drinking as part of an individual practice, family pattern, or national culture can contribute to lowered performance and failure even in the artistic and commercial world of pottery production.

As the relationship between the brothers deteriorated, the company faltered. In 1968 Nils withdrew as an active partner but remained as an owner. Five years later, Herman, then 70 years old, was forced to retire. During his last two years Herman employed his own son with the understanding that the latter would take his place as director. Then, suddenly the son was fired by his own father in yet another flare-up of family discord. The Kähler factory was virtually bankrupt.

The son of Nils, a trained ceramist, became manager for a year, but failed to get support from Herman's side of the family. He, too, was let go. Thus, with the fifth generation, the family lost the factory. It was purchased by the town, which, in 1975, sold it to Bøje and Palle Degener, a partnership of father and son. The firm now (1976) seeks new life, but once again is organized on the family paradigm.

As with the founders of El Palomar (Tonalá, Mexico) the new owners came to their responsibilities with improbable backgrounds. Bøje Degener was a coffee importer until, in his mid-fifties, serious illness forced him into retirement for almost three years. Palle began but

never finished an apprenticeship at the Kähler factory. After working for a time in Sweden as a bricklayer he set up a ceramics studio in his father's garage. There the two of them began to experiment with stoneware produced in a small electric kiln. On that basis they persuaded a desperate town council to entrust the factory to them. The agreement speaks for Bøje's talents as a salesperson, a splendid quality for the head of a factory.

Fortunately, Bøje also possesses aesthetic sensitivity. His home, as we saw it, discloses a family tradition of interest in the arts. Whether his artistic judgment is excellent enough for the decisions he must make remains yet uncertain, but his background as a "coffee man", as he puts it, is not in this case delimiting.

Palle, in his early twenties, found it difficult to take charge of production management. Known to the staff shortly before as a teenage apprentice, it was difficult for him to gain acceptance as the "boss". He also found that he had much to learn about the technology of the plant. He is not trained or experienced either as a chemist or as a production engineer. Palle has overcome his difficulties in being accepted. He is improving his technical expertise. At present he is learning to operate a salt-glaze kiln. Again, whether self-training will lead to professional levels of achievement remains uncertain.

Supervising a staff of thirty, father and son reveal the strengths of a family structure in their loyalty in one another and their willingness to work long and hard at the job. They reveal also the weaknesses of a family structure in their lack of training and experience as managers of a ceramics factory. Rectification of these weaknesses requires syncretism with the paradigm of modern design, but to do so is difficult. One major obstacle is that to make the syncretism work, management must know how to identify and recruit the experts they need. They must also teach themselves, with wastage and frustrations inevitable and success uncertain. Eventually, whether they succeed or fail will depend upon their ability to handle this procedure.

An equally major difficulty is that they are under-capitalized. One must be cautious not to attribute to the defects of the family paradigm the consequences of insufficient financing. To hire engineers and designers is expensive. The Degeners at this time do not have sufficient funds to bring in all of the help they need. Therefore, of course, they

fall back upon family resources. They do much of their own designing, some by Bøje, much by Palle.

Palle, as the factory's main designer, does well, even though he is self-taught. For the most part he imitates the good designs of others, as he is the first to admit. His interesting bud vase with cowling edges, for example, is inspired by certain of the creations of Carl Cunningham Cole, in whose studio he worked for a short time. His new hanging lamp is merely a version of lamps put on the market by other firms. The factory is also reviving older designs and continuing many of those of Nils Kähler. Since the goal for the present is to get the company financially solvent again, these efforts seem justified, but they are merely expedient if the goal is artistic.

Other expedients include production designs contributed by various members of the staff, designs by local semi-professional artists, and a few designs commissioned from established artists. In part because of lack of funds, their design is inferior when compared with earlier work at the factory.

Under-capitalization also makes it difficult to solve engineering problems. Palle experiments with the salt kiln in his spare time. Bøje recently worked nights until three in the morning to clear out the warehouse and organize it for efficient inventory control, packing, and shipping. However, the factory is very old and badly laid out. Glazes are prepared deep in a damp cellar. Kilns are badly located for access from the mold room. The throwing room is so cold in winter that throwers suffer joint pains. Design rooms are overheated from proximity to kilns. The resultant inefficiencies are fully as serious as are those of El Palomar (Mexico). Remedies come slowly as Bøje and Palle try to handle everything themselves. They need an engineer not merely to take some of the burden, but above all to provide overall planning.

The staff, for their part, are adapting to new ownership. A leader among them who could not accept young Palle as a boss is now gone. Those who remain accept low pay and heavy demands as unavoidable. They belong to the national union of potters that struck the Royal Copenhagen Factory in 1976, but they cannot strike. When staff and management work so closely together and under such restrictive circumstances, resort to union pressure is unthinkable. Meanwhile, there is hope, but not promise, in syncretising the family paradigm.

Søholm: The Royal Copenhagen Paradigm at Work on Bornholm

To explore a link with the RC Paradigm, we return to Bornholm to describe one of the oldest and most successful pottery establishments on that island. When Lauritz Hjorth established his terracotta firm in the middle of the last century it became one of approximately forty pottery works in Rønne. Perhaps the finest of them all at that time was Søholm, founded in 1835 by Herman Wolffsen. A score of years later Wolffsen saw his daughter married to Lauritz Hjorth, thus creating a family link between what were to become two of the biggest factories on Bornholm. The two factories remained independent, however, and for three generations Søholm continued as a Wolffsen enterprise. Led by two brothers in the second generation, the firm built a reputation based upon its so-called *majolica*, a dark-toned, multicolored glazed ware. The plant grew in size until, in the hands of the third generation, momentum and initiative fell away. In 1912 the business had to be sold.

For a number of years the firm experienced continuing management problems until, in 1939, the national Ceramic Trade Union acquired full ownership. As now organized, the factory is managed as a limited stock company with the union and company employees as principal shareholders. The board of directors is made up of representatives from the union and the factory, but day-to-day management is entrusted to a man who was trained as a merchant and worked as a bookkeeper until he was appointed director twenty-five years ago. The company, in short, broke completely away from the family paradigm. With one-hundred employees it now provides an excellent example of a medium-sized factory organized along the lines of the Royal Copenhagen paradigm. Excellence, as we shall point out, can fall short of perfection.

Art Management. In accordance with the Royal Copenhagen paradigm, artistic leadership is in the hands of a highly gifted person. That person is Haico Nitzsche. Trained in ceramics in Germany, the land of his birth, and stimulated by a year at the National Design Institute in India, he was employed for four years at the Gustavsberg Porcelain Factory in Stockholm before he came to Søholm as operations director in 1974.

Engineering Management. The artistic and technical credentials of Nitzsche are excellent. At present some of his private, studio creations in ceramic sculpture are on exhibition in both Rønne and Copenhagen.

He works at Søholm in collaboration with Svend Aage Jensen. Jensen is an expert in glazes by virtue of years of experience. He was trained as a potter-craftsman under the old apprenticeship system. He is not a qualified engineer.

Business Management. The effectiveness of Nitzsche is limited less by technical shortcomings than by those of business leadership. The company director serves as the administrator of board and committee decisions. His basic skills are purely managerial. Both the board and the director are committed to one all-dominant goal: fiscal stability and market success. Aesthetics are evaluated almost solely in business terms. When Nitzsche offers new designs for evaluation, they are judged by a committee consisting primarily of the sales staff. Twice a year, representatives located in various parts of Scandinavia are brought to the factory for this purpose. If in their opinion a proposed product offers sales potential, it passes. If not, it is generally doomed.

This technique for reaching decisions in a rational manner has the effect, then, of giving potential buyers the dominant voice in aesthetic decisions. On the whole, the feedback reports of sales staff are that customers prefer products not dissimilar from those produced by the Andersen factory: objects that are cute and slick.

The most productive designer at Søholm, as a consequence, is Noomi Backhausen. Born on Bornholm and trained as a potter rather than a designer, she displays extraordinary talent within the genre. Perhaps she is better than Marianne Starck of the Andersen factory, perhaps not. Like Starck, her work at times resembles the art of cartoonists or magazine illustrators, although inevitably with a pleasing use of color and line. Some of her designs break from this pattern. A few succeed as minor *objets d'art*.

Feedback via the sales staff is not the only determinant of art policy. Production considerations are also influential. This year's featured design was created by Svend Aage Jensen. Over the years Jensen has contributed many designs for production. The present series features a slick glaze not dissimilar from that of Johgus wares, which seems untrue to the potentiality of stoneware. The glaze fails to reflect that maxim of Danish design that equates beauty with honesty in letting the materials show through. These pieces have a somewhat plastic appearance. Evidently

it is an appearance that buyers like, since to get them into production required that they have sales appeal.

In addition, however, the series was approved because it could be put into mass production with a minimum of handwork. It is shaped in molds and painted with spray guns in brown and tan. Given an aesthetic that places Disney above Picasso, the result must be considered quite good.

Nitzsche succeeds in his own designs and in those of his artists to produce some works of lasting value. The committee can be convinced that they should go into production. In part they do so because they accept the premise that the reputation of the factory requires at least a small investment in outstandingly fine pieces. In part they also do so because the board of directors and the sales and design committees are not completely without aesthetic sensibilities. Production itself is carried out in a highly efficient manner. The organizational structure is excellent. The flow of production proceeds smoothly from raw clays in the back area to finished products in well-appointed sales rooms at the front. Aesthetic considerations aside, the factory offers a fine example of rational management. Staff morale is high, and so are profits.

Conclusions

It is almost a century since the Royal Copenhagen paradigm was created in Denmark by artists and businessmen who were not related as a family group. Of five contemporary medium-sized factories we investigated, all were originally organized in terms of a family paradigm. Our studies make it clear that the family paradigm at times can maintain very high standards in industrial art. They also make it clear that the maintenance of high standards will be transitory, since a family organization incorporates structural features that tip toward mediocrity and become dysfunctional when observed over longer periods of time.

The paradigm of modern design has exerted a powerful influence upon the entire ceramic industry. Family firms tended at times to incorporate features of the Royal Copenhagen Paradigm in a syncretism, as we have seen. Of the five firms studied, however, only one actually abandoned the pattern of family management. Even when we look at the two giants of the porcelain industry, we find that one of them Bing

and Grøndahl, functions still as a family firm. *(see the Epilogue for an update on this.)*

In our study of Søholm as an example of a successful, medium-sized factory, we find the Royal Copenhagen paradigm operating incompletely. The aesthetic success of the factory is limited. Perhaps the paradigm can never do better insofar as it incorporates feedback from an aesthetically naïve clientele. Even at Royal Copenhagen and Bing and Grøndahl, fine products constitute the smaller part of an otherwise unexciting production. Eight or ten times the size of Søholm and El Palomar, these two giants of Danish ceramics possess financial resources far beyond those of other factories. They can and do commission and employ some of the finest designers in Denmark.

The two giants operate in terms of the paradigm that originated with them. Yet, for them as for others, the paradigm includes a feedback loop to consumers as well as competition to succeed in sales. Part of their clientele supports works of highest quality. Often, their finest works fail to bring profits to the company. They are able to produce and sell extraordinary sets of porcelain designed by Henning Koppel or Eric Magnussen. They also run small productions of superb faience and stoneware designed by individuals with talent. The bulk of their sales, however, is in dinnerware and decorative pieces that fall short of the highest standards. Some of the designs that sell the best are as trivial as a greeting card cast in porcelain.

From this perspective, how then do we evaluate the practices and promise of El Palomar? The Mexican factory seems to be in less difficulty than we initially thought. It does have problems, many of which are shared with firms in Denmark. It also has different problems, since it employs peasant labor no longer existent in Scandinavia. On the other hand it is not enmeshed in the difficulties many Danish firms experience because they are family enterprises. On the whole, however, it lacks the artistic success that the Royal Copenhagen paradigm can offer. The same can be said for other Danish firms, although some clearly do better than others. In either nation, a truly extraordinary individual must be involved if the R.C. Paradigm is to succeed. Truly extraordinary individuals, and those with varied expertise to make up the core creative cluster, are rare.

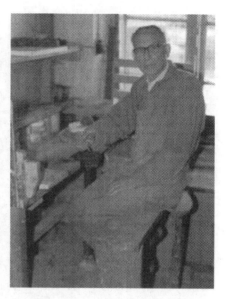

Gustaf Ottesen, founding partner
in Joghus, Bornholm, DK
Below: Eric Hjorth and Edna at
the Hjorth factory on Bornholm
(1977 Authors' photographs)

Adolph Hjorth, founder, (1922)

Ursula Munch Petersen and Edna
1977, at Hjorth workshop

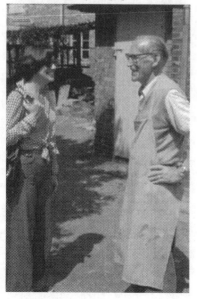

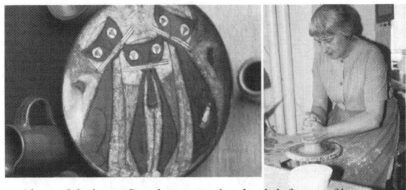

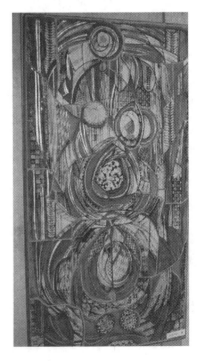

Above: Marianne Starck at potter's wheel; left one of her plates made for A/S Michael Anderson Studio on Bornholm (1977)

Below: Lisbeth Munch Petersen (at Hjorth Factory, Bornholm, 1977) showing her bowl and one of her paintings.
(Authors' photographs)

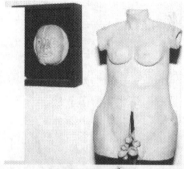
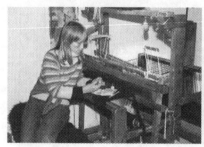
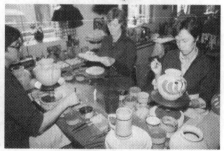

The Søholm factory, island of Bornholm, 1977, and a pile of clay waiting to be processed.

Middle: Haico Nitzsche and Edna outside the factory; a ceramic sculpture

Bottom: Mrs. Nitzsche at her loom. Right: the Søholm painting room.

(Authors' photographs)

Finn Carlsen at home
on Bornholm (1977)
interviewed by Edna

Below: Nis
Stouggard,
Bornholm painter and
ceramist.

*(Authors' photo-
graphs - taken by
Robert Anderson)*

Arne Ranslet with
a sculpted head

Below, with his
wife, Tulla, and
Edna in his studio
on Bornholm

*(Authors' photo-
graphs, 1977)*

Peter Duzaine Hansen
(aka Peter Duz) at his
Bornholm home. He
was the first president of
the association of artists
on Bornholm.

Below: Edna with Jacob
Bang in his home, 1977.

Bang's teapot
and pieces
exhibited in
Copenhagen
1977

*(Authors'
photographs)*

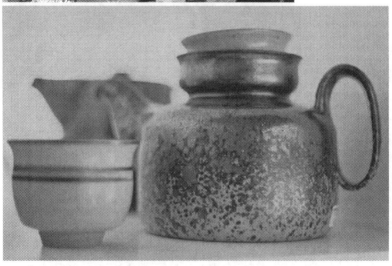

Nils Kähler and his wife in their home in Naestved after the factory was sold to Degener (1977).

Below: a casserole dish designed by Nils Kähler styled after an old peasant pot: deep blue glaze inside, unglazed on the outside. *(authors' collection)*

Above: At the Kähler factory, a highly valued wall mosaic by
Reistrup was saved from the fire. (1976)
Below: stoneware hedgehogs made to sell to tourists by the
Kähler factory. *(authors' photos and, below, authors' collection)*

The new owner of Kähler, 1976, Bøje Degener. Dinner at the home of the Naestved artist, Kroyer.

Below: an antique Kähler bowl, a gift to the authors from Bøje Degener. *(Authors' photographs)*

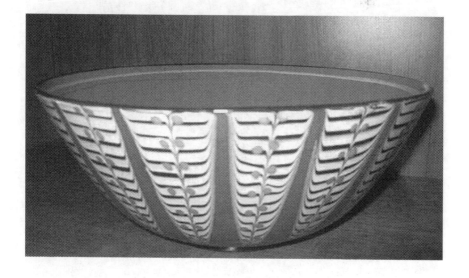

Robert Anderson (author) examining an antique Kähler vase owned by (Sir) Holger Rasmussen. (1976)

Anderson and Rasmussen, at his summer home in Jutland

Below: In the Naestved home and studio of artist and sculptor Kroyer (in striped shirt).

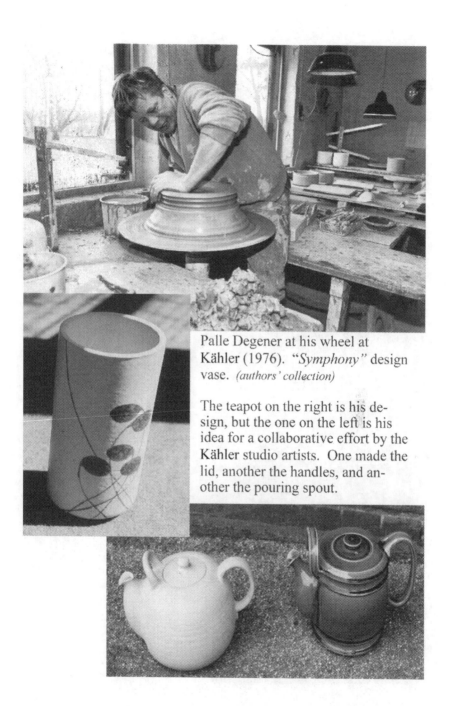

Palle Degener at his wheel at Kähler (1976). *"Symphony"* design vase. *(authors' collection)*

The teapot on the right is his design, but the one on the left is his idea for a collaborative effort by the Kähler studio artists. One made the lid, another the handles, and another the pouring spout.

Knud Jensen, age 71, famous
Sorring potter making pots
the "old" way, mostly now for
tourists. In his home, 1977.

His old workshop is now
reconstructed for display and
demonstrations at the Open
Air Musem near Copenhagen.

Ib George Jensen, II, (below)
demonstrates the old method
at the museum. Ib is a son of
Georg Jensen, the famous
silversmith. He also works at
Royal Copenhagen as an
artist.

*(authors' photographs,
1977.)*

Chapter Five
Designing in Denmark—the Paradigm Develops

There is nothing more difficult to take in hand, more perilous to conduct, or more uncertain in its success than to take the lead in the introduction of a new order to things.

—Niccolò Machiavelli

With time, a paradigm may evolve or transform without becoming a different paradigm. It is to be expected that with the passage of almost a century, the Royal Copenhagen Paradigm would undergo some modification. From our investigation it appears that the major change to have occurred concerns the designer, that key figure in the effort to join aesthetic perfection with commercial gain.

Until the middle of the twentieth century, with some exceptions, designers customarily specialized in a particular industry or material even though they may have had broad experience with different materials. It sometimes happened, as we saw, that a designer had experience in more than one field, especially before the turn of the 20th century. Georg Jensen worked briefly in ceramics before he established his silversmith shop. Kay Bojesen was trained in silver before he turned to wood. Most commonly a designer would have apprenticed, even if also formally educated, and specialized.

Today, the characteristic career pattern is more diverse. Top artists almost routinely work in a variety of disparate materials (Sten Møller, 1975, 78). There is restlessness and an impulse to experiment, to try something new, that leads them to move from one material or one process to another. We can illustrate this using the cases of three top designers: Eric Magnussen, Henning Koppel and Bjørn Wiinblad.

Erik Magnussen: Bold but Cold.

The old gray building is nearly indistinguishable from others on either side of it and across the street. With its neighbors, it creates an urban canyon out of the street below, where flows a seemingly endless rush of automobiles, buses, bicycles and pedestrians. Small stores occupying ground floor spaces radiate from a nearby crossroads to identify an old urban neighborhood of a sort characteristic of parts of Copenhagen away from the main shopping center. Not far distant stretches the broad, well-tailored expanse of a park, salvaged from its history as a gigantic commons. Inside the building, past the lower-floor offices of lawyers and accountants, seemingly endless flights of stairs lead to a dwelling located just under the eaves, an exhausting five flights above the street. The door is plain. To it is attached a simple plaque with the name "Erik Magnussen."

As the door opens, dimness on the small stairwell transforms into a deep cavern of bright whiteness. Old walls and doorways that once broke up space are gone. A stark absence of color and a selective sparseness of furniture enhances the largeness of the room. Three or four chairs of shining chrome and black leather and a large old dining-cum-drafting table clarify the designer's intent. The room is that of an artist's studio and a young person's residence—functional, totally without clutter, created to facilitate rather than dominate the dual activities for which it was created. It is contemporary. The outer shell of the apartment is old Denmark, but that tradition disappears under the transformation inside the apartment. Perhaps it symbolizes our time in history. Certainly, it reflects the design sensitivities of its creator who, in porcelain as in the remodeling of an old residence, creates thoroughly new forms to replace the old. He strives for simplicity, directness and compositional strength, but eschews color modulation for a bold but cold Nordic iciness.

Ceramics. Born to a suburban, professional family and educated in a private school with a liberal educational philosophy, young Erik gave two years to the study of graphics at the Art Academy in Copenhagen. This is Denmark's prestigious center for training in the fine arts. Soon he found his way out of academia and into the handcraft tradition of the School of Applied Art. Located on the open farmers' market where even today those who resist supermarkets can buy fresh produce and flowers on market days, the school offered a training program in ceramics that

emphasized working with one's hands and the goal of providing well-designed objects that people can use for practical purposes. The head teacher was Richard Kjaergaard, an acknowledged master craftsman whose credits include *Pyrodan*, produced by the Bing and Grøndahl Porcelain Factory. *Pyrodan* tableware is designed to withstand harsh temperature changes. Pieces can be taken directly from the oven to the dining table facilitate serving meals gracefully in a modern home. Functionally designed to meet a modern need, the pattern is useful, but aesthetically cold.

Under Kjaergaard and others at the School of Applied Art, Magnusssen perfected his basic skills as a designer. Yet it is impossible to identify exactly what these skills comprise, yet skills based upon a thorough understanding of materials and technology, to be sure. They included an awareness of what other designers were doing, including Kjaergaard at the school, other Danes in the late 1950s, and ceramists in other parts of the world. The school focused on craft production, while avoiding drawings and sketches in favor of three-dimensional models made by hand. In all events, while the school was important, the rapid maturation of his skills grew out of a cultural milieu of which the school and its staff were just a part. Magnussen characterizes his training as "a way of life." Certainly, it matured out of an abundant innate potential. While still in the school Magnussen developed a technique for producing teapots that reduced the number of molds required from four to two, thus simplifying the process.

From school to the establishment of a small potter's studio is the route many young ceramists have taken. Many continue in such a way for years and lifetimes, producing good, solid work perhaps, but not earning special distinction. Often they find it hard to support themselves as ceramists and seek work as teachers, employees in ceramic factories or workers in other occupations, ceramics becoming no more than a sideline. Magnussen, however, did rather well.

In his own shop he designed a new teapot, a special challenge for potters. So many gifted individuals have designed teapots over the centuries, in tea-drinking Asia as well as elsewhere, that it taxes credulity to think that further innovation is possible. Yet it is, of course, and Magnusssen is among those who prove it. He created a pot, which on first glance appears to lack a handle. It is held by

grasping through a slit at the back where space between the bowl and the outer surface accommodates the hand, and since it incorporates no external protuberance, is much less likely than ordinary pots to break, particularly since the spout extends only slightly beyond the wall of the vessel. In all, his teapot meets most of the criteria of modern design: it is highly functional, well adapted to the material, and elegant though simple in appearance. The only drawback is that a small portion of the population may find it awkward to use. Like an old-fashioned mustache cup, it is meant to be held in the right hand, not in the left. It is warmer in texture and color, incidentally, than is most of the later work of Magnussen.

So impressed by the young potter's success with teapots, the management of Bing and Grøndahl hired him, at the age of twenty-two, to join their staff. He has been with the firm ever since, although with a significant change of status in the last decade. Originally hired to come daily to an atelier assigned to him in the factory, he has in recent years worked in his own home studio, accepting a smaller monthly remittance from the company, but being free under this arrangement to design for non-ceramic enterprises on a commission basis. However, we are getting ahead of our story.

Two ceramists who formerly designed for B&G complain bitterly of their treatment. One argues that the company is not really committed to industrial art, but uses the designs of people such as him only for the good publicity it brings. In reality, he insists, they continue to produce old items that have been popular, in some cases, for generations. His work meanwhile no longer is in production.

Another designer echoed these sentiments and complained that aesthetic values are abandoned whenever money can be earned from faddish products. The company rejected her better designs believing they would not sell well, and asked her to create items that might earn popularity as a confirmation gift. This, she felt, trivialized her work.

As anthropologists who interviewed individuals on both sides of these disputes, we hesitate to take on the ombudsman function. We summarize here the complaints of two designers, but other staff designers do not agree. The company, for its part, can and does insist that their record for producing good ceramic art is a matter of record. The disagreement, in fact, has characteristic elements of the kinds of

misunderstandings that arise when individuals from different cultures get socially and economically involved with one another. The dissident designers tend to subordinate all questions to those of good design, as they perceive what is "good". The company tends to subordinate aesthetic values to that ultimate criterion of survival, financial viability. For either party, it is difficult to strike a balance between economic and aesthetic considerations. Thus, production stopped on a set of fine tableware designed by one of these two ceramists. The factory owners liked it. So did the public. However, it did not sell well enough because elevated production costs forced the retail price up too high. From the management point of view, it was only reasonable to terminate their commitment and to look for new designs that would earn profits. Yet, in searching for alternatives, they seem unsure of just what they want. As one of their staff explained, "They feel that they should hire good designers, but are not sure of how they should use them." From the designer's point of view, the factory should have struggled harder to advertise and to keep production costs down. From our point of view as anthropologists, it would seem that each side has difficulty in breaking free from a kind of sub-cultural ethnocentrism.

The point of this discussion is that occasionally the company is able to identify a designer who can combine high aesthetic standards with sensitivity to production problems. Magnussen is just such a person.

His first success in this many was Form 679, a set of tableware consisting of only eleven shapes in place of the forty to forty-five that make up the usual set. The key idea in this design was to eliminate duplication. A cup without a handle can hold hot coffee or tea quite comfortably if the inner bowl is separated by an air space from the outer surface. Such a cup can also be used for soup or creamy desserts as well. A small and a large plate take the place of an assortment that ranges in normal sets from dinner plates and serving platters to butter dishes and saucers. Plates in Form 679 do additional duty as bowl covers. There are multiple ways to combine the pieces. Devoid of decoration and handles, they stack well for compact storage. Straightforward simplicity of this sort requires adjustment on the part of consumers, however. Not everyone thinks about their dinnerware as though they had to store it in the galley locker of a small yacht.

The name, by the way, reflects the simplicity and functional utility of the set. Form 679 was the name for this dinnerware because that was the identification number assigned to it when it went into production. As journalist and art critic Henrik Sten Møller, observes, "It would have been ridiculous to call it *Petunia*." (Sten Møller, 1975, 151).

Recently, Magnussen returned to the problem of tableware, this time with restaurants and hotels in mind. As witness to the serving of food in public places he observed clumsiness due in part to poorly designed wares. The traditional shapes of wares intended for home use are utilized in commercial establishments without significant modification. Stepping one morning into a hotel corridor while maids were serving breakfast, he was appalled to realize how difficult their work was, and how cold the toast could become. They were forced to juggle an assortment of coffee and teacups, pots, egg holders, marmalade dishes, plates and silverware without spilling the contents or letting them get cold. Similar problems beset cafeterias, restaurants, and snack bars. He set to work on an eighteen-piece set of dishes to which Bing and Grøndahl gave the name "HANK".

The basic approach of Form 679 was applied, although these cups have handles. The cup, however, shaped to fit over the egg dish, provides insulation to keep the egg hot. The cups and saucers stack easily, carried on top of the coffee pot to fill a tray without becoming unstable. The raised centers of the saucers keep the cup above spilled coffee, since only basketball players need to dribble. For convenience in stacking in dishwashers, and to eliminate the breakage of delicate handles, a tough plastic handle, easily removed or replaced, holds the coffee pot. Most of the pieces are white, but the bowls for serving hot food are red with plastic covers (plates stack on top of them), the peppershaker is black, and the carrying trays of plastic are yellow. The logic of color becomes less obvious at this point. The color scheme of white with rare splashes of color is simple but striking. Stacking for storage, serving and washing is carefully worked out. A small lip sculpted around the rims of plates to keep crumbles from scattering, is an example of combining form and function.

Beyond Ceramics. The full-time association with B&G worked out well for both parties, but Magnussen wanted opportunities for a wider range of activities. He continues to design new items for the porcelain

company. Lamps hanging by cords from the ceiling over the desk-table of his attic studio, like small white porcelain bells, are prototypes of a new line soon to go into production. So, too, is the white porcelain clock on the wall. He lives with these products for a while before putting them on the market. His most exciting work in recent years, however, has been for other companies.

Taking on the problems of eating utensils, Magnussen designed cutlery of durable plastic (including a serrated metal blade in the knife) designed to sell cheaply and to be discarded after three or four years of service. He is currently working on stainless steel vinegar and oil flasks and ashtrays. Above all, he earned a reputation for design in furniture.

After six years of work in collaboration with Per Kragh-Müller, Magnussen designed a line of tube-steel and polished wood school furniture that is relatively easy to produce. Strategic bending of the tubing, for example, eliminates the need for cumbersome welded joints. Considering intended use he applied simplicity and functional adaptation. The pupil's desk is larger than usual, since their investigation revealed that the standard sizes are too small. Desks can be joined together to form a larger table or they can be stacked to clean the room. The height is adjustable to give some flexibility in accommodating differences in the growth rates of children. Even repair problems are taken into consideration. A single screw holds the desktop in place by so that disassembly is easy.

The chairs, which give comfortable support for long sessions of sitting, hang from the desk when not in use, enable the janitor to sweep without obstacles. They also stack as easily as do the tables if the teacher wants to clear the floor of furniture or move pieces to another location. Bernadotte School, the reform-minded private school that Magnussen attended as a child, incidentally, commissioned the furniture.

In the area of home furniture, Magnussen proved his skill in working with stainless steel tubing and leather. Some of his designs were manufactured by a Danish firm—others by a firm in Italy. Although Magnussen has created some items of stoneware that are warm in color and rich in texture, it is characteristic of his work that he favors the clean contrastive qualities obtained from joining leather to steel. It is perhaps because he feels so comfortable with bold but cold, clean effects

that he developed one of his finest pieces for Stelton, a manufacturer of household objects of stainless steel and plastic.

The Danish State Railway Company felt that they had a problem in the thermos flask used for serving hot coffee and tea on a moving train or ferry. It was really quite nice to look at, and kept fluids hot, but travelers had difficulty with the stopper, particularly when the ride was rocky. They asked Magnussen to design a canister that would be easy to open and close. This is exactly the kind of problem Magnussen handles extremely well.

His thermos has the basic shape of a liter-sized length of steel tubing. To this he added a black plastic handle and cover. The cover, with a pouring lip, is flat across the top. When the flask is tilted a built-in stopper rocks. When pouring coffee, the stopper opens automatically, much the way a doll's eyes open when shifted from reclining to a vertical position. Similarly, when the jug is upright again, the stopper closes itself. To clean or fill, one simply tilts the jug backwards, and the stopper lifts out easily. One replaces the insulating glass filler simply by pressing two black buttons on the side and lifting out the whole unit. The flask is as simple to produce as it is to use. It is also quite handsome on a tray or table.

Henning Koppel: Silver Symmetry

Magnusssen may be representative of the designer who began in ceramics and branched into other fields; however, his former father-in-law, Henning Koppel, also experimented with different materials moving from hard stone to soft metal, including silver, and finally included ceramics.

Enrolled in the Academy of Fine Arts in Copenhagen for two years, Koppel went to Paris for a subsequent year to work in the *Académie Rancon Malfrey*. He remembers his year in Paris as more inspirational than instructive. Language problems and a teacher who was rarely present for drawing classes, reduced the effectiveness of the academy, but left him free to soak up the artistic atmosphere of the French Capital. Back in Copenhagen, he worked for several years in the studio of Anker Hoffman where the older artist and he each sculpted in stone. From 1935, when he was 17 years old and exhibited a portrait bust in the Autumn Exhibition, until 1945 when he joined the staff of the

Georg Jensen factory, Koppel studied and worked to perfect himself as a sculptor.

Always interested in materials and their potentials, he abandoned the Danish Academy because the focus was on bronze and he wanted to work in stone. During World War II, however, he moved away from stone to discover an interest in metals; not in bronze, but in pewter, silver, and gold. He liked sculpting soft metals, and approached the Jensen factory through the influence of his mother-in-law, well connected in artistic circles. The shift to silver released an enormous potential. He became the most successful innovator in silver since Georg Jensen himself, half a century earlier.

Gone from Koppel's silver are the embellishments of the Art Nouveau, however. He prefers to bring out the pure innate strength and texture of the metal in bowls, dishes, pitchers and teapots that are full and well rounded, yet taut and smooth. Most of his work shows the balance of perfect circular or bilateral symmetry, but some of his pitchers and other pieces are eccentric. The complex curves of his 1956 pitchers are translations into silver of the eternal beauty of a pregnant girl seen in profile. The balance is that of bosom to buttocks, fairly bursting with sensuous fulfillment; and like the skin of a full breast, the texture of the metal begs to be touched. All of his pieces ask to be held and used. Above all, his works are to be seen, for they are Lilliputian works of art, pieces of sculpture that translate curvaceous lines into voluptuous forms.

Ceramics and Porcelain. After establishing his credentials as Denmark's (and the world's) top designer in silver, Koppel moved easily into other materials. He worked with glass, stainless steel, plastic, wood, fabrics, paper and porcelain. Since good design requires sensitivity to the potentialities of each material, we wondered how he could achieve success with such a variety of substances. Was it not difficult? Was it frustrating? "No," he responded with complete assurance. "I find it easy to move from one material to another. One only has to acknowledge the capabilities and limitations of the material." Only glass, it seems, was in any way frustrating. Glass is especially difficult, since one must work very fast while the temperature is high and just as a shape seems about right, the whole piece may collapse. Yet, he did master glass, also.

We were, of course, especially interested in his success with porcelain. In 1962, Bing and Grøndahl asked him to design a new set of tableware. He set about the task in a way fully consistent with the demands of Danish design. The ware is functional. Handles are comfortable and secure to hold. Pots pour with ease. Plates and dishes are stable. The ware is simple, yet elegant. The aesthetic potentiality of the material is released: the set is pure, porcelain white. It lacks unnecessary embellishment of form. To attain balance of form he forms grasp-knobs, edges, and spouts emerging compactly and with strength from the body of the piece.

In a second version of this pattern, the same forms in white porcelain appear, decorated with a single symbol that resembles a Chinese ideograph. It comprises an apparently abstract configuration of brush strokes in pure, cobalt blue. It is an isolated piece of calligraphy contrasted against the shiny, white hardness of porcelain. Although apparently without meaning, it is in fact a scrawled letter "K," which stands for Koppel. Only the initiated see it as such, however. The feeling is that of handling a perfect hybrid of oriental and occidental arts.

This so-called *Blue Koppel*, used as a complete pattern, or mixed with unpainted pieces to reduce the amount of blue and increase the contrastive power of the color that remains, has creative and practical versatility. Either way, and with either set, one sees in the work of Koppel much of the cold but bold sense for simplicity in form and contrast in color that we identified in the work of Magnussen. Lest it be assumed that Danish designers subscribe to a "glacial" aesthetic, let us look just briefly at another contemporary designer of ceramics.

Bjørn Wiinblad: Fantasy and Color Trump Function

Born like Henning Koppel in 1918 and like Koppel, a student at the Art Academy, Wiinblad turned from fine arts training to the field of ceramics at about the time that Koppel turned to silver. The year that Koppel joined the Georg Jensen firm (1927) was the year that Wiinblad held his first one-person show as a new phenomenon on the horizon of ceramic design.

Parallels in the careers of the two men continue. Also like Koppel, Wiinblad branched into a variety of fields. Although he remains to this day best known for his work in faience and porcelain, he has also

applied himself to textiles in the manufacture of sheets and pillowcases, tablecloths and napkins, curtains and furniture coverings. His ceramic tiles are built into a variety of lawn and patio furniture, including grill tables, breakfast sets, and end tables, any of which may be matched by lamps of his design. He has created theater sets, patterns for embroidery (on commission to the Danish Society for the Advancement of Handcrafts), glass table items for distribution by Germany's Rosenthal Porcelain Company, and hand painted bowls made of papier-mâché. He has written and illustrated books for children and created some of the most sought-after poster art since the demise of Toulouse-Lautrec. Yet, above all, he remains known worldwide for his fantasy in ceramics.

Unlike Magnussen and Koppel, Wiinblad only seldom gives attention to function. The objects he creates often reflect a concern with form as an aesthetic experience, leaving function as decidedly secondary. Above all, his creations serve as vehicles for line and color. Whether simple blue-line drawings on white faience that first introduced him to many of his fans, or the deeply rich barrage of rainbow colors against a dark blue background that identify his *1001 Arabian Nights* series, Wiinblad shows a love of color largely absent from other Danes we have described. It makes him kin to the two Mexicans introduced in the chapter that follows, particularly the flamboyant Sergio Bustamante, but also Jorge Wilmot.

As in the painting of Wilmot and Bustamante, Wiinblad is skilled in creating a Picasso-like land of people and animals. Whether in his cubist-style Arabians, his quixotic females in neo-art nouveau, or his humanoid animals where in two-dimensional graphics or in effigy vessels, he captures a mood that is an important part of being alive. Curiously it is nearly always a variation on a single mood, one that is light-hearted—either happy or pensive—but other-directed as a sociologist might put it. The people of his fantasyland seem always aware that you are observing them. It is said that his work is natural and timeless. It is. However, if the products of Magnussen and Koppel are destined to endure, like the writings of Kierkegaard, in essence profound but coldly analytical; those of Wiinblad are like the fairy tales of Hans Christian Andersen, warm, lively, colorful imaginative. All three are equally Danish. Each is different; each has qualities that are international and universal.

As a whole, Danish designers do not fit a single pattern in any neat way. Those we investigated do fit the model of Arnold Krog, however, in their ability work for a factory without losing their individuality. They succeed in being creative even though they must accommodate themselves to institutional demands. In addition, they appear to be more creative than otherwise would be possible were they not associated with factories.

The paradigm shift does not appear to have reduced creativity. On the contrary, it may have enhanced it. In all events, beautiful, Koppel, Wiinblad, and Magnussen have developed well-designed products under the new, more fluid regimen. This we attribute to the persistence of the Royal Copenhagen Paradigm in its essentials. Business managers still subscribe to the ideals of industrial art, purpose and profit. They still provide outstanding technical collaborators. They still strive to combine function and appearance in ways that are honest. They are supported by a mature infrastructure for sales, training and development. However, this is in a society where dissemination of new ideas, communication for problem solving, innovation supported by technology are easily within the grasp of the aspiring artist. While wealth is not expressed through opulence, poverty is not endemic. Variation, innovation, and change are valued within the ubiquitous cultures of Scandinavia and much of Western Europe.

We turn next to the unique designers and innovators around Guadalajara, Mexico where creativity and cultural traditions may clash. Yet, the personal stories of a few of the trailblazers in ceramic design and production in Mexico do have narrative threads in common with those we have just described for Denmark.

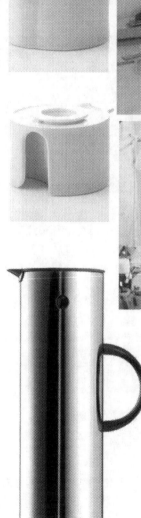

Eric Magnussen in his studio in
Copenhagen, 1976. Lower picture is
interview with Edna.

Left top: the famous teapot de-
signed with no handle and with a
ceramic filter fitting inside.

Left bottom: the award winning
steel thermos with the rocking
stopper to prevent spills.

(from the authors' collection)

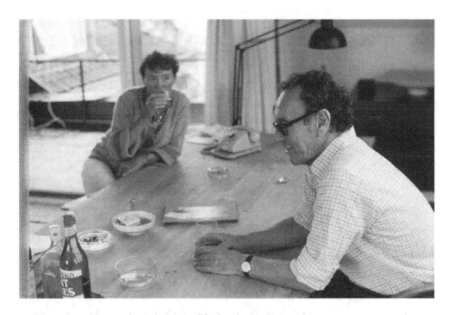

Henning Koppel and his wife in their Copenhagen apartment/
studio, 1976. Below left, the award winning "Pregnant Duck"
in silver. Right, the innovative dinnerward for Bing and
Grøndahl, "Koppel Blue" with his signature hidden as the
design.

(author's photos. 1976)

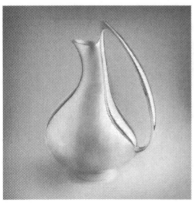

Month of May in his
12-month fantasy series

Bjorn Wiinblad, quixotic artist

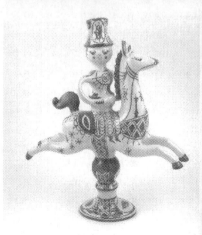

1000 Arabian Nights plate (left)
Wiinblad in later years (below)

Chapter Six
Mexican Designers—Sophistication
Meets Simplicity

History with its flickering lamp stumbles along the trail of the past,
trying to reconstruct its scenes, to revive its echoes,
and kindle with pale gleams the passion of former days.
—Winston Churchill

In the course of our research we occasionally shared a pipe dream. How fascinating and exciting it would be if by means of distance-crunching jet airliners we could bring together the Danish and Mexican ceramists we now know. In particular, we wished we could bring Magnussen and Koppel together with Jorge Wilmot and Sergio Bustamante. They have so much in common. That, in fact, constitutes one major finding of our investigation. Artists raised in middle-class homes and trained in institutions of higher learning belong to a single world of art, sharing much of their value system and aesthetic training in disregard of national boundaries.

Overlying these shared traits are, to be sure, differences related to national origins. Ultimately it makes a difference that Mexican designers work in the absence of the Royal Copenhagen Paradigm. But we begin the comparison by drawing attention to a shared, international orientation. We will observe that in Mexico as in Denmark, individuals today may begin with a specialization in designing for particular materials such as ceramics, but customarily diversify in order to design for a wide range of products constructed of highly variable materials.

Jorge Wilmot: Deceived But Not Defeated

Jorge Wilmot is quoted as saying *"La cerámica de las artes es una de las más antiguas y a su vez de las más modernas"* (Ceramics is one of the

oldest and at the same time one of the most modern art forms,) referring to the need to preserve tradition and modify it. Wilmot combines pre-Hispanic designs and motifs with modern elements as well as international influences, especially those from Asia.

"My work has been done against the most incredible obstacles." Jorge Wilmot concluded one afternoon as we chatted while walking a dusty side street in Tonalá. He was not referring to an impoverished past because he grew up in a prosperous home in the north of Mexico, remote from the peasants around us. The son of a Mexican mother and an American father who did business in the city of Monterey, he studied for a year or so in Germany and Switzerland to prepare himself for a career as an artist. He was trained to paint, but put painting aside to become a ceramist. While still a student he set for himself the goals he is achieving now at his half-century mark.

A quarter of a century ago, his hope as a potter was to culminate two great ceramic traditions in the work of a single person. Awe-struck by the beauty and craftsmanship of works first encountered in a museum in the Netherlands, he decided that his goal in life would be to add a final era to the history of Chinese ceramics. He remained, however, fervently Mexican in loyalty and spirit. On a visit to Madrid he was enraptured for days by a display of old Mexican pottery in the Museum of the Americas. He was attracted above all to several sections filled with objects from eighteenth and nineteenth century Tonalá.

The painting on Tonaltecan pots showed affinities, he felt, to Chinese painting. He learned that the technique was identical with that of the Orient, since both hold the brush in a vertical manner. With that knowledge he arrived at the decision that shaped his life. He could attempt to create Chinese-like wares through the amalgamation of Chinese and Mexican ceramic art in the village of Tonalá where local potters would collaborate in their manufacture. He was destined to face obstacles. To work with the potters of Tonalá was perhaps the greatest of them. He came to the village in 1957 with enormous respect for the painting skills of these poorly educated, often illiterate, peasant farmers. Their activities, it seemed could be channeled, their poverty, eliminated. With Wilmot, they could become creative and successful participants in the wealthier, more sophisticated Mexico that lay beyond their impoverished community. To this end, Wilmot

formed a partnership of five — four village men and himself, splitting the profits equally among them.

The need for immediate profits provided a challenge. Hopes to advance Chinese ceramics in a Mexican way required first that they build up a capital fund. Wilmot was prepared to design new products in familiar Tonaltecan materials. But, what should they be?

Roots in Tonalá Folk Art Traditions

For as long as history records, villagers had supported themselves by producing maize, beans and squash on their fields and pottery in their kilns. Always responsive to changing market demands, they specialized in plain or decorated table and kitchenware of low-fired terracotta in either burnished or glazed finish. By the 1920s painting techniques had barely survived in the hands of a few. Most of the objects manufactured were either an undecorated brown or a brown embellished with no more than a cream-colored Greek meander (*greca*) around the edge. Nearly gone were the rich floral patterns of eighteenth and nineteenth century burnished pottery, the birds, animals and plants of Spanish inspiration that until World War I were a specialty of the village. Nearly gone, too, were the richly embellished genre scenes of glazed ware known as *petatillo* because the background was a cream-colored crosshatch that resembled the woven reed sleeping mats villagers call *petates*.

Edward Weston, an American photographer, noted in his journal for 1926 that Tonalá at that time produced scarcely anything other than the Greek meander. Weston went from door to door in his search for well-painted pieces. He found only a few, including what we assume were two examples of *petatillo,* one of which pictured two men with guns hunting deer against a background of butterflies, birds, rabbits and greenery. When he asked a villager why he did so little work of that quality he was told, "I would like to, but we can sell only *grecas*. I must live." (Newhall, n.d., 189-190.)

By the 1950s, village potters sold more of the richly painted ware that displayed a wide repertoire of painted cats, cows, deer, herons, rabbits, and other animals. But while flora and fauna on painted ware survived through the twentieth century, however modified from their Spanish dominated ancestors of earlier centuries, three-dimensional sculptured animals became nearly extinct. The tradition of producing

terracotta figurines persisted in ducks made in the recent past and of older animals that included a large-bodied, small-headed bird, a thin-legged pig, and a black-faced dog. All completely different in style from anything being made today. The latter considered antiques or museum pieces. Current in the 1950s was a popular coin bank in the shape of a human head, also thoroughly different in style from present work. Some bird figurines that do resemble styles of the 1970s seem also to have been in production in the 1850s.

Wilmot decided that the nearly exhausted tradition of small pottery figurines had better market possibilities than did utilitarian ware. He knew of older Tonaltecan sculpture specimens encountered in museums, just as he knew of a far richer tradition of effigy pieces from the ancient civilizations of Mexico. In his search for ideas, however, he looked beyond the Mexican figurine tradition to whatever happened to come his way. It is perhaps curious that in this effort to create designs that would be distinctively Mexican, he felt that it was enough that they be distinctively his.

He obtained ideas from Mexican sources, including fauna painted on older Tonalá pottery. He used ideas remote from Mexico as well. Perhaps the most famous of his designs is that of a reclining cat, its hind legs hidden behind an encircled tail, its straight but unrealistically shortened front legs positioned piously in front as though it is holding its paws in contemplation or prayer, its head erect. The coloration is muted except for stripes on the tail and forelegs and a dorsal surface emblazoned with a floral splash.

Cats were not new to Tonalá. In the 1950s, local painters of *petitillo* were already known for their long-tailed, black-silhouetted cats that resembled the cat designed by Wilmot. Both portray the proud independence of cats. Some people thought the cats of *petitillo*-ware survived from pre-conquest beliefs in *nahuales*, animal spirits that sortied from natural haunts to influence the destinies of people. Amado Galvan, a painter of burnished ware with a wider repertoire than any other potter in the community, painted a feline figure that probably first came to Tonalá as the lion rampant of medieval European heraldry. He also painted a lion or cat – it is hard to decide which – that stood poised on three legs, its left paw raised in a human manner as though signaling a greeting. The face is drawn with a nose and mouth that look human.

The posture of Wilmot's cat is comparably hominoid in body and the face shows the human expression of Galván.

Wilmot clearly strongly influenced by the painters of Tonalá, yet consciously used a foreign work of art as his model. In his search for ideas he came across a reproduction from the Art Institute of Chicago portraying a woodcut engraving that included a lithe and mysterious cat created by an anonymous, nineteenth-century Russian purveyor of popular prints. Therefore, the cat model is not from old folk patterns, but rather is Russian by way of Chicago, much reworked by Jorge Wilmot in the style of Tonalá. It is unique.

Within the space of a month, Wilmot created not only the cat, but between thirty and forty figures that included quail, chickens, owls, and ducks. (The collection grew eventually to nearly a hundred forms.) It was a month of exuberant, exhausting, creative outbursts. The figures became Tonaltecan. In addition to drawing upon local ceramic motifs, animal forms were designed with smooth surfaces so that they could easily be painted in the Tonaltecan manner and burnished using traditional pottery techniques. Wilmot provided prototypes for facial and bodily features, but left the artists to add customary floral motifs to other areas. Finally, Wilmot rediscovered old colors now lost and unused, so that the terracotta brown background color could be varied with shades of green, blue, pink, red and white. His figures, though objects of modern design, possess deep roots in the traditions of Tonalá. They seem in no way Chinese, however, and contribute to Wilmot's ultimate goal solely by providing an income to support his research on Chinese glazes and by providing experience in working with local painters.

A Village Partnership Doomed by Stupidity and Greed

The experience of organizing a partnership to produce burnished terracotta sculpture proved frustrating for all concerned. This experience twisted the idealism of Wilmot into cruel disillusionment. By 1960, each of the partners had gone his own way to leave Wilmot convinced that village artisans were all dishonest and dissolute. Let us begin with the charge of dishonesty.

The most daring of the four was the first to cast off. He did so by getting secretly in touch with a wholesale customer, a woman who

owed the partners 50,000 pesos for previous orders. Apparently greedy enough to deceive Wilmot in order to profit in a small way, she advanced 10,000 pesos to the daring potter on the promise that he would use the money to establish his own business and sell figurines to her for one peso a piece less than she was paying. The savings to her were so little that it is hard to understand her culpability, but this much is clear, the daring one climbed over a wall at night to steal molds for making two of the dozens of figurines and established a business to compete with that of his former partners.

A second partner engaged in a different scheme to cheat but also hoping to set up a competitive business. He wrote to several customers informing them that Sr. Wilmot had committed suicide and asking that they send future orders to him as Wilmot's successor. The letter was too preposterous to succeed, but while it did not establish the man in his own business it did get him out of the partnership. Wilmot broke off in disdain.

The disdain of Wilmot is easy to understand, but how can we understand the cheating of these two partners? They were making more money than they had ever made in their lives and the future was promising. Even after deducting expenses of the business and splitting profits five ways, each man earned four to five thousand pesos ($300 to $400) per month where formerly he got along on 125 pesos ($100). Before the forming the partnership, none ever dreamed of earning such an income in his whole life, yet at least two became greedy for more. Why would they cheat to get even more money when they could have increased production?

The answer is complex and to a degree uncertain. To some extent, the men cheated because Wilmot failed to relate to them in a way that they could understand and trust. Unfamiliar with modern business management and the contribution of a trained designer to an enterprise such as theirs, they justified their actions to themselves and others by accusing Wilmot of exploiting them. From one day to the next, the four worked tirelessly with little evidence that Wilmot also did work. Sweating over the kneading of clay and the molding of forms, painting in endless repetition until fingers and eyes burned with fatigue, rubbing for patient hours and days to polish each piece to a shiny finish, tending a kiln that burned hot even in the heat of summer, packing

and shipping—all of the laborious work of pottery production fell to them. Wilmot, who shared equally in the profits, dressed comfortably in slacks and shirt to look in on them occasionally, but often was away for days at a time. A member of the urban elite which is believed by the less privileged to live off the work of poor peasants, Wilmot compounded his class identification by possessing an American name and being married to a German woman with whom he spoke only German. Wilmot has lived in Tonalá only for the past few years since his wife died. At the time of the partnership he resided in Guadalajara. Not only did Wilmot live in the city among the wealthy and foreign, he purported to spend time and money on trips paid for as business expenses by the partnership. It proved possible in time for two of the men to convince themselves that they were being badly used.

Peasant ethics supported their self-deception. Villagers for centuries have lived on the thin edge of starvation, disease and abandonment. Only the hardy, the fortunate and the clever survived. There is no cushion or margin for failure. There are no savings to tide one over from a bad harvest or business deal. There is no way a hungry person can cinch his belt tighter in order to wait for better times. Each person learns to look out for himself, at most for himself and his family, a syndrome Edward Banfield identified as "amoral familism" (Banfield, 1958). Beyond the immediate family, self-interest and distrust are customary.

Under these conditions, invitations to cooperate are always suspect as schemes to cheat. Lacking ability with arithmetic, unfamiliar with urban and commercial ways, and suspicious that everyone is trying to get a bigger share than he deserves because they think in terms of what George M. Foster calls the "image of the limited good," any cooperative venture is pre-programmed to fail (Foster, 1965). They always have in the past.

At about the time that Wilmot's partnership was struggling along, the director of the school in Tonalá, a native of the community, attempted to organize a cooperative pottery factory that everyone agreed at first was a splendid idea. "However, as usual, the discussion soon reverted to the old themes: how could an individual member be sure he was not being cheated? What could prevent those in charge from running away with the group's funds?" (Diaz, 1966, 188). Mutual distrust prevented that co-op from being established. Mutual distrust led to the dishonesty of

two members of Wilmot's co-op. Their distrust became a self-fulfilling prophecy. It left them bitter. It left Wilmot bitter. It was not a product of simple stupidity or unleavened greed, however. Stupidity and greed were involved, but more profoundly it was a product of cultural dissonance as peasant artisans and a skilled designer failed to hold fast across a cultural abyss.

Wilmot and the two remaining men also failed to hold fast. Both of the latter fell into bad work habits and chronic alcoholism. The one had to be discharged rather soon when he drunkenly lost control of himself in the workshop and broke every piece of pottery in sight with a beer bottle. In severing with him, Wilmot turned over a share of the molds so that the man could go into business for himself. Instead, he chose to take up employment with José Palacio (not Norman), a peasant potter who for a time was employed by Wilmot in a menial capacity. Within a week, the alcoholic got drunk and sold the molds and color formulas to Palacio, who almost immediately fired him for the drunken and incompetent worker that he had become.

Palacio subsequently did well with burnished ware. He works hard and lives successfully in a home that is small, but comfortable and attractive by village standards, graced by large potted ferns and caged songbirds. He now is well known in the region as the maker of some of the finest burnished wares that come out of Tonalá. The alcoholic, in contrast, remains a ne'er-do-well to this day.

In the end, only one man remained. The least capable in reading, writing and calculating, he was also the most skillful in painting. It seemed that the partnership would work out after all. Sharing profits on a fifty-fifty basis, the remaining partner found himself bringing home each month an income that was enormous by local standards. Had he continued to work steadily and had he invested wisely he would be rich today. Wilmot, unfortunately, was away more than ever. While he concerned himself with business arrangements and new designs, his partner neglected his painting and the supervision of others in the shop. For a time Wilmot was unaware that the man was spending his money wildly, was drinking daily, and was letting the workshop fall apart from neglect and mismanagement. When Wilmot at last learned how bad the situation had become he dissolved their partnership agreeing to pay his former partner 100,000 pesos in installments of 5,000 per month.

The man immediately sold his promissory note to a moneylender for one-fourth of its value and within weeks squandered it all, confirming Wilmot in the belief that village men care for nothing but whorehouses and tequila.

From a village point of view we gain a perspective that helps better to understand what turned these two men into spendthrifts and drunkards. In part, behavior that was senseless in terms of the opportunities provided in working with Wilmot made sense in terms of understandings they grew up with as peasants in Tonalá. To sell a promissory for only one-fourth of its value in cash can seem very intelligent when you live in a community in which it is common for people not to pay debts. Particularly is this so when a man with foreign and elitist associations lives in the city where he must surely have wealthy and powerful friends now owns the debt. It was not foolish to think that a man in Wilmot's position might manage to escape payment to a debt; outsiders sophisticated in urban ways frequently bilk villagers. Of course, the man made a mistake, but his mistake is understandable in village terms.

Again, neglecting work may seem like killing the goose that laid the golden egg, yet it occurred in a community in which an accepted pattern of behavior for men is to use cash wages to drink and carouse, even if neglecting their families. In part, such behavior seems rational in an economy of chronic deep poverty. "Eat, drink and be merry for tomorrow we die" in village thought becomes take what you can when you can because poor men can never truly afford the luxuries of wine, women and song.

The "eat, drink and be merry" syndrome as a defensible idea (as distinct from a moral ideal) can be found in other societies of deeply poor people. Oscar Lewis identified it in other parts of Mexico as characteristic of what he termed a culture of poverty, describing it as a strong present-time orientation with relatively little disposition to defer gratification and plan for the future. (Lewis, 1966, 7).

This syndrome in Tonalá is rooted in a cultural double-bind built into sex roles, family life, and personality development. Based upon careful ethnographic enquiry, May Diaz identified a family system in which children grow up with a father who spends his leisure time with other men away from the family while the mother is the parent who

remains at home to take responsibility for daily needs. But while the mother is the responsible parent, the father is the one with authority and prestige. The greatest deference is owed to him. He makes decisions. He stands above overt criticism, at least in principle.

"As a consequence of these factors," notes Diaz, "the child sees authority as power shorn of responsibility and clothed in the outward symbols of the male role, *machismo*, if you will . . . For men the ideal is to be strong enough to do what one pleases, to defy the feminine pressures of responsibility, careless of consequences and dangers . . ., and able to enforce one's wishes and desires on others" (Diaz, 1966, 90-92).

It is understandable, then that two of the men in partnership with Wilmot soon turned success into failure. Entangled in the double-bind of acculturated perceptions and personal greed, they did not live up to their responsibilities.

Fellow villagers do not consider the former partners wise. Their alcoholic, spendthrift and dishonest ways seem foolish and immoral, particularly to women. Other villagers would agree with Wilmot that the men failed him miserably. Yet the village consistently produces men subject to such failures. Wilmot and people like him do indeed face grave obstacles in attempting to put the artistic skills of Tonaltecans to better contemporary use. For Wilmot, such experiences and others led him to his present point of view.

He still believes in the importance of social equality, and still finds it uncongenial to relate to people in any but an egalitarian way. However, he feels that he can succeed best in working with villagers if he accepts their predisposition to submit to a strict authoritarian mode. In his working relations at this time, Wilmot is the boss and his men take orders. He supervises them carefully to minimize any possible tendencies to stray from prescribed procedures and, in effect employs them just as El Palomar employs men. He seems to be doing quite well in this way as he concludes, "I dislike hierarchy, but now I know it makes some sense." Recently he hired an engineer he hoped would manage the day-to-day operation of his factory, yet he complains constantly of carelessness and thievery.

An Uneasy Partnership—Jorge Wilmot and Ken Edwards

By the time the village partnership fell apart, Wilmot found himself in competition with a large number of peasant potters who had learned to produce copies of his burnished terracotta figurines.

The concept of patent rights or copyrights is foreign to the community. It surprised no one, least of all Wilmot, that his success bred imitators. Particularly was this true insofar as local potters were experienced in working with the molds and clay that Wilmot used. It was time to return to a larger purpose.

Jorge Wilmot was indeed destined to face obstacles. To recreate and perfect the glazes of ancient China has challenged innumerable westerners in the last several centuries. A few have succeeded. The difficulty was all the greater for Wilmot because he hoped to develop Chinese-like glazes that would fit the rather ordinary clays of Tonalá. Also, he began with a minimum of training and experience as a potter.

The first need in his search was to obtain a high-fire kiln. In order to be near Tonaltecan painters, it ought to be located in the community. Rural electricity was too weak and uncertain, however, for the operation of a standard kiln. Badly needed was one that would function without a fan to inject air. Feeling quite defeated by the problem, Wilmot sought out Ken Edwards when he learned that Ken had been experimenting with porcelain and stoneware in a small kiln brought down from the States. The kiln did not require a strong current of electricity to operate. Ken was agreeable to joining forces. They formed a new partnership. (Recall, this was before Ken met Arthur Kent and even before Ken signed a contract with José Norman Pallacio.)

Wilmot brought his molds to the partnership. He developed additional forms. So, too, did Edwards. Soon, using imported clays, they were able to produce figurines in glazed stoneware that competed successfully with those in terracotta produced by villagers. The resultant income financed a continuing search for glazes.

The Wilmot and Edwards partnership lasted only a year or two before it disintegrated. For a time, however, it was a honeymoon. Enthusiasm soared as they joined forces to attempt to match the best of Chinese ware. They tasted early success when they hit upon an oxblood glaze. Neither one was trained for chemical research, so they employed a trial-and-error approach. They experimented with glazes used by

124

village potters. One that yielded a shade of green in local low-fired ware produced a very nice red in stoneware. They bought the glaze mix from an old woman who agreed to make a batch so that they could see what went into it. Her approach was that of an old-fashioned cook— she used a bit of this and a touch of that, or so Wilmot told us. Taking her mix to their make-do laboratory, the men measured out the ingredients in order to turn her recipe into a precise formula with which they could experiment by varying the quantities of each ingredient.

Eventually they discovered that the key ingredient was copper oxide fired in a reduction atmosphere. All of the other elements were unimportant. It seems clear that the two men between them still had a lot to learn about high-fired ware at that stage of their careers. Any standard text on glazes would have informed them of what they discovered at great effort for themselves.

The men began to quarrel. Perhaps it was inevitable. Each is so much an individualist, so independent, so temperamental. They disagreed over the work of Magdaleno, a painter of Tonalá who later killed a man and had to move his home to Tlaquepaque to be safe. So liked was he by Edwards that he eventually was made the head painter at El Palomar when Ken went there. Temperamental differences between Wilmot and Edwards included nearly opposite attitudes toward the organization of work. It disturbed Wilmot to find Edwards at his ease with the men when production was falling behind schedule. Edwards felt Wilmot was greedy. Wilmot felt he was supporting a vagabond. Accusations flew until a time arrived when Edwards was in the United States visiting his sister and got a telegram from Magdaleno telling him to return instantly. Wilmot was disbanding the partnership.

The partners at that point were so unable to get along that they divided the shop by drawing a line down the center. Each was to work independently on his own side of the line. Half a year later they separated completely. Wilmot kept the kiln. Edwards took the air compressor. The molds, some created by Ken, were divided so that each could continue to produce the full range of figurines: Edwards for El Palomar in white stoneware and Wilmot on his own in brown. Today, stores of the region sell painted birds and animals that are identical because Wilmot and Edwards designed them. They differ in that those made in peasant homes are of low-fired earthenware while those produced by CAT are

in faience, those of El Palomar are in white stoneware, and those of Wilmot himself are in brown stoneware. Buyers generally assume that they are buying objects in traditional, peasant styles. In reality, these objects are the creations of two non-peasant university educated men influenced by international modern design.

After the break-up, Edwards went on to El Palomar and continued to look for a glaze that will fit the local clays. Wilmot continues his search as well. To produce brown stoneware he hit upon mixing local and imported clays in proportions of three to one. He found a glaze that worked quite well with it. For a decade he has produced not only his figurines, but also a wide selection of vases, bowls, large platters and tableware in what does indeed approach in quality and appearance old Chinese standards of excellence. While much of his work is brazenly Mexican, often with a bright red or yellow sun-face as the central feature, much, too, is rather oriental, displaying a delicate spray of leaves and a bird in flight that transform Tonaltecan motifs into a Mexican-Chinese hybrid, just as Wilmot originally set out to do. In anthropological terms, the paradigm was still in Wallace's first stage of innovation. Never content with success, Wilmot continued to search. As the 1960s grew into the seventies, his reputation extended to international dimensions. He won prizes in Mexico for some of his work. He won prizes abroad as well, including in 1974 a first prize in Munich for his new, life-sized brown stoneware duck. From primitive beginnings with Edwards, his studio grew into a factory that rivals in size that of El Palomar. Although he employs only twenty-two people, including a store and office staff and five painters, he keeps three shuttle kilns in production that are the same size and design as those of El Palomar. He plans to build three more.

Employment problems set limits on future growth, however. He intends to reduce rather than increase staff. The new status of Tonalá with regard to minimum wages, social security benefits and unionization makes labor very expensive. When Tonalá came under the jurisdiction of Guadalajara in January, 1976, the minimum wage instantly jumped. Employers also for the first time had to pay social security benefits. The total effect was to impose a sudden seventy-five percent hike in wages.

These financial difficulties were compounded by legislation to regulate job security. In the words of Wilmot, under the present law,

hiring people is "like adopting adults." This is because employees cannot simply be terminated if their work is poor or if their services are no longer needed. Under present legislation, a termination payment is required even to fire an incompetent employee. Since the payment must include three months pay plus the pay of twenty days for every year of previous service, it can cost thousands of dollars to let a single person go. Small business concerns such as that of Wilmot find such regulations a financial straight-jacket. A worker who develops bad habits can become a permanent liability. Further, the firm must continue to pay increasingly high wages during months or years when sales are off. Wilmot is understandably reluctant to take on such obligations any more than he must. The problem, and his reaction to it, is very similar to that of Gustav Ottesen who owns the Johgus ceramics factory in Denmark.

In December, 1976, Wilmot developed a glaze that surpassed what he was using. It allows him to produce an object of brown stoneware with floral sprays and flying birds, but with a greater sharpness of detail and greater depth of appearance than he was getting before. It looks Chinese. The finish, however, is glassy and brilliant, as smooth and shiny as water on a flat tile. It is much more mirror-like than anything traditional to China and very much within the more flamboyant art tradition of Mexico. Wilmot has done it! He has produced a superb kind of stoneware that in a sense culminates the traditions of both China and Mexico. In all events it represents a new achievement. It constitutes a Mexican expression of a Chinese mood.

Freelance Designer, Entrepreneur. Both to earn money, which he accepts realistically as a worthwhile goal, and to express himself artistically, Wilmot willingly moves beyond ceramics. Within a year of setting up his original partnership to produce terracotta figurines with local artists, he introduced a kind of art work very new to the area. He got the idea when he learned than an entrepreneur in the southwestern United States had produced paintings by engaging Native American potters to reproduce traditional designs on horizontal surfaces. Wilmot decided that the same could be done in Tonalá, but with modifications. Wilmot took certain traditional pottery motifs, including that of the cat, but used them in a thoroughly original way to produce surrealistic painting that were his own creation. The cat, as we have already seen,

is his cat, although it has Tonaltecan affinities. The painting is his, but also with some roots in the local tradition.

Working with acrylic on boards covered with cheesecloth, later simply on masonite boards, the final paintings were textured by using an antiquing technique acquired from an American artist residing in Tonalá. Trained as a painter, Wilmot produced with the sureness of a professional. He painted only the prototypes, however. As in ceramics, a local artisan coached by Wilmot, then reproduced each. The quality of their reproductions was excellent. Wilmot directly supervised the work.

Wilmot refers to the first of these paintings as a self portrait. It shows a sitting cat full face, but made up of the roofs, windows and appurtenances of buildings so that it is at once both a cat and a building. Later, these in several variations show nimble cats cavorting across the rooftops of a silhouetted city. Still others deal in a rather oriental fashion with birds or animals in dream-like floral settings. The first cat was painted in 1958. In 1970, cats provided the themes for an out-of-series collection painted by their creator for the Shell Oil Building in Houston, Texas. Some of these works were as large as two meters tall.

Once again, there are no patent rights on art in Tonalá. Local artisans learned rapidly to work in acrylic on masonite. Their paintings in part mimic the work of Wilmot and of the designer Sergio Bustamante. In part, they reproduce traditional designs and stereotypes of Mexico.

Wilmot has also done highly original work in an old Mexican folk-art medium, cut tin. He recently completed a large mural for a skyscraper in Mexico city with hammered tin highlighted against a dark blue background. For sales in the tourist market he has produced other items of tin, including at present a favorite theme of his, the owl. This owl, constructed of bands of tin shavings to give it a fluffy though metallic appearance, stands twenty-five centimeters high.

Over the years, Wilmot's excursions beyond ceramics into the broader field of modern design have proven artistically and financially successful. His time and energies, however, are committed heavily to work with stoneware. For a freelance artist who ranges by preference throughout the whole realm of modern design, we must turn to a quite different person.

Sergio Bustamante: Mexican Rural Roots, International Reach

As we stood by the phone, the young, handsome and articulate Sergio Bustamante talked with associates in Mexico city who were arranging a grand opening of the gallery that will feature objects and clothing he designs for wealthy sophisticates. Sergio Bustamante has become one of the top names in design while another man, also named Sergio Bustamante, has become a movie star known to everyone in Mexico. The coincidence of names is noteworthy, since the names are Italian rather than Spanish, even though the two men are Mexican. (The designer, to be exact, was born in Mexico to a Mexican mother and an Italian father.) Over the phone the designer learned that the actor wanted to be present at the opening of the gallery so that he could meet the other famous Bustamante for the first time. The meeting was arranged with enthusiasm. It would guarantee coverage in the mass media — that was reason enough to be happy. In addition, the designer loves to meet people and to perform, as it were, in the international, jet-set theater of fashion and entertainment.

Growing up on a rural estate in Sinaloa, northern Mexico, Bustamante was influenced by his Mexican culture and in his earliest years by the experiences of his grandfather, a Chinese immigrant. While Sergio studied architecture at the University of Guadalajara, he began making and selling crafts in his junior year. With no obvious jobs available for him in architecture he continued his craft selling quite successfully. In the midst of what appeared to be a flourishing business, he left to live in Amsterdam.

In 1975, not long after his return to Mexico, and about the time we met, he established his Family Workshop Studio in Tlaquepaque with native artisans. "Tlaquepaque is the ideal place for working and having a studio," gushes Bustamante. "People here have been working with their hands for generations. They are true artisans. When you are talking about dreams, they understand exactly. It is like working with your family. You start to think together."

Still in his mid-thirties, Bustamante is a young man who dresses casually in skin-tight clothes that show off a small, lithe figure. He speaks rapidly with intensity of expression, a ready smile and flashing eyes. He prepared for his career by travelling in France after studies at the University of Guadalajara. His university work qualified him

broadly for a career in art or architecture. Brief months in France confirmed a commitment to the effervescent world of fashion design. Many creative people in Europe provided a model for his personality and predilections. Confident of his own ability to design, but untrained in any craft, he took apart items of his own wardrobe to learn how clothes were made. He was far too impatient to take courses in tailoring. Today, he creates ultra-modern clothing that is French in inspiration, but Mexican in heritage. Now, he has contracts for dresses that will be made of material he designs. The colorful Mola cloth art of the Cuna Indians of Panama inspires his fabric.

Papier Maché Art. Around 1963, shortly after Ken Edwards and Jorge Wilmot ended their partnership, Sergio Bustamante arrived in Tonalá with the idea that he would design pottery. It is characteristic of whatever he turns his hands to that, if he can, he finds a craftsperson to instruct him in technique. Knowing nothing of ceramics, he searched for a local potter to instruct him. His hopes were dashed in an experience that inaugurated a decade of frustration with members of the community. No one would teach him how to pot.

Forced to consider alternatives, he hit upon the idea of working in a medium that resembled clay, might in some ways be easier to work with, but would require inventiveness to succeed. He decided to produce works of art of papier-mâché in pulp form. No one could instruct him, because no one at that time was working with molded papier-mâché. He turned to books as teachers.

Ever curious and ever ready to innovate, Bustamante's greatest challenge comes in choosing what it is he wants to create next, and in what medium. "I've been switching from one medium to another all my life," laughs Bustamante. "I'm always asking, How can a similar piece be fashioned in another medium?"

Papier-mâché can produce rather uninspired objects, as many a grade-school teacher can attest. Bustamante intended to produce works of art. Through reading about techniques and by experimenting with processes, he developed the techniques. He developed a lacquer that produced a glass-like finish. But what should he design?

The figurines of Jorge Wilmot served as inspiration. Bustamante designed a cat. Drawing upon the feline paintings of Tonaltecan potters, including the rather human nose, mouth, eyes and mustaches

common to both the old peasant Amado Galván and Wilmot, he largely duplicated the posture of Wilmot's then five-year-old reclining cat. Bustamante created a cat with a lion's mane, flower tattoos, and an incongruous relationship to a small cat that reclines upon its back. Known as *Tonalá cats*, they became an instant success, along with a growing assortment of companions.

Small parrots, fish and other creatures uniquely his own but in the size range of Wilmot's sculpture gave place to large pieces made possible by the light weight of the material. Typically realistic in form, they are transmogrified into fantasies of bright colors with the painted floral motifs of Tonalá. Except for the cat, never imitative of Wilmot, the menagerie grew to include dazzling larger than life parrots on bird stands, Atlantean fish joined in Siamese-twin fashion at the abdomen to spout papier-mâché water in vertical columns, rhinoceroses nearly half of natural size, ducks, armadillos, lobsters, crabs, giraffes. In short, he created an enormous zoo of creatures, most of which are not indigenous to Tonalá, but all of which grew out of Bustamante's sense for style potentialities in the local tradition. More recently, Bustamante found a local tinsmith with whom he now works to produce the same forms in tin and brass. Learning from the man he taught, they succeeded in reproducing the whole range, from small fish to chest-high rhinoceros. Papier-mâché pieces are produced in Bustamante's own workshop, where he can exercise daily supervision. The tin-brass copies are manufactured in the shop of the smith on a cottage-industry basis.

Bustamante produces furniture in the same way. He purchased power machinery for a young cabinetmaker of Tlaquepaque who will pay for his new equipment by filling orders for Bustamante. Eventually, it is hoped, the machinery will belong to him. He should end up with his own first-rate shop. At present, however, it is too soon to predict how well Bustamante's furniture business will develop.

Unlike others who produce copies of a work as long as market demand holds, Bustamante commits himself to continuous creativity by destroying molds or ceasing production after making a certain limited number of copies. Out of a fertile imagination he leaps into projects that, when he talks of them in advance, sound frankly bad. Yet in his capable hands they evolve with remarkable regularity into pieces so desirable that people seem to crave them, even though a full-sized

papier-mâché zebra or crocodile will not fit easily into most homes, nor be paid for easily out of most pocketbooks.

The energy of the man is boundless. Not only does he design, but also unlike Wilmot and Edwards, he executes critical details of the painting himself. He personally does extensive work on the life-sized lion's head, for example, not only on the face, but also on the large mane that surrounds it. The combination of well-executed detail with imaginative overall form makes his work memorable.

Working with People. The inspiration for his papier-mâché objects grew out of highly romantic feelings about Tonalá and its "noble peasant" artisans. "Tonalá used to be magical," he now recalls in disillusionment. Not easily convinced that individuals may betray or misuse him, and non-judgmental about his initial failure to find a pottery teacher, nearly ten years of experience finally convinced him that he could no longer work in the community.

In part, he grew tired of the pressure to manufacture duplicates of successful designs. He and a non-villager, Melchiares Presiado, joined forces some years earlier to establish a small factory and retail store on the main street of Tonalá. From their first names they devised the name *Sermel* for their enterprise. (Shades of Johgus on Bornholm Island in Denmark!) Presiado, as a businessman by profession, succeeded in helping Bustamante make money. However, with time and personal differences the arrangement became limiting rather than liberating for the artist. His growing success led him to terminate the partnership and abandon the community in 1973.

The decision to leave the community grew out of more than a change in business status. It represented a conscious disavowal of Tonalá and its people. The magic was gone. He felt cheated to find his papier-mâché creations copied. It was not that they were reproduced by a few independent craftsmen. That he considered of no importance. But it irked him that copies were mass produced in sweatshops in which local artisans received starvation wages to put out shoddy work that cheapened the reputation of his own. It was also upsetting time after time to find that his own workers were as he puts it, "tricky." Ostensibly cooperative, they proved irresponsible when not constantly watched. Worst of all, they betrayed their employer, selling his designs to competitors. At one time the practice got so out of hand that his creations were on sale in

the shop of a competitor before his own first models had reached the market.

Bustamante "divorced" himself from Tonalá, as he puts it, for the same reason that Wilmot gave up trying to work in partnership with Tonaltecans. Both men feel betrayed. But whereas Wilmot responded by organizing his factory on authoritarian principles, Bustamante chose a familistic approach. Employing fourteen people, each person has had a long, highly dependent relationship with the young head of the "family." Bustamante's closest associate is his business manager, a Dutchman about his own age whom he met and came to know in 1973 during a stay in the Netherlands.

Assured now of stable, honest financial management, Bustamante has more time for design and the supervision of production. The young men who work for him include one who grew up on the Bustamante estate in Sinaloa as the son of their gardener, and two who were penniless when he gave them work. Others he learned to like as individuals as well as to respect as workers. By constantly insisting upon the family-like character of his enterprise, paying well, and giving workers a sense of importance and dignity, Bustamante appears to have created an organization with integrity and loyalty. He spends brief but intensive periods abroad with the jet-set, flying to Los Angeles, for example, to pose for publicity pictures and attend a Hollywood party, but returning to Tlaquepaque the same evening. He returns to work closely with the fourteen members of his extended family. "I marry and bury them," he remarked at one point, since one young man was killed the week before in an accident while another recently married a young woman on the staff.

Three of the four painters are from Tonalá, but they live in Tlaquepaque now or commute there to work. One could not find work in Tonalá when Bustamante hired him. He is unstable and he drinks. Although he is a good painter, he only works at times. It was he who recently married, and it is everyone's hope that marriage will settle him down.

Now, Bustamante is happy with his staff, but he has felt that way before only to feel betrayed in the end. The family, or commune, approach may be no more proof against interpersonal conflict than is that of the partnership or the authoritarian employer-employee contract,

or the family paradigm of potters on Bornholm who limit decision-making to genetic affiliation.

Artistic Loyalties. For Bustamante to leave Tonalá was to cut off the artistic loyalties of a decade. His romance and marriage with the commune, to use Bustamante's own analogy, left bitter feelings that led the designer to disavow the community. He did this by consciously dropping more and more of the motifs of Tonalá from his work. This is seen most clearly in his painting.

Again taking an idea from Wilmot, Bustamante painted flora and fauna on masonite boards, often featuring cats and lions. Again, his work is quite original, although its debt to Wilmot as well as to published books is apparent. During his stay in the Netherlands, while getting through his cultural "divorce," he took to painting in a more profound and diversified way. At first characteristic Tonaltecan motifs were apparent. He painted cats. But increasingly a new kind of imagery evolved, one more inspired by Europe than by Mexico.

Returning to Mexico, he continued more and more to remove Tonalá from his work. His current fashions in dress are Latin American in inspiration without being Tonaltecan. His papier-mâché creations remain Tonaltecan only in a willingness still to apply painted floral designs. His furniture is very Mexican, but on the whole not Tonaltecan. His earlier pieces, still in production, feature cut tin patterns with Tonaltecan animals. His most recent designs incorporate brass scroll work on flat tin and painted tiles showing scenes such as that of Adam and Eve in Paradise under the apple tree. Tonalá may end up for Bustamante as no more than a youthful phase in his career. His own hopes for himself are that he will do more serious, sophisticated work, in contrast to the cartoon-like and "cute" objects that he has produced to date.

It remains to be seen whether Sergio Bustamante will succeed in becoming more sophisticated. Like Wilmot, and despite excursions into the United States and Europe, Bustamante remains artistically rather isolated. His ideas for the most part have been Mexican and Tonaltecan. He is limited as a result. He is significantly limited by the materials with which he works. Nearly everything has been produced in papier-mâché, tin and brass, or cloth, none of which is durable. Even his paintings may not last; two interesting miniatures painted four

years earlier are already peeling. Nothing he makes has the durability of stoneware. He is limited also by an indifference to, or unawareness of, functional utility in design. Papier-mâché and tin-brass *objets d'art* are fragile, easily damaged even in a home without children or pets. But, when these pieces are in the form of ducks or swans, open on their backs to serve as plant holders, dysfunctional features become even more detrimental. Only with great care and no slip-ups can plants be watered without eventually destroying the papier-mâché structure that supports them. (Note: *in 2010, some thirty years after this was written, a beautiful, although slightly flawed papier-mâché duck, given by Sergio to the authors, remains in almost perfect original condition without the careful treatment we thought was necessary, but a potted living plant now sitting inside it does not bode well.*)

Furniture designs show equally serious functional defects. His headboard, for example, sells to people as famous as the American actress Lucille Ball (who had commissioned one we saw in progress), but it may be impossible to live with. The decoration utilizes motifs out of Tonalá but is cut from tin using techniques long practiced as a folk art in the city of Tasco, south of Mexico City. It consists of sharp-edged pieces of tin that project into space like leaves on a branch. Leaves on branches in fact are one of the Tonaltecan motifs used, along with birds, sun faces and more. When brushed against they will catch and tear clothes. They will tarnish. They are impossible to keep dusted. And they make the head board useless for its purpose, since one cannot possibly lean against it while in bed. When we discussed this problem with Bustamante, we were answered with a refreshing frankness. He agrees that they are impractical and suggests that they might work better if placed upon a wooden base that would reach high enough for pillows to lean against. The basic issue was not discussed, however. In our time, furniture really ought to be functional as well as interesting.

Perhaps the dysfunctions of Bustamante's designs are offset by what they communicate. Bustamante would like to think that his work has no meaning. Yet often the symbolism is consciously contrived. It offers, frequently, a commentary on life. The artist is obviously making a statement in a self-portrait that shows the key figure naked and exposed with a gigantesque tear dripping from his eye. He is also making a statement in his project of papier-mâché monkeys (somewhat like the

wooden ones of Kay Bojesen) that will swing pendulum-like between natural dignity in a Garden of Eden and the silliness of clowns as they are portrayed sitting at a table in human clothing. Less obviously, his work as a whole offers a message. In riotous colors and flamboyant effects they ask those who enjoy them to forget for a moment the sordidness and drabness of life. Bustamante can turn living into a vibrant adventure if you let him.

The Missing Part of the Paradigm— A Milieu Supporting Creativity

Were Bustamante, Wilmot, Koppel and Magnussen to chat together in a single room, they would clearly share observations about much that they have in common. Yet, in significant ways, it makes a difference whether one is Danish or Mexican. What is the difference?

Regarding training, the differences appear less in the formal institutions than in the urban milieu. Bustamante's training in the University of Guadalajara and that of Koppel and Magnussen in the Danish Academy of Fine Arts must be evaluated as comparable insofar as the subjects of this study are concerned. The Danish School of Utilitarian Arts has no peer in Mexico. It provided Magnussen with technical training in ceramics and a handcraft orientation to design which is otherwise unmatched. All of the others, including Wiinblad, are essentially self-taught in the technology of their crafts. However, as Magnussen himself insists, it is the milieu as a "way of life" and not a particular institution that creates a designer.

In both countries, aspiring middle-class artists have approximately the same opportunity for travel abroad. At least those we interviewed were nearly identical in this regard. Wilmot and Bustamante each spent about a year in Europe, and each describes the experience as inspirational rather than instructional. They were stimulated by people they met and art they saw, but were not formally trained. The same is true of Koppel's year in France. Only Magnussen never resided abroad. Of the four, the two Mexicans are by far the most international at this time. Both frequently visit the United States. Of the four, Wilmot speaks the most languages (Spanish, English, French and German, all fluently.)

Concerning milieu, however, clearly Denmark is more supportive than is Mexico at this time. Copenhagen provides the stimulation of changing exhibits in the Museum of Industrial arts and other museums, in Den Permanente, in numerous craft and art stores, large department stores, annual exhibitions, newspaper and magazine coverage, and social and associational gatherings of artists. Even the provincial towns of Rønne and Naestved provide exposure to the work of a large number of artists, both Danish and foreign. Mexico City, as far as our limited acquaintance indicates, and certainly the area of Guadalajara, provide comparatively little opportunity see the work of others and to meet with other artists. Wilmot and Bustamante were both very aware of trends in design. They meet people and read magazines and art books. The depth of their exposure, however, lacks the more intense involvement in the world of art that we sense in the lives of Koppel and Magnussen. (This is true even more of Wiinblad.)

Why this difference in the two countries? Unquestionably the major factor is the socioeconomic variable. Denmark has, in the last century, transformed into an essentially middle-class nation with middle-class tastes and sophistication in art. (See Robert Anderson *The Success of a Developing Nation. 1975)* The feed-back loop between creator and consumer feeds into a substantial population that interests itself in modern design and invests in it. The many tourists who visit Denmark provide added support for art. The Mexican middle-class, in contrast, is smaller and newer. Fewer among them are patrons of innovation in design. Foreign tourists at this time provide little additional support. They underwrite, instead, a large commerce in what they perceive to be folk arts. The fact that the larger part of the production of both Wilmot and Bustamante is shipped abroad confirms the inadequacy of the Mexican market to provide support and stimulation for modern design.

We do not know whether to be alarmed or hopeful in learning that the quality of art in contemporary civilizations is set by the consuming public, the patrons of a Democratic Age. But we are inclined to be hopeful. Although Danish consumers frequently support aesthetic mediocrity, they also support the milieu that created the producers of modern Danish design.

Given designers as talented and skilled as the Danes and Mexicans we write of here, what of the factory environment? Do they all enjoy the advantages promised by the Royal Copenhagen Paradigm?

Koppel and Magnussen clearly do. The facilities of a large porcelain factory are at their disposal. They explore freely the possibilities of collaboration with trained chemists and managers oriented to achievement in industrial arts. The finest of equipment is used. Speaking of Nils Thorsson, one of the most creative designers to work for the Royal Porcelain Factory in our time, the art historian Merete Bodelsen concluded that if he had worked independently in his own studio he would not have achieved as much as he did. "It is the fantastic possibilities of the experienced ceramist given by a big factory with the combination of laboratory, chemists, and tunnel kiln where you can get daily answers to your questions which took him as far as he is today." (Bodelsen 1960, 56.) Yet, as she points out, he and the other designers in a large factory become slaves of the kilns, which must be kept busy. They go far, but the strain is great. Particularly has this been true insofar as they must constantly think of production and the need continuously to produce new designs to justify their salaries. In this regard, Koppel and Magnussen enjoy an advantage still new in Bing and Grøndahl. They receive royalties on their designs rather than just a single honorarium or salary checks.

Among our study subjects, the two native-born Mexicans who have achieved international renown, Wilmot and Bustamante, have each established their own factories. Like the two Danes, Koppel and Magnussen, they feel the pressure of needing always to think in terms of production. They feel the additional pressure of needing to handle the whole range of responsibilities, including engineering and commerce. The pressures, as a result, are greater, compounded by the difficulties of operating in a less prosperous but equally controlled economy. Pressures are additionally compounded by the difficulties of working with undertrained or unskilled labor, or alternatively, with skilled peasant artisans under the strain of adapting to a factory situation. There are compensating advantages. Since they make all of the decisions, their freedom is greater. Since they own the businesses, their profits are greater. It is our impression that Wilmot and Bustamante make more money than do Koppel and Magnussen, although none is either rich

or poor. Certainly, the economic status of the two Mexican designers is vastly higher in comparison with the average citizen of their country than is the economic status of the two Danes. (Wiinblad, however, is undoubtedly the wealthiest of all.)

We conclude, then, that the creativity of the two Mexicans, as extraordinary as it is, is achieved in a factory and urban milieu that is less supportive than is that of the two Danes. They must create with less stimulation and information from others. Hence, one finds no awareness of the need for form to fit function in the work of Bustamante. They must also create in slower, more poorly equipped and staffed factories. Hence, the long time it has taken Wilmot to develop his glazes and designs. The Mexican milieu is less effective than the Danish in supporting creativity. It lacks the advantages of the Royal Copenhagen Paradigm without offering equal advantages of its own. The transition from folk art to modern design is incomplete in many ways. Phony folk art flourishes in the form of decorative objects that have long lost their original function. They exist in an international market as quaint reproductions of a former era, or as attractive art objects with modifications of old designs. Few factories, as well as few independent potters can survive in a global milieu; few can survive dependent upon the local economy. Yet, these old arts are not extinct in Jalisco.

We return now to discuss how Denmark is re-connecting with its folk art past. We will look at the consequences of the lost layer of society, the local potters producing utilitarian ware; and we will explore the wisdom of preservation efforts.

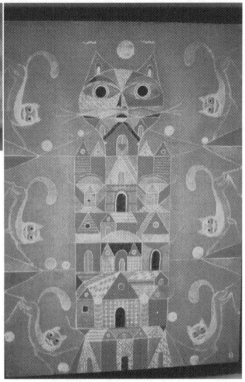

Work by Jorge Wilmot, Tonalá, Mexico.

(above) One of his cat designs, (Right) A self-portrait with cat motif.

Below: a plate with his Chinese/Mexican blend of glaze and design.

Below right: one of his owl designs with muted browns, meticulously painted flowers and birds.

(authors' photos 1976.)

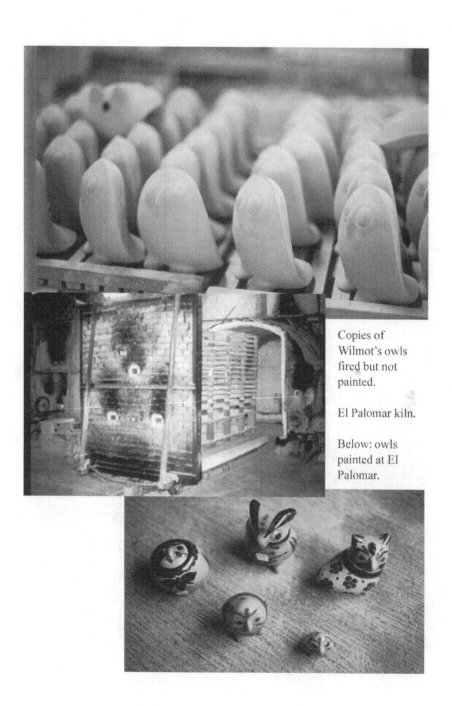

Copies of
Wilmot's owls
fired but not
painted.

El Palomar kiln.

Below: owls
painted at El
Palomar.

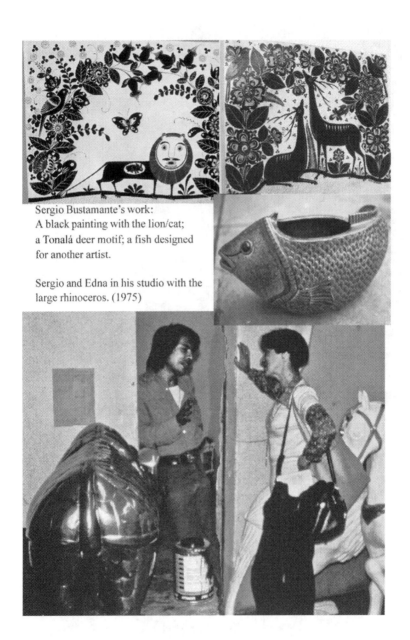

Sergio Bustamante's work:
A black painting with the lion/cat;
a Tonalá deer motif; a fish designed
for another artist.

Sergio and Edna in his studio with the
large rhinoceros. (1975)

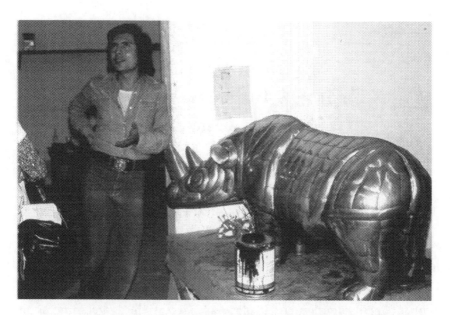

Sergio and the rhino... this one is paper mache. Below is a cut
tin headboard commissioned by actress Lucille Ball..... and a
cut tin sun. *(authors' photos, 1976)*

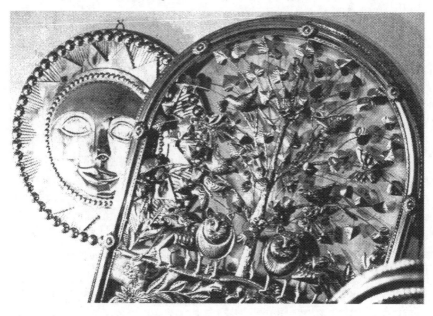

Chapter Seven
Denmark Industrializes with Unintended Consequences

*Access to talented and creative people is to modern business
what access to coal and iron ore was to steelmaking.*
—Richard Florida

Demise of Danish Ceramic Folk Art

In Denmark, the major functional consequence of the Royal Copenhagen Paradigm took place as part of the larger process of industrialization. Superior factory products at competitive prices at first threatened, and then ultimately destroyed, a flourishing folk industry in pottery.

Exploring paradigmatic analysis as an approach to the study of cultural process, Anthony Wallace observed that in a given situation, exploitation of the paradigm might lead to what he termed functional consequences. That is, with time and application the paradigmatic process may engender unintended changes beyond the institution directly shaped by the paradigm. When that occurs, people characteristically respond, at first, by adaptive expedients. They attempt to salvage the old cultural system by employing minor "first-aid" measures. Such adaptations can persist for years, as we believe we see in Mexico. Ultimately, however, major adjustments may take place. The result will then be that the new culture becomes significantly different in areas beyond those directly implicated in paradigmatic change.

Two major traditions of folk pottery co-existed in recent historical Denmark. The black pot industry was in the hands of peasant women. The glazed pot industry belonged to town and peasant men. In both, the reaction to competition with factory-produced ceramic and metal wares at first took shape in attempts to make traditional wares more

144

attractive. Both folk industries rapidly succumbed, however, in spite of these ameliorative efforts. The extinction of the crafts provides a basis for anticipating what may happen to the ceramic crafts of Mexico.

The Black Pottery of Jutland: A Rare Encounter

We made our way cautiously along a country path leading we were not sure where. The last sign of living people was behind us as we turned a bend to find ourselves suddenly deep in an earlier century. At the edge of a field, huddled against a glade of trees, we encountered an old farm building with smoke curling from the chimney. The roof was of straw. A well in the ground provided water. In the absence of electricity, we learned later, kerosene lamps and candles provided light. A cart stood nearby, but no automobile. In the house lived a woman potter.

Clothed in the simple manner of a country woman, she scarcely raised her eyes as we approached, so absorbed was she with the clay in her hands. What wonderful good fortune for a pair of itinerant ethnographers. She was making what appeared to be a black Jutland pot (*jydepotte*). We whispered encouragement to one another as we drew near. So eager were we to interview her that we became nervous that our sudden appearance would frighten or annoy her. To our delight, she smiled when we said, in our most rustic accent, "Go'dag, fru." Her name, she told us, is Grete Andersen. It is a good, peasant name.

During the summer she lived alone in the farmhouse. Using a couple of pots made by herself, she prepares simple porridges and soups, supplemented by fish and meat smoked in the fireplace chimney. Her milk comes fresh from the cow. Up early in the morning to tend the garden, she spends most of her time at her craft, kneading clay in the living room or sitting, as we encountered her, on the bench along the front of the house, shaping with strong, sure fingers and simple tools a kind of pot that once constituted a well-known product of Denmark. She lives as though the twentieth century did not exist.

Appearances can be deceptive, as we have all been warned. Ms. Andersen is a modern, trained artist, and not truly a peasant at all. In the winter she lives in Copenhagen where she maintains a potter's studio. Her summer home is a facility of the historical-archaeological Research Centre at Lejre, about forty kilometers southwest of Copenhagen.

Ms. Andersen began to work at the Center about six or seven years earlier. Three years before we interviewed her, she learned to

make Jutland pots for the first time. Unfortunately, she did not learn directly from an old potter, but rather from ethnographic and historical documents and from her own experiments. She is self-taught. Her products attest not to the survival, but to the extinction of the craft, other than as an antiquarian enterprise.

At the Centre she creates pots almost exactly as was done historically. She hardens them in a smoke-oven built for her by Arne Bjørn. Mr. Bjørn, an engineer, is the nation's top authority on the structure and operation of prehistoric pottery kilns. Ms. Andersen fires her wares in an open pit rather than a kiln, however, the way farm women originally did. And she recreates the entire ambiance of folk pottery, for herself as well as for visitors to the Centre, by living as much like a peasant as she can—for a couple of months each year.

Nineteenth-century Women Potters

According to old newspaper and magazine accounts, observers of the Danish countryside during the nineteenth century felt that peasant life was turned topsy-turvy. Traditionally, villages stood apart as isolated clusters of farm houses. They were surrounded by fields that were divided into long strips shaped to accommodate large wooden-wheeled plows. By mid-century, this landscape had changed to one in which farms were scattered among the fields. The communally structured village was replaced by the individualistically oriented farming family. The holdings of a single farmer were worked independently rather than by groups of villagers. The heavy plow that required several teams of draft animals was replaced by a steel implement light enough for a single horse to pull and for a single person to manage.

Yet, revolutionary though the changes were, the peasant's technology remained pre-industrial. Fields were normally worked with horsepower. Grain was usually harvested with the scythe, then a new implement. The scythe released women from the back-breaking labor of cutting with short-handled sickles, but this shifted them the equally arduous labor of binding sheaves. As the men moved ahead of them in a row, keeping time with wide-cutting swings, each was followed by a bent-over woman who prided herself on her ability to keep up as she gathered and bound the grain.

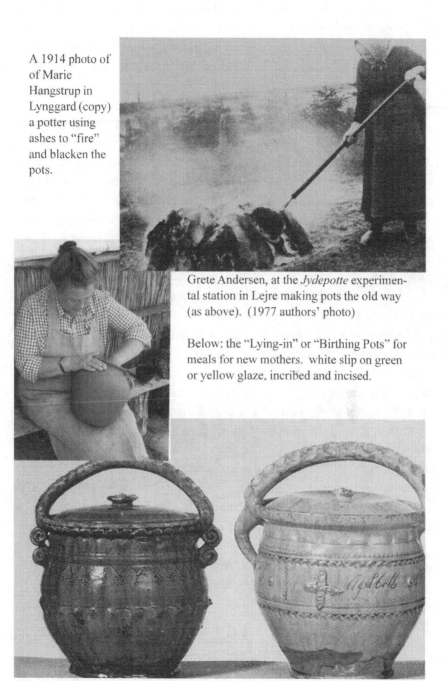

A 1914 photo of of Marie Hangstrup in Lynggard (copy) a potter using ashes to "fire" and blacken the pots.

Grete Andersen, at the *Jydepotte* experimental station in Lejre making pots the old way (as above). (1977 authors' photo)

Below: the "Lying-in" or "Birthing Pots" for meals for new mothers. white slip on green or yellow glaze, incribed and incised.

Everyone worked hard in such an economy, and not the least did women. At various seasons they undertook field work. Shoveling heavy, clay-like marl and spreading it to enrich the soil was essentially a woman's job. Women also helped in other so-called "light" field work such as harrowing, digging water channels, clearing the fields of stones and roots, pulling out stumps, and helping to dig peat for fuel.

Around the turn of the century H.F. Feilberg, an early ethnographer, described peasant living conditions. At one point he took note of the poorly sewn patches on the clothing of children. Suddenly he realized how hard women worked in the fields, for the patches revealed that their unpracticed, calloused hands fumbled badly when they were put to needlework. Yet women did perform housework. They cooked meals and cared for children in addition to brewing beer, churning butter, making cheese, dipping candles, carding, spinning and weaving wool, making bread, liming walls, caulking buildings and cleaning rooms.

Women contributed directly to the cash income of the family as well. Many peasant dwellings contained looms at which women and girls worked to produce textiles for sale as well as for family use. In other homes, women knitted stockings and sweaters. In still others, located in areas where clay was abundant, they made pottery for sale. Women often earned money by weaving textiles during the winter and firing pottery the rest of the year. Many turned to ceramics in the early spring when the pile of clay in the courtyard was no longer imprisoned by frost. The clay, which men dug and carted in the fall, formed a midden in the winter, which was covered with grass or turf to stay clean. Winter freezing helped break it down.

Women took over in the spring when clumps of clay were placed on a freshly swept floor, usually in the main living room of the house. Sprinkled with sand (which served as temper), it was kneaded by tromping with bare feet. Impurities detected with the toes were removed. Shaped into loaves, the prepared clay was stored under a damp cloth until needed, when it was given a final kneading with strong, tough hands.

To work, the potter sat on a chair or stood with a board on her lap. She began by pinching out the basic shape of the pot. (On the island of Funen, the process was somewhat different, the pot being built up of coils in clay on a rotating, but not spinning, wheel.) The shape was

hammered out by beating on the inside with stones of various sizes against the hand held on the outside. Feet and legs were pinched on. The surface was then smoothed and scraped before it was coated with a layer of fluid clay (similar to what is currently called "slip") which made it easier, subsequently, to burnish (polish).

After the pot had dried for about a day, part of the piece was polished, using a broken shard as burnisher. Usually, pots were only burnished on the rim and upper part of the body, but milk sieves, beer funnels, baking forms, and other utensils that had to be kept especially clean might be given more treatment. The ware was purely utilitarian. Burnishing was done mainly because it made the pot more useful, since it made the surface less porous and easier to clean.

On some pots additional areas were burnished for purely aesthetic reasons. Yet at best, decoration normally amounted to no more than a circle, cross, square, spiral or wavy line rubbed with a smooth stone on the otherwise dull surface. It was executed in a hasty, sloppy manner. Only rarely was a large plate or bowl intended for use in a peasant feast decorated extensively and with greater care. Sometimes, on the other hand, the aim of the design was magical rather than aesthetic. Just as peasants marked crosses on their bread or over the bed, they might also place a cross on the bottom of a pot to help keep food from spoiling or to make the contents more auspicious for consumers.

The rubbed-on decoration was primitive. In contrast, the shapes, dictated by custom, were well composed in a bold and attractive manner. They were rugged and somewhat irregular in appearance. At the time they merely seemed cheap for the most part. Now they are highly appreciated by collectors. At the time of manufacture they were not meant for display, but for use. Above all they served as kitchen ware: cooking and storage pots, jugs and pitchers, sieves and funnels, baking molds, coffee pots, and candle holders.

The pot was placed in the shade for several days until it became leather dry. It was then transferred to a semi-subterranean drying oven where, for three or four days, it was smoked. The temperature of 100° to 150° C. was low enough to allow the attendant to crawl inside several times a day to add peat to the fire, an unpleasantly hot and dirty task. The pots acquired a layer of smoke-borne tar, which turned them deep brown in color. They were then ready for firing.

The actual firing took place in an open pit where the pots were piled on top of one another and covered with turf or wood. The fire burned for five or six hours until the red-glow of the pots indicated that they were finished. The temperature probably did not rise above 700° to 800° C., except in a couple of parishes where deeper pits and harder-burning beech wood were used.

Centuries ago, the production of these pots was probably a common home craft throughout Jutland. Peasants had to be largely self-sufficient in everything they required. By the end of the eighteenth century, however, and into the mid-nineteenth, the potter's emphasis shifted to producing for sale and for market. Certain areas of the Jutland Peninsula and the island of Funen emerged as ceramic centers. The craft thrived above all in poor heath areas where it was difficult to live and where extra income was especially needed.

In 1881, the census revealed 516 families of potters located in 136 parishes of the peninsula, all concentrated in the three areas of Vorup, Fjends and Varde. We know, however, that Vendsyssel had been a center for black pots earlier in the century. In addition, potters were still active on Funen.

Each of these areas developed its own style of black pots. The styles did not remain completely separate, however. Good potters were much sought after as wives. When a young woman married into another community, she usually continued to produce in the style she had grown up with even though surrounded by women who produced in the local style. One village, therefore, might export pots in several styles.

As women increased their production in the eighteenth and nineteenth centuries, men expanded a subsidiary occupation as merchants. Often a man loaded his wagon with the products of his wife and daughters. Many men, however, established themselves as middlemen for a number of families. Typically based on a standing agreement with certain women to buy their pots for resale, middlemen carted wares as far as to the German-speaking market places of Danish Slesvig and Holstein. Some drove even father into northern Germany, where the pottery was known as *Jütsch Prozellän* (Jutlander porcelain). Some of these middlemen were the skippers of small coastal craft, which traded into harbors along the coasts and among the islands. The volume of trade grew large before it went into decline. It is estimated

that between 1840 and 1850 over 1,360,000 pots were produced each year in Jutland. Earlier in the century, the figure would have been even higher, since decline had already set in by mid-century.

Extinction. By the 1880s the number of potters had fallen to eighty in the country as a whole. Only about ten remained by the turn of the century. As late a 1910-1915 a few women were still producing black pots in and around Varde, but they were the last. When Denmark emerged from World War I, the black pottery tradition was dead. A victim of an industrializing economy it no longer was competitive. Factory-produced ceramic, iron and enamel wares were more durable and relatively cheap

Jutland potters made efforts to survive. New items were produced, including teapots, decorative flower pots, ash trays and vases. More attention was given to decoration. Wares were more carefully burnished. In order to produce a tougher product with a deeper, blacker finish, some turn-of-the-century potters learned to fire their goods underneath overturned iron cauldrons. These functioned as small muffle kilns that raised the temperature and assured a more completely reduced atmosphere to turn the pots a richer black.

A market for black ware as objects of beauty did not develop, however, until the craft was extinct and the pots available only as antiques. At the same time, even the new products seemed crude in comparison with factory-made ceramics which had more sheen, were more colorful, more complexly decorated, more precisely shaped and sturdier. Black pottery became technologically obsolete as well as aesthetically imitative.

The new technology of the kitchen required utensils of tougher material. Kitchenware required adaptation to the cast-iron stove that replaced the open-hearth fire. Only metal at that time was rugged enough to tolerate the higher temperatures that were produced. Wood in an enclosed chamber with a chimney flue burned much hotter than did peat bricks on an open hearth. Women adapted the shapes of black vessels to fit into fire holes on the stove surface. Some of the last of the black ware resembled contemporary cooking pots in form. It was not enough to change shapes and sell at low cost.

Toward the end, women who had shifted to iron pots and enamelware still clung to an earthenware pot for heating small amounts of cream. They were convinced that the flavor was enhanced by this

old method. The black-ware industry, however, was moribund. (In contrast, in Arizona, USA and Mexico contemporary black burnished pottery is made and sold today as expensive non-utilitarian art by a few distinguished potters.)

Ethnologists attached to the National Museum in Denmark were able to interview, observe, and photograph some of the last traditional potters. Photographs and notes along with museum collections and various archival and published resources kept knowledge of the craft more alive than is the case for prehistoric materials known only from archeological excavations. At present, as a hobby, a few individuals have revived the black pot art. Some are experimenting with new forms utilizing the old clay technique. We encountered one studio potter on the island of Bornholm who recently began to reproduce copies of the traditional black ware for commercial sale. It is interesting that this potter is male and the tradition of black pot making was kept among females. And, then, there is Grete Andersen, as previously mentioned, at the experimental center. With these exceptions, however, the tradition is extinct.

Glazed Pottery— Medieval Denmark

For thousands of years only unglazed, hand-shaped earthenware was manufactured in Denmark. It was, then, a break with an age-old tradition when a very different kind of technique appeared on the scene. The new method diffused from elsewhere in Europe in the decades just before and after A.D. 1200. It began around 1160, when the use of a lead glaze was introduced. All of the older ware was unglazed. A generation or two later, in the early decades of the 1200s, the potter's wheel appeared for the first time. With the wheel, the production of pottery became uniform and more efficient. The decoration of these medieval pots was characteristically simple, largely limited to incised or embossed designs and to variations in glaze color.

Changes in technique and product introduced a very different division of labor. The new potters were men, not women, and they were culturally part of the world of town-dwelling burghers (in contrast to women potters who were home bound). Young men were trained in formal apprenticeship to a master potter. The master was not normally a kinsman. Also in contrast to the village orientation of the women, the

training of men climaxed in foreign travel, a journeyman's tour known as "the waltz."

A potter "out waltzing" usually lived away for at least a year. Often it was much longer. As a new journeyman, still unmarried, he paid for his travels by taking employment in foreign centers. Temporarily settled in places quite distant from his native Denmark, he usually learned to speak German, the language of townsmen in much of Europe at that time. He also adopted the customs and mannerisms common to burghers throughout the continent. As a potter, he became acquainted with the skills of craftsmen in major urban centers.

Eventually the craftsman usually returned to Denmark to marry and settle down. On his return, each young journeyman brought back from his tour an up-to-date knowledge of pan-European uniformities both in style of living and in the technology of his craft. He then characteristically never travelled again, but in subsequent years other journeymen returned from their waltzing. The year-after-year travels of young craftsmen constituted a cultural process that ensured a high degree of consistency in burgher culture throughout Europe. The organizational basis of this process was the guild.

In the status ranking of town craftsmen, potters were low. Their craft was too humble to warrant the organization of its practitioners into guilds. They aped the customs of guild craftsmen without forming guilds themselves. Only once in the history of Denmark did potters of any area feel sufficiently strong and refined to surmount this tradition. In 1742 the potters of Odense, the home town of Hans Christian Andersen, formed the only potters' guild ever to exist in Denmark.

The number of potters in medieval Denmark was not large, and the amount of pottery they produced was not great. Ordinary Danes at that time apparently owned little material wealth. A household acquired very little pottery, whether it was the new red glazed ware or the old black unglazed.

Town Style Potters— Effects of the Renaissance

The half century before 1600 witnessed a dramatic change in this situation. The Renaissance ushered in a period of extraordinary prosperity. It was a time when new technology diffused among rich and poor alike, including glass windows, chimneyed fireplaces, new

styles of furniture, ceilings and new kind of glazed terracotta known in Denmark as Town Style.

The limited inventory characteristic of the Middle Ages effloresced into a new, more varied assortment of plates, cups, pitchers, jugs, pots and pans. The restrained decoration of earlier centuries was replaced by a free, imaginative style of painting made possible by a new polychrome palette. Lively, free-hand paintings of colorful, stylized flowers, birds and animals on objects rimmed by brightly colored line-and-ray borders betray an inspiration in part from southern Europe, and ultimately from as far away as Persia.

The designation as Town Style is appropriate. Most of these Renaissance potters undoubtedly resided among fellow burghers in new and growing merchant towns. The guild approach to craftsmanship, with its emphasis upon apprenticeship and the journeyman's tour, ensured that Danish potters remained substantially uniform throughout the nation in developing and perpetuating the Town Style.

Localization in a limited number of merchant towns reinforced the tendency to uniformity. A law of 1558 that made it illegal for most craftspeople to reside in the countryside applied to the makers of wheel-thrown pottery. It specifically exempted certain crafts, including blacksmiths and carpenters, but while it did not mention potters by name, perhaps because they were still few in number and humble in status, the regulation most probably applied to the producers of glazed ware, but not to the peasant women who shaped black pots.

As the number of potters increased during the 1600s, many moved illegally into the countryside, where they lived and worked as residents of peasant communities. This situation ended precipitously with a new law in 1683, which again forbad them to reside outside of designated merchant towns. Denmark in the early 1700s reverted, in this respect, to an earlier rule of residence which clearly distinguished two kinds of potters and two kinds of ware: (1) men in towns who produced kiln-fired, wheel-thrown, glazed, utilitarian goods that were reddish-brown in base color and commonly were richly decorated in polychrome designs, and (2) women in villages who produced pit-fired, hand-shaped, unglazed or not decorated at all.

Country Style of Sørring Challenged by Faience Factories.

As the eighteenth century progressed, the situation grew more complex. Town potters found themselves in competition with faience factories (after 1722) and porcelain factories (after 1775). Faience, at this time was low fired porous earthenware glazed with a lead based coating after firing. In the production process, an unglazed article is fired in a kiln and is then dipped in the tin (lead) glaze, which is allowed to dry. Designs are then painted on the glaze.

In addition, makers of glazed pottery moved again into the countryside to produce a third kind of earthenware, a yellow rather than red ware known as Country Style. In contrast to the uniformity that characterized town pottery, that of the countryside tended to vary from one center to another, often blending several styles together. No two areas were exactly alike. Variations ranged from the very small divergences of individual pieces to the large-scale differentiation of local sub-styles. Variation also occurred in any one area with the passage of time. Work might be rather crude at one period, but extraordinarily innovative and well-made at another.

Many of these new country potters were recruited from the peasantry. At that time, peasants often moved into towns and into urban occupations. When they did so, they became burghers in habits and personality. The cultural transformation of peasants into burghers did not take place, however, when the apprentice remained in the village. In such circumstances he continued to live among peasants and to share their way of life. For the most part, he even continued to keep fields and grow crops so that pottery-making in a sense was merely added on to traditional rural involvements. In this way the eighteenth and nineteenth centuries supported a new type of person who produced colorful glazed pottery, but was a peasant. A community of such peasant potters grew up in and around Sorring, a village located on the peninsula of Jutland.

Sørring Potters

The Danish Law of 1683 that confined red-ware potters to merchant towns was early circumvented in Sorring. There, the year 1700 found one Peder Pottenager (literally, Peter Potter) already settled and working at his craft. By 1740 approximately five potters were established in this

peasant area, including Anders Pedersen (literally Anders, the son of Peter Potter), who apprenticed to his father.

Two archival clues add to this indication that Sorring was a center for Country Style potters. One is the eighteenth-century list of fourteen potters who practiced their craft in Horsens, about forty kilometers distant from Sorring. Five of the fourteen were born in the Sorring area. A second clue concerns a court case that came up in 1779. At that time, a landless peasant from Dallerup Parish, where Sorring is located, was apprehended by the sheriff of Aebeltoft, a small market town about ninety kilometers distant. The peasant was there to sell Sorring red ware, and had his goods confiscated because it was still technically against the law for red-ware potters to reside and sell in the countryside. The peasant merchant, however, had sold in other markets and therefore felt his arrest was unfair. He appealed to a higher court. Ultimately his case went to the king, producing a Royal Resolution taking the position that it was true, according to the law, that only the makers of black pottery were entitled to live and sell outside the merchant towns. That position had been reaffirmed as recently as 1736. The royal response went on to point out, however, that it would create unfair hardship if red ware could only be sold in a few designated towns. It would make such products difficult and expensive to acquire. It was decided, therefore, that the merchant should have his confiscated wares returned and that he should be permitted to vend in markets as had been his habit. The law, which made it illegal for potters to live and work in rural areas, was not formally repealed until 1827. It is clear, however, that a substantial pottery center existed throughout the eighteenth-century in and around Sorring.

Throughout the eighteenth-century, the busy potters of Sorring numbered four or five families. The amount of pottery in use by Jutland peasants was not great. A few potting families met their needs. From the beginning of the next century, however, peasant demand for solid, glazed pottery increased and with it the number of potters. By 1837 there were fifty "Sorring potters"; thirty-six were located in and around the village while the rest were settled nearby. The number almost doubled in the next three decades. By 1870 the thirty-six alone had grown to seventy, not counting apprentices and dealers. By 1882 that number was seventy-five (Sten Møller, 1969, 87). So prominent had pottery-making become

that Sorring and the surrounding area became known throughout Denmark as "The Pot Area" (*potteegnen*). All wares produced in the area, including those not from the community of Sorring or the parish of Dallerup proper, were known as "Sorring Pottery" (Sorringlertøj).

Most of the potters did reside in Sorring proper, causing the village to appear pleasant and prosperous to other peasants since its houses and buildings were covered with red tile rather than straw. Tile seemed more colorful. It also reduced the danger of fire. The village took on a special appearance also because nearly every house had, adjacent to it, a whitewashed building that served as a workshop and kiln.

We can take a closer look at one of these workshops. In 1844 Rasmus Laursen Yde, the son of a Sorring potter, built a fine new kiln and building which a century later was dismantled by a team of European ethnologists to be reconstructed at the Open-air Museum (*Frilandsmuseet*) near Copenhagen. Through exploring that building, and the archives of the museum, we gain a vivid sense of what Rasmus Yde was like as a potter.

The Workshop

The potter himself dug clay for his work. Red clay was found in Sorring village, which inspired a local ordinance that made it illegal for potters to dig up the streets to obtain it. So-called blue clay was available from sites near the community. The two were mixed to produce a material that fired to a light reddish-yellow color. Fetched in the fall, it was stored outside through the winter so that freezing would make it more friable. In the spring it was brought indoors, although not until stones and other impurities had been removed and the rest churned in a pug mill rotated by human power, or by the carousel-movement of a horse. Stored in the coolest corner of the workshop or in a cellar, it was covered with damp sacks to keep it moist until needed.

Clumps of clay were further cleaned and kneaded when they were removed from the mound and brought to the workbench for turning. Pots and platters were formed on the wheel by shaping with the hands and smoothing with a scraper. Although most wares were thrown, animal-shaped savings banks were pressed in molds. For drying, the newly shaped pieces were placed on planks high in the room or, in the summer, out-of-doors in the sun.

Sorring produced a range of pottery similar to that of other parts of Denmark. It included figurines that portrayed dogs, birds, lions and fantasy shapes. It included plates, mugs, coffee-pots, funnels, small-mouthed jugs with embossed designs of a bearded man, and single-handled cups. Forms distinctive of the area were also produced, above all, a two-handled cup.

It was in decoration rather than form that Sorring displayed a talent for inventiveness. The style is that of other folk-pottery areas: green, brownish-red or yellow glazes over a light-colored slip, so that when a design is scratched on (*sgraffito*) it shows as a contrasting color. Decoration also included free-hand designs painted under a clear glaze and embossed medallions showing a human profile or leaves and flowers. The genre was found throughout Denmark. Sorring versions, characteristically direct and robust, were unusual in the amount of variation that was encouraged as each potter tried to outdo his neighbor. Particularly was this so in the creation of birthing pots, (dinner pails for women in confinement).

Birthing Pots Tradition

Throughout the Danish countryside it was an old tradition that friends and neighbors bring food to the family during those days after childbirth when the mother was lying in. From around 1840 it became stylish to bring the meal in a glazed terracotta pot with a loop handle. The original purpose got submerged in a visiting ritual in which each visitor vied with others to provide the most tasty and substantial meal. To demonstrate appreciation, the bed-ridden mother felt obliged to eat heartily in the presence of the donor and the other women present. It mattered little that she had just finished a previous meal; she had to do full justice to the next. She might well consume three, four or five dinners in a row if she and her circle were among the most affluent of the community, each eaten as her guests look on over coffee and cakes.

Central to this rite of amity was the pot, which Sorring craftsmen sought to make as attractive as possible. Spontaneity and imagination were encouraged as each potter tried to express himself as uniquely as he could. The result was a production of lying-in pots that were relatively uninhibited by that loyalty to tradition one usually finds among folk artisans. Sorring decoration, which earlier had been quite

undistinguished, in the second half of the nineteenth century included dramatic and innovative pieces, alongside of a substantial production of quite ordinary utilitarian ware.

Sorring Today

As the twentieth century progressed, peasant pottery making went into decline. Decades earlier than in Mexico, metal ware and factory produced faience crowded folk pottery out of the market for utilitarian containers. By the time plastics came onto the scene, the demise of traditional pottery was already accomplished.

In 1911 death took Ole Rasmussen, after which the kiln-workshop erected by his father Rasmus collected dust until it was acquired by the museum. By 1954 only four potters remained active in Sorring and by 1967 only one, Knud Jensen, born in 1906 and still at work as an aging man in the shop inherited from his father. We searched him out for one of the many surprises of this investigation.

Sorring is still just a country village, despite paved roads, electricity, television and other products of modernization. Finding Knud Jensen was easy. Everyone in the community knows him, as does nearly every trained potter in Denmark. He is as famous as the two-thousand-year-old Tellund man, and for the same reason. Each represents a type of person who has just barely survived to our time. We were told that Mr. Jensen was badly crippled by the effects of lead poisoning, the price that he and many before him paid for working with old-fashioned glazes. We found him spry and alert, however, busy practicing his violin at the piano in his living room, quite undaunted by his disease-crooked fingers. He is quite prosperous.

Collectors began to seek him out as the last Sorring potter. He found that he could sell all he could produce. To take advantage of his expanding sales appeal, he grew to five potter's wheels, two of them powered by electric motors. He doubled his firing capacity by installing two electric kilns. (The old wooden kiln now serves as a conversation piece.) As the only active potter in the whole Sorring area, he was contacted by schools from far afield. They needed clay to be used in educational programs. Therefore, a sideline in digging, preparing and shipping clay grew large enough to require the construction of a corrugated steel building and the acquisition of a motor-propelled

factory lift. Recently, on a sunny summer day, we took a picture of Knud Jensen. He was dwarfed against the background of his small factory with its mechanized equipment and staff of a dozen employees.

It now appears that his daughter and her husband will take over the old pottery shop. She will be the sixth generation in succession to possess it since it was founded by Jens Lauersen Yde. It is something of a tradition for anthropologists to reconstruct the genealogies of people they work with. We did so in this case and were rewarded in our effort when we discovered that Knud Jensen's great-grandfather, Jens Lauersen, was a first cousin of Rasmus Yde the man who built the workshop we visited in the open-air museum near Copenhagen. This workshop was a reconstruction of a typical Sorring Potter's space. Despite the fact that our research took us all over this small, yet complex modern nation, we seemed to have entered a network of ceramists that in some ways was as intimate as an old fashioned village. We had already received a similar surprise in the workshop itself in the Open-Air Museum near Copenhagen.

Sorring Pottery Preserved in the Open-Air Museum

During the summer months when weather is mild and people enjoy vacation freedom, the Open-Air Museum sponsors activities that recreate aspects of preindustrial life. On certain summer days, a miller starts up the watermill to turn giant millstones which otherwise might slumber forever; a weaver manipulates an otherwise obsolete loom; and about twice a month, a master potter is engaged to sit at the wheel of Rasmus Yde. We appeared one Sunday to see for ourselves how this workshop might have looked when it was active in Sorring more than a century in the past.

At a quiet moment in the day we began to chat with the man throwing pots. Since he did not object, we took extensive notes on the things he told us. Now about fifty years old, he had apprenticed in the traditional way, and once maintained a potter's shop in Copenhagen, but currently he was employed by the Royal Copenhagen Porcelain Factory. In the summer he did demonstration work for the museum as a way to earn extra money. "May we ask your name?" we inquired. "Ib Georg Jensen II", he responded. Now, since each of those names is quite common in Denmark, we did not in that moment assume that

he was related to the famous silversmith. More to be amusing than as a serious probing question, we responded by noting that we had heard of another craftsman with essentially the same name. "Yes," was the response, "he was my father." Edna and Bob looked at each other with astonishment and delight.

We then learned some details of the several marriages of Georg Jensen, of his last marriage to a woman very much younger than he, and of this son of his old age. When the master silversmith died, internecine maneuverings essentially disinherited his last wife and child. Young Ib grew up without the advantages of wealth and factory ownership. Just as one branch of the Hjorth family grew up without involvement in the famous ceramics factory. But, we digress. The point here is that the network of craft and industrial designers and artisans is remarkably personal for an institution of national dimensions, and this vitalized our reconstruction of old Sorring.

The tradition that gave Sorring fame is now dead, however, The current products of Knud Jensen's factory, for the most part formed in slip molds rather than by potter's hands on wheels, constitutes only a minute fraction of the amount exported from that area a century ago. A few potters in other parts of Denmark also still produce traditional glazed wares or facsimiles. One of the studio potters of Bornholm contributes her share. Such products may well continue indefinitely to be manufactured for sale in gift shops and tourist outlets. But the tradition as such is dead. It is circumscribed in scope, and where the painting and shaping was once alive, creative, and purposeful it now suffers from stylistic rigor mortis.

Demise of Town Potters — The Last of the Jutland Master Potters

The demise of town potters was even more complete. For many, World War I was a watershed. The case of the last master potter of the province of Sleavig is southern Jutland is characteristic. Nils Heinrich Rathenburg was born on the Street of Potters (*Töpferstrasse)* in Flensborg in 1870. Apprenticed to his father, his journeyman's waltz took him to Poland, Silesia, Bohemia, Italy and Bavaria before he returned home. He then settled fifty kilometers north in the south Danish town of Haderslev.

It was not at all unusual for a town craftsman to be German in language and origins. In preindustrial Denmark town culture was very different from that of peasants, which again was very different from that of aristocrats. The German duchies of Schlesvig and Holstein, including the town of Flensborg, were under the Danish crown until the war of 1864, just a few years before Nils Heinrich was born. The custom of the "potter's waltz" kept townspeople a part of a pan-European world of burghers in which men commonly spoke German as a trade language, much as aristocrats spoke French. The German origins of potter Rathenburg did not distinguish him significantly, then, from other town potters of his time.

By 1900, Rathenburg managed a flourishing business that kept six or seven journeymen at work alongside of the master. It employed Mrs. Rathenburg to manage a retail store on the premises, where she also kept house and raised a family. The firm supplied sixteen or seventeen merchandisers who drove wagon-loads of pottery to sell through the south Jutland countryside. Yet, when the Great War struck, Rathenburg's was already the last kiln in the area. In 1914 all but one of his journeymen were drafted. The master himself donned uniform in 1916, leaving no alternative but to close the shop. It became a permanent closing. When Rathenburg was demobilized, nearly fifty years old, he found that he faced harsh competition from factories. Ceramics seemed no longer to have any future for him. Southern Slesvig lost its last producer of hand-crafted earthen ware.

The Decline and Transformation of Naestved

Just as Sorring was the leading center for rural pottery in the nineteenth century, an earlier center was in Naestved, the leading center for town pottery between 1580 and 1610 when five master potters maintained shops in the community. Recent archaeological research has uncovered thousands of shards from this period, as well as the remains of workshops and two kilns. Throughout the 1600s Naestved remained a leading center. In 1699 a shop was established that especially interested us because it was sold in 1839 to Herman Joachim Kähler, aged thirty, a German-speaking immigrant from near Kiel in the Duchy of Holstein.

As mentioned in chapter four, the Kähler shop produced fine tile stoves and unremarkable but sturdy utilitarian ware, most of it sold

to farmers in the area. At the turn of the century approached, firms of this sort began to feel the pressure that led to the demise of the Rathenburg shop discussed earlier. Just north of Naestved in Holbaek, a rural town, such pressure resulted in 1878 in the withdrawal of Johan Christian Lund. This was a rather startling event, since he was the eighth Lund in succession to manage the family kiln. He became the last in a rather unusual manner. A journeyman, H. J. Kahler, came through the community one day to ask for employment. "No," responded Lund when asked for work, "but you can have the whole works, because I'm quitting." Since Lund had only inherited the shop the year before, the decision was unexpected. The startled journeyman answered by saying, "Thanks, but I'm broke." "As far as I'm concerned," retorted Lund in his crusty manner, "we can work it out. I'll help you with a firing or two to get you started." (Ehlers, 1967.251).

That was a generation when many potters went out of business. Unlike Johan Christian Lund, Herman A. Kähler, who joined his father in 1872, revolutionized the family business after his father died in 1884. Kähler thrived when others failed as we have seen. Where Rathenburg, Lund and many others found the competition of factories and new technology overwhelming, Herman A. Kähler responded by transforming the traditional shop he inherited into an enterprise modeled upon the factories that were creating the competition. Unwittingly, he adapted the Royal Copenhagen Paradigm to his family enterprise.

The urban and rural folk potters who survived did so by transforming their shops into factories. This was true of Knud Jensen in Sorring. It was true of Kähler in Naestved. It happened in a few other instances. Where firms survived, however, the production of traditional wares generally did not. The craft as such became extinct. It is perpetuated only in demonstrations and experiments at the Center for Experimental Archaeology and History in Lejre, in demonstrations in the relocated Sorring workshop in the Open-Air Museum near Copenhagen, and in other similar efforts of an antiquarian nature. A century ago, peasant pottery in Denmark was as alive and interesting as peasant pottery in Mexico is now. Can we see in Mexico any resemblances to Denmark? Will the ceramic arts of Mexico also become extinct or nearly so? Let us examine Tonalá with these questions in mind.

Chapter Eight
Changing Traditions—Mexican Folk Art

The art of progress is to preserve order amid change
and to preserve change amid order.
 —Alfred North Whitehead

In Mexico today one can identify about seventy-five major pottery centers as well as scores of lesser centers. Each traditionally produced simple utilitarian wares for the area it served. Further, in the words of Carlos Espejel, Director of the National Museum of Arts and Popular Industries, they were as a whole "distinguished only by their ordinariness." (Toneyama, 1974, 214). Tonalá is a major center, along with the neighboring communities of Tlaquepaque, El Rosario, Santa Clara and several others located near Guadalajara in the State of Jalisco.

The Potter's Way of Life in Tonalá.

Quality of life is largely shaped by work. The disadvantages of the potter's profession include hard work, low status and small income, but there are compensations. Work is integrated with family and community life so that people avoid that schism of the modern industrial world that alienates the working individual from daily involvement with family and friends. The potter is also less bound by the tyranny of calendar and clock, although this freedom is tempered by need. The potter works hard.

Up before dawn to moisten enough clay for the needs of the day, a good worker keeps going until dark. The day is broken, however, to attend mass, to eat, to rest, to run errands, or to visit. The eight to ten hours of actual work melt into a full day that offers a variety of rewards.

Women, even more than men, interrupt pottery making to take care of other life needs. Sweeping the house, preparing breakfast, and shopping, cooking, and caring for children all have priority in the pacing of a day. Children help when not in school.

The year, too, is humanized by activities that break up the potting routine. A rich cycle of fiestas is arranged by families celebrating baptism, confirmation, wedding, and funerals and by the community as a whole participating in holy days prescribed by the Church. Most potters grow crops and must abandon their kilns for days at a time in response to seasonal needs to plow, harvest or otherwise tend fields. The fact of agriculture in competition with ceramics makes them less efficient producers than if they pursued only one career. From another perspective, however, days and years of diversified activities reduce the redundancies of work and maximize social rewards.

The repetitiousness of work is reduced also by the practice of doing everything for oneself. Men with their sons and burros or pickup trucks quarry the clay they need, unless they join a growing number of those who buy it delivered to their homes. Newly dug clay spread out to dry on the street and sidewalk is partially broken up by people going by. Later, indoors, it is further refined by grinding under heavy stones. This arduous work is usually done by men.

Enough prepared clay is moistened each morning to meet the needs of the day. It is kneaded by hand to remove the last of its impurities and then is flattened into "tortillas" and spread over molds to produce the forms desired (Foster, 1967a, 108-115).

Shaped clay is placed in the sun to dry unless the piece is so large that it is better left to cure more slowly in the shade. To prepare it for painting it is coated with a slip, a liquid solution of clay that provides a base color, usually reddish brown but possibly white or one of the colors developed by Jorge Wilmot.

Most of the painters, but not all, are men. Fifteen years ago they sat on the floor or ground to work, but now it is common to sit on a low stool or chair, a shift encouraged, it appears, by the feeling that the old position was primitive and unbecoming for modern people. After painting, the pieces are either coated with glaze or burnished. In the latter case, using a piece of iron pyrite or some other tool, small sections of the pot are moistened and rubbed to produce a finish so shiny that it

almost looks glazed after firing. Women as well as men do the hard work of burnishing. Women also assist in loading the small, wood-burning kiln that is usually fired on Wednesdays and Saturdays. At times, men go off to get wood although frequently they purchase what they need from sellers who come to their doors. After cooling over night, the kiln is unloaded and the head of the house is ready to negotiate with dealers and storekeepers who arrive every Thursday and Sunday, the two market days of Tonalá.

New Designs and Patterns

As far back as memory goes, the potters of Tonalá earned their living by supplying a market for cheap cooking pots, griddles, water bottles, plates and cups. Through the 1920s, a decade of revolution, and the 1930s, a decade of economic depression, the market for utilitarian goods held up. The 1940s saw decline set in, however, first in competition with aluminum, steel and enamel ware, later as plastics came into use. Fortunately, the falling off of demand for utilitarian ware coincided in time with the growth of a tourist and export market. Families could continue to live from producing pottery even though the conditions of survival changed. Success came best to those who introduced new or better products, especially if they were better decorated.

Several now prosper by producing old decorated pottery in as careful and fine a way as possible. José Bernabe gained a reputation as a maker of beautifully painted *petatillo* ware. Pablo Jimón brought the white-on-red bandera style to high standards of excellence. He and José Palacio also paint fine burnished ware. Others, however, learned to mass-produce objects of inferior quality, making their profit on the large volume of their sales. These are the producers of objects poorly decorated and easily broken but cheaply made. Still others again produce new kinds of pottery or new products in other media.

Comparison with Tzintzuntzan

Located farther south in the state of Michoacan, Tzintzuntzan is perhaps the best studied community known to anthropology. George M. Foster has conducted research there almost continuously since 1944, and has documented innovations as they took place during the course

of more than three decades. At times he served as a participant himself in the innovative process.

Changes that influenced Tonalá affected Tzintzuntzan at about the same time. By the mid-1930s the paved highway constructed years earlier was bringing a steady traffic of Mexican and American tourists to the very edge of the settlement. One enterprising villager decided in 1955 to sit alongside the highway with an assortment of pots spread out on a blanket to sell. He did well and was soon joined by his younger brother. Within a few months a dozen or more rough, wooden stands had been erected to create a small roadside market place. Potters found themselves in daily contact with tourists and buyers. A growing sensitivity to tourist tastes and desires emerged (Foster, 1967b, 282).

Some responded to the tourist market earlier. A few of the boldest and most artistic began to make new forms such as fish decorated flower vases, tripod fruit bowls, and large red-burnished platters (Foster, 1967b, 282). This tendency grew with the growth of the roadside market. In 1957, Teófilo Zaldívar introduced black burnished ware using a technique he probably learned from a Oaxacan potter met on a marketing trip, since black ware is traditional to Coyotepec in that state. Within a year, four or five potters were making black burnished pottery.

Roadside sales were good enough to encourage several to import pottery from other communities for sale. Imports included green-glazed ware from Santa Fe and Patamban, which sold so well that Faustino Peña and two or three others decided that they ought to produce their own. They experimented with copper they were familiar with as the ingredient of a traditional black glaze and succeeded finally in duplicating the green, although without as brilliant a finish as the other communities achieve. Tzintzuntzin is now known for its green-glazed tableware.

Bernardo Zaldívar, aware that the new black-burnished products were selling well, attempted to increase his share of the market by developing a line of white-painted black-glazed pottery. His new variation did not succeed well on the roadside, but a representative of the Mexican Folk Art Museum of Mexico City thought well of it and bought some to sell in the Museum store. Zaldívar's white-on-black has done well in Mexico City since that time. (Foster, 1967b, 303-306).

The visitor to Tzintzuntzan today will find that the display of a few goods first laid out on the ground two decades ago has grown to a stretch of highway crowded with sales booths, stores and a new sales center elegantly constructed with large display windows, tile roofs and a mall. In addition to a wide assortment of pottery, sales places are festooned with ornamental tule-reed mats and figurines. The latter include Madonnas, crucifixes a meter or more in length, men and women represented as carrying fish, pots or other items and designed to cover liquor bottles, airplanes to hang as mobiles, nativity scenes for Christmas, and more.

Many Tzintzuntzeños manufacture reed objects now. Their productivity was seeded by the work of a single member of the community, Plácido Pablo. Foster and Gabriel Ospina, also an anthropologist, discovered in 1945 that Pablo could deviate from weaving utilitarian reed sleeping mats to manufacture ornamental mats and animal figurines. The anthropologists wanted to encourage a craft that they felt might bring additional income to the community. They gave orders to Pablo for ornamental work and helped him find sales to make his artistic efforts worth while. From that simple beginning, grew the distinctive art form that is now as diagnostic of Tzintzuntzan as is pottery (Foster, 1947b, 45-46).

Adaptation in Tonalá

The innovative pattern identifiable in Tzintzuntzan can be described in part as follows: given an active competitive market for decorative wares, some traditional artisans may be expected to innovate by borrowing, imitating, or adapting products within the capabilities of their customary technology. Most, of course, will be followers rather than leaders, but in any community such as Tzintzuntzan we would expect to find a few individuals as innovative as Teófilo Zaldívar, Faustino and Adolfo Peña, Bernardo Zaldívar and Placido Pablo. The pattern seems to apply to communities throughout Mexico. It appears to apply to the pottery producing community of Atzompa (Stolmaker, 1976, 204). It certainly applies to Tonalá.

Tonaltecans have been known to imitate the pottery of other communities. They produce pig-shaped banks like those of neighboring Santa Cruz and cinnamon-painted water jars (*cántaros*) that duplicate

those of nearby El Rosario. Vicente Silva and several others produce black burnished ware, which, like the black ware of Teófilo Zaldívar of Tzintzuntzan, is meant to reproduce the black polished finish of pottery made in Coyotepec. The Tonaltecan version was developed some twenty or more years ago by Jorge Saltillo, who evidently was never taught by any non-local potter how to get red ware to come out black. (In Coyotepec they bury the kiln-hot articles to produce a reduced oxygen environment.) The method developed by Saltillo is more primitive. At the end of firing he throws sawdust on the fire and covers it to make smoke. The pottery turns black from soot, which is subsequently rubbed in to provide a finish that often is brownish rather than black. Such a pot left in the rain turns white as the color washes out, unlike the black pots of Coyotepec and Tzintzuntzan or the old ones of Jutland, Denmark.

For the most part, the artisans of Tonalá copy and reproduce wares designed by non-peasants. We have already had occasion to describe the extent to which the figurines of Jorge Wilmot and Ken Edwards have been reproduced. Wilmot's paintings and those of Sergio Bustamante have also been widely copied. Traditional Tonaltecan flora or fauna against a background of bright red, green, blue or another vivid color are the simplest and most common form these paintings take, but some feature animals in a Bustamante manner while a few show cats on rooftops clearly imitative of Wilmot.

Non-Ceramic Arts with Folk Motifs

Papier-mâché. When Sergio Bustamante developed his technique of papier-mâché sculpture he created a new product for peasant manufacture as well. As we have seen, some of his designs were "imitated" even before his own originals could get on the market. Imitators, however, fall short in quality. It is not that they lack skill. Except for certain detail work, Bustamante's own productions are constructed and painted by local artisans. The failure is that they attempt to produce too many in too short a time. The worst pieces are carelessly made and inadequately painted. Inspired by works of art, they end up as travesties of art. Even reproductions done at Sermel after Bustamante left the organization are tainted. Generally well molded, the painting is less complex and lacks the fine detailing that Bustamante would have done or insisted upon.

Carved Wooden Retablos. One of the most copied artists in Tonalá is Dolores Chiappone, an American who arrived in Tonalá around 1963, about the time that El Palomar was established. She came to Mexico planning to design and produce clothes, but the cloth she expected to work with was confiscated by customs authorities at the border. Her plans unexpectedly aborted, she arrived in Tlaquepaque to find that she could earn money with skills she learned from her father, a furniture maker. She antiqued merry-go-round animals for a tourist store. Eventually she taught Jorge Wilmot her method of antiquing, which was much easier than the one he had been using on his paintings. In that way she, too, contributed to the local art of painting in acrylic on masonite as now practiced by local artisans. Beyond that, however, she introduced a quite different kind of painting: the low-relief carved and painted wooden plaque *(retablo)*. She was the first to produce the now widely sold pictures of brightly painted flowers, butterflies and birds raised over antiqued work.

The idea of retablos grew out of a holiday in Puerto Vallarta that brought her to a man who did low-relief carving and willingly taught her the technique. When she returned to Tlaquepaque she adapted the art motifs of Tonalá and her own method of antiquing to the technique she was taught in Puerto Vallarta to produce a new competitive item in the market for crafted art.

Her mode of production was that of other designers: setting up shop in Tonalá, she trained local people who did the actual work under her supervision. Painting skill did not seem necessary, since bold primary colors were used with little detailing. Flowers and other parts were colored in a way that resembled "filling in the spaces." She did not need skilled local painters. Nor did she need to apply her own skills as an accomplished painter in oils. Rather, she hired untrained young women who were paid low wages to paint. She trained the man hired to carve since wood carving is not indigenous to the area.

Unskilled personnel required constant supervision or disaster could ensue. For example, at one time Chiappone set up production on a large order destined for Pier One, a chain of retail stores in the United States. With everything set to go in what was to be a routine operation, she departed for a three-day rest in Puerto Vallarta. On returning, she found that the execution of the retablos had been radically changed

both in design elements and in composition. She was horrified. The results were degenerate. "Why?" she queried in shock and disbelief. "It was easier, and we don't like your designs," was the ingenuous response. It was, she learned later, to be a familiar problem. Her sense of quality was frequently challenged by employees motivated to work faster in order to earn more money in that day or week, unthinking of the effect of poor work on future orders.

Tired by 1966 of the repetitiveness of problems and designs, Chiappone sold the business to Jackie Edwards, the wife of Ken. She took a week to teach Ms. Edwards and a helper to carve and antique. The new owner decided to upgrade the product by hiring qualified painters. Ms. Edwards began with Pepe, who had just started at El Palomar as an apprentice. She persuaded him to leave the factory to paint and supervise for her. Pepe immediately brought in his younger brother, Jorge, and then asked if he could hire his father, an established Tonaltecan painter. 'How can you hire your father?" Edwards asked with good reason. It would normally be unthinkable for a man to work for his son in that manner. The answer was that it would be acceptable. Rosario, the father, could no longer paint pottery because he had problems with his eyes. He would be happy to do simpler work.

Jackie Edwards and Rosario eventually became partners. The medical problem improved, and with glasses he could see again. This allowed him to take charge of supervising all painting. When the head carver quit, he took charge of carving as well. At that point, Edwards and Rosario agreed to split responsibilities on a partnership basis. He was to have charge of production, and she, of sales. Sales declined badly, however. Rather than struggle along, Edwards withdrew, making a gift of the business to her partner.

Rosario has not done well alone. He needs more help, but is afraid to hire because, as Wilmot put it, employing people is like adopting adults. So he limps on with some assistance from his family. Unable to produce enough to support himself well, he recently began to paint part-time for Ken. Meanwhile, others have gotten into the retablo business. They keep the market well supplied with carved-wood paintings that show every sign of remaining a craft that will be identified with the peasant artisans of Tonalá.

Cut tin, painted in
brilliant colors. A
design by Dolores
Chiappones, Tonala,
1975.

Chiappones, now in Carmel,
California, taught villagers
how to carve and paint
retablos for mass marketing to
Pier One, Cost Plus and big
hotel chains.

This wooden piece is painted
in bright colors, red, orange,
yellow, green..... very attrac-
tive and lively for commercial
space.

Painted Tin. Chiappone was able to abandon the production of retablos because a year of two earlier she created a new craft to take its place. Inspired by Italian painted iron work and thoughtful of potentialities of working in tin as done in Tasco (in the State of Guerrera), she designed candelabras, figurines, baskets, boxes and other objects to be cut of tin and painted in pastel colors. The results look Italian rather than Mexican, above all since she used solid painted surfaces in contrast to the practice in Tasco of working in unpainted tin or on painting in shiny, transparent colors. The shapes are equally different.

Chiappone's tin work sold very well. When she left Mexico in 1969 she left a flourishing industry that continues to the present. The finest of current work is sold in retail stores in Guadalajara, Tlaquepaque and Tonalá, including the stores of El Palomar and Sermel. Returning to Tonalá in 1976, where she rented an apartment in the home of Jorge Wilmot, she did not return to either tinwork or retablos. Rather, she was, with Wilmot's encouragement, attempting to paint faster. Her canvases sell well, but because it took her about a year to finish a single work, she could not live by painting. Meanwhile, she commuted to a small office in Tlaquepaque each day to work on designs for Artisan Imports Company, a Texas company that plans to produce furniture to sell at moderate prices in American import stores such a Pier One and Cost Plus.

Planning to take advantage of relatively cheap skills labor and excellent woods, the Texans want Chiappone to design furniture that will have a hand-crafted, rustic, Mexican appearance. They expect the factory to be large, and hope to produce furniture of good quality. They are constructing a large wood drying kiln. The wood must not split from imperfect aging. It seems that another category of local craft is about to emerge. Dolores Chiappone, however, will watch it from a distance. As this is written she lives in Carmel, California, where her paintings can be purchased in a local gallery.

Wrought Iron. The creations of local designers are not inevitably emulated. This is evident in the case of an American couple who settled in Tonalá around 1970. Driving into Tonalá today one finds at the edge of the community a walled establishment displaying a sign that reads

in English "Rowe Originals." It is the home, store, and workshop of Joe Rowe and his wife Sylvia.

It is hard to know what to expect when you enter private property in Tonalá. To the street, all but a couple of ultra-modern homes reveal little more than a wall and a door. Behind the walls you may find squalor. This is true of certain natives of Tonalá. It is true of Ken and Jackie Edwards, who seem indifferent to the absence of toilet and shower and whose kitchen appears never to have known the touch of a mop to remove the grease of food scraps thrown to a pack of dogs more loved than cared for.

Behind other walls, on the contrary, you may find simple elegance, as in the case of José Palacio. Although his kiln at one end and his kitchen at the other are no more than twenty meters apart, they edge a shaded patio of polished tile graced by potted ferns and song birds in large cages. A Tonaltecan home can be as lovely as that, and no surprise to those who know the community.

It is a surprise, however, to breach the high blank walls that surround the home, store and museum of Jorge Wilmot. From a bright sun and dusty lane one enters a labyrinth of curved stairways, small ponds of floating leaves and Chinese fish, odd-shaped rooms featuring furniture designed by the owner and a garden between the living room and the main bedroom that points tall plants and stones toward a high, hidden skylight that softly illuminates a larger-than-life-sized stone hand of Buddha that once was at home in a temple garden of Southeast Asia.

Behind the walls of "Rowe's Originals", one is equally hard put to remember that the location is a peasant community. Sylvia as an ex-WAC and Joe as an ex-soldier came to Mexico after World War II to study, benefitting from the G.I. Bill of Rights. They met at the Art Institute of San Miguel. Sylvia painted in oils under the name of Laks. Joe was trained in commercial art at the Museum of Industrial Art in Philadelphia and proved to be skilled in using his hands and in organizing the mass production of items ranging from wire and metal mariachi figurines for sale in Tlaquepaque to decorative painting to fill the rooms of three new Holiday Inn hotels under construction at that time in Mexico.

For over a quarter of a century, the Rowes have lived in Mexico. In that time Joe Rowe has created a variety of metal and other art objects

that earn enough to live on and to be able to save a little toward the day when they would build a home of their own.

The commission by the Holiday Inn Company was a turning point. The Rowe's hired the children of Tonalá to paint for them, taking some as young as eight years of age. Skill was not required. Work was organized by having some children trace the outlines of the painting using stencils while others painted by filling in colors. Drawing upon his training in commercial art, Joe Rowe devised every possible way to speed up the work of unskilled, infantile hands. The product was liked. An order for additional paintings soon came their way. In six months they produced a total of 1500 paintings that cost three dollars each to produce and sold for eight. The profit was a windfall in a lifetime of just getting by. After years of saving and planning, they bought land and began building. Tonalá was chosen because it is a good place to display and sell to wholesale dealers and urban clients.

The gates of the Rowe establishment open to a grassy garden featuring life-sized mariachi musicians and horse-riding caballeros constructed of welded iron. A brass reptilian sculpture climbs the wall of what on entering proves to be a sales room suffused by the light of concealed windows broken by angled walls and cool tile floors. The Rowes often invite visiting Americans to have a cup of coffee in the garden behind the store. There a grassy plain centers on a small pond and tall sculptured pylon. In the distant corner one spies a swimming pool in the shade of large trees. The dwelling, located toward the rear of the garden, features tile floors and walls, hand-wrought iron balustrades and large windows as well as a built-in stove, refrigerator and oven. This, too, is now part of Tonalá.

A dream has come true for the Rowes as they approach their sixties, but they must struggle to keep the dream alive. They are caught, as are others, in the dilemma of paying high wages to people they cannot dismiss. For this reason, Mr. Rowe is developing new projects to keep his staff of five busy. Most of his products are made of metal. He is not trained in ceramics. He constructed a small tunnel kiln, however, to make the tiles that generously cover his floors and walls. Now he is constructing a small high-temperature bell kiln as he plans to design new creations in stoneware based upon an expertise he plans to acquire in the use of the potter's wheel.

The yard and show-
room of Joe and Sylvia
Rowe in Tonalá,
Mexico 1975.

Joe worked with
metal, glass, wire,
wood, some painting,
but not with ceramics.

Sylvia was a painter,
first of all.

Sylvia and Joe
Rowe (below)

(authors' photos)

176

Joe Rowe is undeniably gifted in working with metal, and particularly in producing with efficiency. He resides in the community and is recognized as a person of high status. He is a productive designer who has developed items over the years for sale in the tourist-decorator market. Yet he has had no measurable influence upon Tonalá and very little upon Tlaquepaque. Why?

A partial answer is that he lives on the edge of the community socially as well as geographically. The four men and women who work for him were first employed years ago when the Rowes lived in Tlaquepaque. Joe Rowe has never worked closely with a Tonaltecan whose exposure to his products, then, is limited to seeing them and talking with workers. It does not include experience in the manufacturing process.

The more fundamental explanation, however, is that Rowe Originals require technical expertise beyond that of all but a couple of local people. The average Tonaltecan artisan does not know how to work with metal. Where that technical expertise exists, imitation becomes a possibility.

That possibility can be demonstrated, although not in Tonalá itself. A couple of Tonaltecan artisans work in welded and wrought iron, including the business, *Fabrica de Figura en Chatarra,* located at the entrance to the main street not far from the Rowes. The Fabrica de Figura has the capacity to copy some of Rowe's metal figurines, but does not so do. At present, they are producing antiqued metal airplanes, automobiles, trucks and buses imitative of old Euro-American toys but meant to serve as conversation pieces. In Tlaquepaque the situation is different. At least twice, the creations of Joe Rowe have been plagiarized.

Artisans in Tlaquepaque for years have produced imitation Spanish antique lamps constructed of sheet metal and colored glass. The metal is shaped to form a post or hanging lamp with holes cut out to emit light. Glass blowers, long established in the community, then blow colored glass inside the sturdy metal frame so that the holes are filled with glass that bulges beyond the exterior surface of the metal. The result is a lamp that is largely opaque, since a sturdy frame is needed to serve as a mold for the glass-blowing process.

Around 1968, Rowe built a frame of welded wire that would shift the surface area almost entirely to glass rather than metal. The technique could be used to produce decorative forms as well as lamps. Rowe's

original design was that of a bird with a body of wire and glass. He brought the frame of his bird to one glass-blowing factory after another, only to be told by six in turn that they could not blow glass in it since the frame was obviously not strong enough. His pleas to the contrary were not believed until finally he found a small place where the owner was willing to experiment with the understanding that he would be paid even if the lamp frame broke in the process. The results were excellent, because the welded frame was in fact, quite sturdy. Rowe continues to produce a small number of glass and metal birds since that successful experiment in the small shop. Over the years, however, other glass-blowers have seen the advantages of Rowe's design and now produce their own versions of his lamps. The technical expertise was there. They needed only to see that a better and more marketable lamp could be made.

Joe Rowe's other contribution to the local inventory of art took shape after they moved to Tonalá. He thought he might create table-sized figures of mariachi musicians constructed of brass and copper. Mariachis in one form or another have always sold well on the tourist market. They are produced in local styles in various parts of Mexico. Glass blowers in Tlaquepaque make them of colored glass (see Price, 1973, 84). Certain potters make them of terracotta. Rowe felt that the market would be receptive to foot-high mariachis in metal. To compete, he needed to keep the cost of production down.

The idea for mariachis was in the back of his mind one day when he came across a broken plastic doll lying in a street. "There is my mariachi," he grunted to Sylvia and they raced back to his workshop. The technique he hit upon was to mold the figure in clay, bake it, and then cover it with annealed sheet copper that was braised to create a brass finish. Production costs were kept down by using the same shape of doll for each piece. (later he adapted the technique to animals as well.) The different body poses of the mariachi band were achieved by breaking the ceramic arms and legs at the joints after the metal was applied so that they could be bent into different positions of movement before final stiffening with the braising torch.

Quite satisfied with his invention, and hopeful that he could ward off imitators, Rowe took out a patent on his process. It had no discernable effect. A craftsman in Tlaquepaque lured away one of Rowe's workers

whom he got to produce copies. Rowe feels that they are not as good as his own. The other shop did not give attention to bending the limbs properly, resulting in pieces that are stiff and unvaried compared with those of Rowe. They sold for less, however, and largely forced Rowe out of the market he had created. The crowning insult came one afternoon from a retail customer who returned all the way to Tonalá to demand and get his money back on the argument that he could get the same thing in Tlaquepaque for ten dollars less. Rowe refunded his money.

The influence of Rowe's designs then can be seen to some extent in the area. So long as his designs require technological skills beyond those of local artisans, however, his impact on local arts and crafts will be limited.

From Imitation to Instruction.

In all, the artisans of Tonalá have reacted with considerable vigor to changes in market conditions. Their responsiveness has kept them in business. They have succeeded largely on their own, but they also have been helped by outsiders. Not merely have outsiders provided pre-cuts for plagiarism, they have also provided instruction, sales facilities and encouragement. The experience of the Mexican folk artist in this way is different from that of Danish craftspeople early in the century. To this extent, the future prospects of survival as folk artists could differ for Mexicans. We need, then to examine this divergent aspect of the Mexican situation.

Chapter Nine
Planned Development or Good Intentions— Mexican Folk Art

Art, as far as it is able, follows nature, as a pupil imitates his master;
thus your art must be, as it were, God's grandchild.
—Dante Alighieri, *Inferno*

Life belongs to the living,
and he who lives must be prepared for changes.
—Johann Wolfgang von Goethe

Helping Potters Succeed

We live in a time when many individuals and governments are concerned about the future well-being of peasants. The word peasant is not used here as derogatory or condescending, although the term will soon be among politically incorrect words. It applies here to those who live and labor primarily on rural land, holding to traditions and ways of life that are linked to pre-industrial livelihoods, including utilitarian arts and crafts. Although most often poor in income and struggling for survival of their lifestyle, they have strong family and communal ties and pride in local life. Many contemporary social scientists feel strongly that the world will be poorer if certain peasant virtues and arts are allowed to become extinct. Others focus more directly upon economic threats and seek ways to integrate an older technology.

Concerns about the fate of so-called peasants is now an issue of public policy and public aid programs. In support of the preindustrial ceramic arts of Tonalá, three agencies of government in particular are given the responsibility to encourage and direct adaptation: the Regional Museum of Ceramics in Tlaquepaque, the Institute of Jaliscan

Arts and Crafts at two locations in Guadalajara, and UNESCO with its local affiliates.

The Museum. Along the main commercial street of Tlaquepaque, across from two big glass-blowing firms and neighbor to other stores, the museum does a small but steady business in pottery of the region. Unlike certain tourist stores and market vendors where customer demand sets standards, which often fall to remarkable depths, the museum sells only the finest of local products. In principle, it encourages high standards among local artisans in this way. In practice, it does help to maintain good quality, but only tangentially. This is because the museum does not regularly solicit the best work of every producer. Instead, it buys the best of what is produced by a few recognized lenders. The *petatillo* it sells is made by José Bernabe. Burnished ware is by José Palacio and one or two others. Bandera ware is by Pablo Jimón. These few men are indeed reinforced in their aim to produce fine wares, although none is heavily dependent upon the museum. Other potters remain untouched by museum standards of excellence.

In the effort to encourage local potters to appreciate their own ceramic traditions and to educate others on the high interest of this tradition, the museum displays pottery of earlier times as well as that of today. Its function for history is weakened, however, by inadequacies, some of which are beyond its control. The collection is historically shallow, for example, because the museum was not established until 1954. It is difficult under the circumstances to expand it holdings from earlier times.

More under its control, however, is a limitation on the type of wares displayed. Since its objectives are artistic and commercial rather than strictly historical, utilitarian wares are neglected, in spite of the fact that simple kitchen and household objects provided the foundation of the whole industry until recent times. Finally, for unaccountable reasons, the collection is shown without documentation. Visitors must rely upon the accuracy of the memory of an elusive curator and a kindly caretaker if they want to understand what they are seeing.

Jose Bernabe, Tonalá -- earlier (1977) and later (2000)
Below: his workshop with his sons as painters.

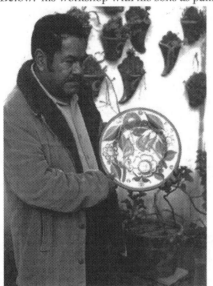
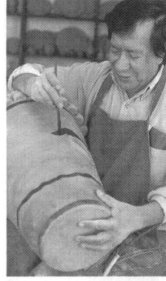

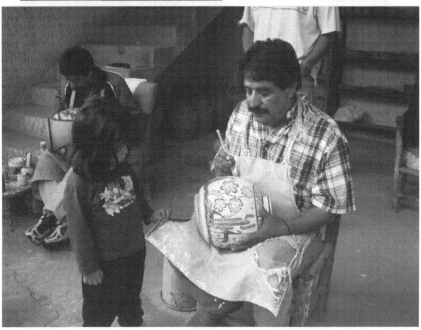

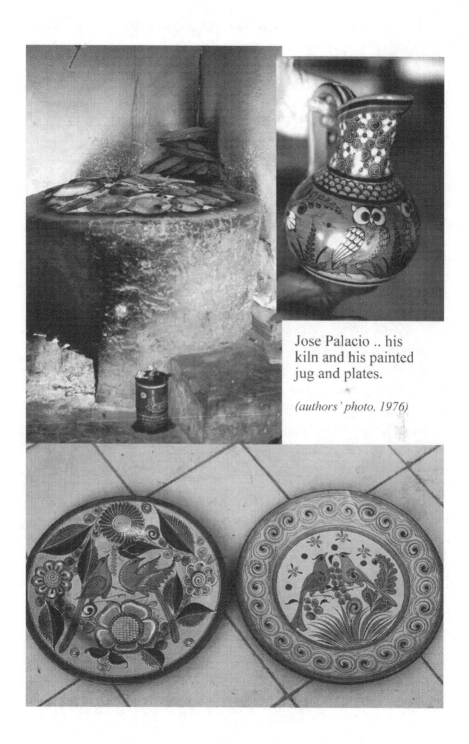

Jose Palacio .. his
kiln and his painted
jug and plates.

(authors' photo, 1976)

In addition to creating and maintaining high standards of excellence, the museum is supposed to encourage innovation. Through a sales room and through the imprimatur of museum acceptance, an attempt is made to encourage new ideas that build upon traditional crafts. Stoneware and faience products are not included, however, since these are recent in the area and do not grow out of peasant technology. Terracotta figurines, on the other hand, are prominently displayed and sold. They have roots in the local tradition and are made by local potters. The fact that they are designed by Jorge Wilmot and Ken Edwards, internationally trained, is conveniently ignored. In innovation, as in maintaining standards of quality, the museum encourages but does not shape. Fine ceramics have ample markets outside of the museum.

The museum is ineffective in providing support and encouragement for new creations in pottery. Tonaltecan potters are quite remote from museum personnel, not only in geographical distance (the museum is located in Tlaquepaque), but more significantly in social and cultural distance. Potters neither trust nor understand the motives of museum consultants. They find it difficult to believe that a sophisticated, educated urbanite on the museum staff can tell them anything of use for improving work they do with their hands. They find it easy to believe that the real intent is to defraud. "It would take a genius at diplomacy to convince the potters to abandon traditional ways of working," notes Dr. Diaz, "and it would take a genius in the triple fields of art, psychology and anthropology to accomplish the museum's stated aims. . . . " (Diaz, 1966, 179.)

The Institute of Jalisco Arts and Crafts. The Institute has been no more successful than the museum in providing help for the potters of Tonalá. As at the museum, the people employed by the Institute are distant from those who work with their hands. No peasant or Indian sits on the board of directors. The manager is a university-trained architect. Office and sales personnel in jackets and ties relate better to a middle-class world than to a peasantry. Distance from local artisans is dramatized by the procedure for payment. The artisan must wait until Friday to be paid, and then is expected to sit patiently in a waiting room until the mysterious comings and goings of clerks eventually produce

a check. It is apparently assumed that a peasant's time is without value and that a peasant's feelings are not easily offended.

The Institute, like the museum, displays and sells current wares of high quality. The Institute is more purely commercial, however, since it maintains large, attractive sales areas in which everything on display is for sale, with the exception of a small arrangement of utilitarian pottery shown solely for its historical interest. The visitor on entering is struck by the attractiveness and size of the building and by the variety and quality of what appears to be traditional hand-crafted wares. As our research proceeded, a kind of detective work on the origins of products began to change this initial impression. By the time we were finished we could identify a major part of the inventory as essentially the creation of modern designers. Whole sections are filled with mass-produced, imitative faience wares from the Gomez and CAT factories. Other areas are taken up with the stoneware by Jorge Wilmot, Ken Edwards and the El Palomar factory. Again, wooden retablos and tin-ware originating with Dolores Chiappone are on display.

The Institute finds itself in a double bind as concerns its policy for supporting arts and crafts. It is supposed to display and encourage traditional arts while in fact it includes a large inventory of objects that are the products of modern design and that draw upon peasant tradition largely by exploiting artisans as cheap labor. It is supposed to encourage innovation, but much that is exciting in modern design is excluded as not sufficiently rooted in tradition. It sells nothing made by Sergio Bustamante, even though he relies as much as do Wilmot, Edwards or Chiappone on local labor, including Tonaltecan painters. In short, it strongly supports neither traditional arts and crafts as such nor modern design in all of its potential growth. It does provide an important volume of sales for certain artisans and factories.

If the Institute falters in providing leadership in design, it fails almost completely in training artists and designers. During the early 1970s the Institute maintained nine schools in the countryside as well as others in the city to give instruction in arts and crafts. Today all are moribund or extinct. They did not reach traditional artisans, who continued to learn by apprenticeship, mostly within the family. They have reached some urban young people and women to teach such crafts as the making of paper flowers, weaving, leather crafts, wood and silver

work as well as ceramics and glass. Few graduates found employment as craftspeople. It was hoped, for example, that El Palomar would hire some. But El Palomar hires through patron-client ties with families in Tonalá, not through the Institute. The main school in the headquarters of the Institute now functions primarily to teach crafts as a hobby to members of the middle-class and to foreigners.

UNESCO. The United Nations organization has sent professional experts to Tonalá to teach potters how to adapt and improve their products. One was a French professor who visited local families wearing a black suit and a tie and carrying a briefcase. The other was a Czech who is remembered as having fought with everybody. Neither spoke Spanish well. Both left without exercising any discernable influence on local potters.

Development in Tzintzuntzan

To provide some perspective, it may be pointed out that more intensive efforts at community development were attempted in Tzintzuntzan in the northern part of the state of Michoacán, not far from Lake Pátzcuaro. Outside experts worked with potters to teach them how to build improved kilns, to use new glazes and to produce new pottery forms. Other experts attempted to help villagers establish weaving, furniture-making, and embroidery as local crafts. Their only success was in embroidery, and that was attributable to a strong-minded capable local woman who already embroidered, but developed her hobby into a small business in an effort to help the development program succeed. The experts in this community were Mexicans who had no difficulty speaking Spanish. They entered with ideas and strategies. Nevertheless, they failed.

The failure of the community development effort in Tzintzuntzan is all the more striking because the headquarters for the national effort was located in Pátzcuaro only a few miles away, and Tzintzuntzan was targeted as a pilot study in which national leaders had a strong interest and desire to succeed.

Failure took place for a number of reasons, but basically it seems to have occurred because of an inability to establish and maintain communication between outsiders and villagers. Agents of change did

not sufficiently understand peasant attitudes and values. They assumed, for example, that potters took easily to cooperative endeavors when in fact they do not. They assumed that peasants understood financial arrangements when in fact they did not. The agents of change also failed to work closely enough with villagers to assure that their teaching was effective and supervision adequate. Techniques imperfectly mastered and inadequately encouraged failed to catch on. Efforts to develop cooperative enterprises proved particularly disastrous (Foster, 1967b, 327-347).

Ken Edwards in Tonalá—Creating Independence—Skirting Disaster

Efforts to teach potters to profit from modern market potentialities have failed. It requires remarkable individuals to mediate between Tonaltecans and others like them on the one hand and the entrepreneurs of modern commerce on the other. Such an individual must be unusually gifted, perhaps even a genius. Is Ken Edwards the genius of Tonalá?

Currently in Tonalá and nearby Tlaquepaque three artisans produce excellent stoneware in their own high-temperature kilns. José Bernabe fired his new kiln for the first time while we were in the area. Even before getting his own kiln, however, he made some pieces in collaboration with Ken. Magdaleno Ramirez, who has painted for El Palomar for years, now owns a kiln and employs members of his family to produce the designs of Ken. Finally, Carlos Villanueva owns a kiln and makes stoneware. In addition to these three who possess kilns of their own, several other protégés of Ken and Jackie Edwards produce Ken's designs by firing them in Ken's kiln.

In his study of Tzintzuntzan, George Foster pointed out that anthropologists err if they look for barriers to technological change only in the community under investigation. He proposed that agents of change, inserted into the community, might encounter barriers of their own creation, which they fail to identify or surmount. Some hindrances may surely lie there. We have seen instances in which the potters of Tonalá failed to surmount technological, cultural and psychological barriers. But it is equally clear that those who have attempted to give impetus and direction to the changing of craft skills have for their own part failed at times to approach the task effectively. Now we learn

that Ken succeeded where others have failed. Ken succeeded, it would appear, because without having heard of the work of anthropologists, he did many of the things that George Foster recommended on the basis of research in Tzintzuntzan. What were Foster's recommendations?

The first is that outsiders must realize that peasant artisans are extremely sensitive "to real and imagined slights and insults, a sensitivity which comes from generations of unhappy dealings with city people" (Foster, 1967b, 346). The first task, in other words, is to win trust. This Ken did by demonstrating for almost two decades that he respects villagers and is honest with them. He brought employment to a substantial number of individuals through El Palomar as well as in his own private enterprises. His position as a powerful person is anomalous, however. On the one hand he is seen as influential and knowledgeable; on the other hand, he is slovenly and chronically short of funds, which is quite out of keeping with what Tonaltecans expect of a person of high status. It is hard to say how peasants react to Ken's style of living, but this much is clear: they do not see hidden insults or lack of respect. On this count, Ken does extraordinarily well.

The second is that it is essential to be aware of how peasants relate to one another. It can be a mistake to assume ". . . that peasant villagers are, or would be, highly cooperative if only given the chance. . . " (Foster, 1967b, 344). Ken knows that Tonaltecans have never succeeded in making a cooperative work. He is involved in a current attempt to establish a viable cooperative to sell supplies to potters. The new co-op has potential value since it makes available in a single shop all of the supplies potters need to ply their craft, thus saving them the frustrations and wasted energy of seeking out different independent dealers for each of the items they must have. Ken attends the regular Monday evening meetings and speaks forcefully concerning policies and decisions under debate.

The co-op, however, seems to be going the way of all co-ops in a community such as Tonalá. Very little continuing outside support is given. Originally established with a small grant from the Institute, it is expected to continue on a self-supporting basis. The bookkeeping system was set up by students from the University of Guadalajara who took on the task as a way of satisfying a governmental requirement to do social service. Ken provides encouragement and ideas out of his

training and experience. Yet the burden remains essentially that of local potters who have not carried it far. Most potters will not pay to become members. Ken encouraged one man to join whom he knows well. The man refused. When asked why, he answered, "Some are richer than I and will look down on me. They will take advantage of me." Ken responded, "But we are all in the same boat now." "No," came the unequivocal response.

Ken is well aware that villagers harbor no hidden tendencies to establish cooperatives. On the basis of experience in the community, however, he evolved his own plan which he feels can be made to work. For several years he discussed his hope to sponsor what he referred to as a "cottage industry" organization to produce stoneware. He would train local potters. In addition to initial instruction and supervision, Ken would provide designs, molds, models, technical aid, and a kiln. He would also sell what was produced. Members would be allowed to make and paint whatever they wished. They could work in their homes where they are accustomed to work, or elsewhere if they preferred. They could even do their own selling or a part of it. In every phase of the process they could remain as independent as they were able or would want. Ken, for his part, would receive a commission for "technical assistance" plus an additional commission if he handled sales. All works would be entitled to the sales appeal of a "KE" Ken's signature label.

The Tlaquepaque Institute—Ken's Imperfect Cooperative

The plan was put into operation in 1976, supported by what Ken earns as a consultant to El Palomar and what Ms. Edwards earns from teaching English. They set up a center called the Tlaquepaque Institute in the town of that name. Located just one block from the business center, it is a feasible if not ideal location for selling good stoneware. With a bit of advertising it could attract customers. A high-temperature, kerosene-burning kiln is now in operation behind the sales area. There Ken fires the wares he now produces independently of the factory. There, too, are fired the works of Jesus Reina, better known as "Mono." At the time we interviewed him, Reina was working long hours daily at the Tlaquepaque Institute painting candlestick holders designed by Ken. His work is selling so well that he is able to employ two assistants.

Reina demonstrates the success of Ken's plan insofar as he profits from a cooperative arrangement, yet remains an independent businessman. Magdaleno Ramirez demonstrates a similar success. However, after Ramirez constructed his own kiln recently, his involvement in the cooperative declined. He pays a small commission for the use of Ken's designs and again for having his wares sold through Ken's store, but otherwise is quite on his own.

Carlos Villanueva demonstrates one kind of ultimate success in the cottage industry approach: he has become independent. After a brief period of producing Ken's designs and selling through him, he shifted, as did Ramirez, to doing his own firing since Ken helped him to build his own kiln. Even more recently, he reduced his dependence upon Ken Edwards' designs when he began to make a large fish-shaped planter and several other items designed for him by Sergio Bustamante. Bustamante does not produce ceramics himself, but felt that Villanueva does unusually fine work and wanted him to have something unique to sell. He is now encouraging him to use his own signature instead of that of Ken, which will be the final step for Villanueva in becoming an independent producer.

The cottage industry cooperative approach of Ken Edwards looks like a success. But it is also a failure, and precisely where cooperation is essential. In addition to candlestick stands, hanging planters, display plates and other individual items, the Ken Edwards' plan calls for producing and selling dinnerware.

Using the technique that worked so well for developing El Palomar's *Tonalá* pattern, a more complex, harder to paint design based upon traditional Tonaltecan motifs is now being produced by the cottage industry group. Called *Turquoise*, its consistent features include turquoise colored leaves against a green background with five other colors used for details. The exact application of the five colors and other details may vary from one plate to another, but in order to have a matching set the major features must be painted in a consistent manner. To allow each painter to work independently, each is given certain molds so that each can produce a part of a set when it is ordered. In principle, each produces according to demand, and Ken organized the effort by gathering the parts together to form sets. The operation has been plagued by difficulty.

One source of difficulty is the need to get each potter to produce enough of the parts he is supposed to contribute. One person's slow work can delay production for the whole group. This happened while we were there, for example, because Ramirez did not produce enough creamers. After delays and discussion, Ken finally decided to make another set of molds for creamers so that someone else could contribute.

More serious are the difficulties of painting. Filiberto paints sugar bowls. He does his job well except that he cannot break the habit of painting the background in blue or green instead of turquoise. This makes his bowls useless when they do not match what is produced by everyone else.

Ernesto introduced still other frustrations. Like others in the group, he makes ashtrays, flowerpots and other items as well as parts of the dinner set. He creates difficulty by painting the pattern specific to dinner plates on all that he produces, which reduces sales since it makes everything look the same. Worse, he paints in a style that may be characterized as rigid. All of the others paint in a rather flowing style. So far no customer has complained, but the fact remains that the pieces do not match very well.

Finally, Ernesto consistently fails to include all five of the colors. Ms. Edwards has worked with him on this, showing him the work of others and urging him to take care. He will not or cannot change. He produces more dinnerware pieces than anyone else, but none of it quite fits with that of the rest.

By setting each member of the organization up as an independent entrepreneur, Ken avoids the problems of rising wages and social security benefits. The legal arrangement is one in which he buys from each producer. This applies to every step of production. He helped one man build his own kiln to do preliminary bisque firing. The shaping (jiggering) of forms is done by another man. Ken provides supervision and coordination. Unfortunately, commercial and organizational skills are Ken's weak areas. The plan is still young. It is premature to evaluate its ultimate potentiality. At this time, however, the dinnerware operation is functioning very poorly. Ironically, it is not for lack of potential sales. The organization cannot produce enough to fill orders already on file.

This disturbs Ken less than one might suppose. He is not really eager to encourage sales in dinnerware. He left El Palomar partly because he

did not want a lifetime of endlessly producing the same products for sale. He would rather devote himself to individual items and changes in design. This may be good and necessary for Ken, but it diminishes the potential earning power of the people working with him, none of whom is making more than barely enough to live on. The only two who are earning well are Ramirez, whose main income is from his job as a painter for El Palomar, and Bernabe, who produces almost no stoneware because he can make much more from the traditional petatillo.

A third barrier for those who would help peasant potters to modernize is created by techniques of teaching. "Constant supervision and attention over a long time are essential." A few demonstrations and lectures will not do. (Foster, 1967b, 347.) Ken fails in constant supervision but succeeds in giving attention over a long period of time. Those who work with him have done so for years. Magdaleno Ramirez has been with him since his partnership with Jorge Wilmot. Carlos Villanueva and Jesus Reina both came to Ken as boys in their mid-teens. As was his custom, Ken took them on first as gardeners or unskilled laborers on his rancho. As was characteristic of such boys, they asked for work in production. Each eventually developed skills he could employ.

Jesus Reina demonstrated skill in business. His first assignment after a time at gardening was to paint wooden retablos, at which he was a failure. Next he was used in the various stages of making stoneware, at which he succeeded well. Because he showed skill in managing people he was entrusted with some supervision responsibilities. Eventually he was placed in charge of the whole ranch operation. Although at first scarcely literate, Ken made him office manager, teaching him a simple technique for keeping books. To further his own success, Reina attended night school in Guadalajara learning to type and speak English. His command of English is sufficient now to allow him to deal with American customers quite easily. After almost ten years of working with Ken, Reina appears to have a good future as a manufacturer of stoneware, although he will probably always be a reproducer, not a creator.

The life story of Carlos Villanueva is similar. His strength, however, is in craftsmanship. After a decade of learning each step in the process of making stoneware he is now highly skilled. He is very successful in the application and coordination of colors. His wares are technically

excellent, apparently because he gives careful personal attention to every step of the process, entrusting nothing to unskilled subordinates. He is successful too because he sets high standards for himself, refusing to settle for imperfect work. Because such standards are difficult to maintain, he has pioneered within the cottage industry group in repairing pieces imperfectly fired for glazing. Reina and Ken followed his lead in this, and now do some re-firing themselves. But while Villanueva is highly skilled in the technology of stoneware, he does poorly in painting. He therefore prefers to limit himself to geometric designs. He shows no potentiality as a designer. All of his patterns and forms were designed by Ken or, in the case of four recent designs, by Bustamante.

The fourth barrier is that one must not attempt "to teach too many new things simultaneously." (Foster, 1967b, 346.) Ken has never made this mistake. He normally shows a worker how to do a single task and then leaves him to do it as his job. Since Ken's instruction never includes any explanation of how the task fits into a larger process nor of ceramic theory, to train men like Reina and Villanueva takes many years and may leave them without adequate grasp of larger issues. The compensating advantage is that the pace is never overwhelming to the learner.

Fifth, "In teaching new techniques, it is often easier to begin with people who know absolutely nothing about the skill involved, rather than to change deeply entrenched practices." (Foster, 1967b, 346.) It is difficult to evaluate this insight. It would seem to be confirmed in the success of Reina and Villanueva, but to be disconfirmed in other cases. Ramirez is a Tonaltecan deeply entrenched in local techniques, yet he succeeds well. The same can be said of Bernabe. Perhaps when other barriers are surmounted, this one becomes less of an obstacle, and particularly when the individuals concerned possess high innate potential. Ken, in all events, has frequently worked with people who came to him without previous experience.

Sixth, "To ask people to assume heavy debts, and to experiment with untried and unperfected techniques, is to invite failure." (Foster, 1967b, 346-347.) This is an area in which Ken barely skirts disaster. One example concerns a major source of livelihood for Ken in the last couple of years. When he left El Palomar to go back to work for himself he decided to produce belt buckles of painted ceramic. *(Note:*

One of the authors bought a KE buckle in a Kansas City shop during this time. To her disappointment, the back quickly broke away.) The ideas succeeded in sales, but still give Ken and "his people" difficulty in the area of technique. They experience excessive breakage, particularly after the first (bisque) firing, but also of the final product, which can be rather fragile for its intended purpose. In this case and at this time, the problem is sufficiently limited to be tolerated.

More serious are untried and unperfected techniques in dinnerware. We have already found that the cottage industry plan for producing dinnerware encounters organizational difficulties. It also involves other serious problems because Ken neglected production and consumer complexities when he designed the shapes. Aesthetically the dishes are pleasing, with gently folded edges along the rims. They are very time consuming to produce, however, since folded edges complicate the process of molding and jiggering. "We keep getting into the most difficult things," sighed Ms. Edwards one afternoon as we discussed this particular problem. Worse, the lipped rims are unsatisfactory for customers. The edges of the lips break when stored because, in stacking, the weight of the topmost bowls rests on the thin edge of the bottom-most rim rather than on the bottom of the dish as such. Equally serious is that the pieces do not fit easily into a dishwasher. The result is that Ken must now create new shapes. In all, the cottage industry plan for producing dinnerware suffers both from failures in cooperation (barrier number two) and from imperfections of design (number six), but the total effectiveness of Ken is still strong since the people working with him produce other stoneware products and do not rely upon tableware for success.

Seventh, and last, it is necessary to "develop a comprehensive, broad plan in which all factors that bear on success or failure are taken into consideration." Certain programs in remote Tzintzuntzan failed, for example, because although goods were produced, no plans were made for getting them on the market where they could be sold. (Foster, 1967b, 345.) Ken surmounts this barrier well. His planning is comprehensive even when execution is poor. His concerns range from finding suitable clays and glazes as raw materials to the marketing of the final product.

For all of his shortcomings, Ken Edwards rates as excellent according to the criteria derived from the work of George Foster. The net effect, however, is small when considering problems of change among the peasants of Tonalá. Success required a decade of time. Only five or ten individuals out of a community of more than four hundred potters profited significantly by graduating from simple terracotta to high-fired stoneware. For those few, however, the achievement is great. They seem well launched on new, more highly skilled careers. If the goal of community development is to select only a few individuals but to train them well, Ken has succeeded. The vast majority of local craftsmen, in contrast, are left to face a threatening future with a preindustrial approach unsuited to modern needs.

Ken Edwards and his protégés are successful where others have failed. What lessons do we learn from this for communities such as Tonalá? Perhaps the main lesson concerns the aesthetic future of this enterprise, and it is a sobering lesson. In general, peasant artisans copy rather than create. The success of Ramirez, Villanueva and Reina is technological, not artistic. We find no basis for thinking that a community such as Tonalá is particularly promising as a reservoir of undeveloped artistic genius.

On the contrary, the population is so small that it would be extraordinary for someone like Ken to identify and train a truly creative artist. Such individuals must be drawn from a much larger pool of potential talent. The contemporary designers of the Guadalajara area, some far more talented than others, to be sure, were recruited from an international pool of potential talent. The creators of present-day Tonalá are Jorge Wilmot, Sergio Bustamante, Ken Edwards, Dolores Chiappone and Joe Rowe. They have their roots in an international world of modern design, not in a village.

A Peasant Pattern of Innovation

We are now in a position to describe what appears to be a pattern of innovation. It applies to craftspeople, including potters, who are dependent upon an essentially preindustrial technology, yet are part of an industrialized world. It takes place in the presence of an active, competitive market for craft products created by a demand for decorative

or souvenir wares. Given such a market, traditional artisans may be expected to innovate within certain limits.

First, they may innovate by changing traditional standards of excellence in order to compete better in the marketplace. This may result in wares of improved quality, as in the case of beautifully painted petatillo or burnished ware. It may also result in wares of inferior quality when poor materials and hasty work become expedient in an effort to produce at a lower cost-per-unit basis.

Second, they may innovate by learning to copy the products of others. The source of the new items may be a matter of indifference. They seem generally to care little whether they copy the products of other peasant villagers, the art work of skilled designers, the creations of foreigners or the novelties of drugstores. Innovation tends to be a question of business, not of art as such.

The quality of items copied is often inferior to the products that were their inspiration. Clearly foreseen forces work in this direction. One is the problem of mastering technique when the borrowing process is that known anthropologically as *stimulus diffusion*. (Kroeber, 1948, 368-370.) In this process, the goal is to imitate a product even though the artisan is untrained in the method of production and perhaps quite ignorant of it, as when smoke rather than a reduced oxygen atmosphere is used to make black ware. Commonly but not inevitably, in stimulus diffusion the results are inferior.

The other force for reducing quality is that which also affects the quality of items traditionally made in the community: for perfectly understandable economic reasons, quality may be lowered as a means of increasing the volume of sales by selling cheaply. Peasants succeed as well as others in using this technique of a free economy (see Kunkel, 1976, 327-331; Acheson 1976, 331-335.) A market for souvenirs seems especially to encourage this mechanism.

Third, original invention tends to be rare or absent. When originality occurs, it tends to be limited to variations within the limits of custom, as when traditional painting is applied to new pottery forms.

True originality in developing products is exceedingly rare. It seems that the value system and social structure work against creativity of this sort in a traditional community of artisans. May Diaz attributes failure to innovate in Tonalá to a family system in which authority is

in the hands of elders who tend to be conservative. Young people who might try out new ideas are subdued. With age, they become controllers in their turn, but by then are themselves thoroughly conditioned to conservatism. (Diaz, 1966, 74-75, 178, 215.) This dynamic is comparable to many of the family enterprises we studied in Denmark.

Both May Diaz and George Foster identify other factors that work against creativity on the part of potters. Most will not attempt to innovate because they have grown up in a community in which adhering to traditional ways is both wisdom and a virtue. When a creative individual does emerge, success is unlikely because fellow members of the community will fail to give support and may even oppose the attempt to change. (Foster 1967b, 167, 247,251, 252-255; Diaz, 1966, 213; see also Anderson, 1975, 40-41.)

Fourth and last, they do not normally attempt to copy if to do so requires skills they do not already possess. If encouraged and aided by outsiders to gain new expertise, they normally fail. Failure has two sources. One is the difficulty of peasants to learn skills that presuppose the training and personality development demanded by an industrial society. The other is the difficulty agents of change experience as they attempt to create a new local industry on the basis of brief contact with the community.

Long-term Prospects.

The experience of Denmark provides a basis for anticipating what may happen to Mexican peasant crafts such as the ceramics of Tonalá. We learned in Denmark that folk pottery failed in the market for utilitarian wares when factory wares of sturdier materials became available. The same process is now repeating itself in Mexico. Danish potters responded by shifting emphasis to the production of decorative wares. That is exactly what is encountered today as the major process of adaptive change. This response failed in Denmark, however, when economically depressed potters found that they could support themselves better in other occupations. We saw in Denmark the withering of production in family enterprises where creativity and innovation were stifled by adherence to old ways, and occasionally we saw dying embers glow with new life when outside designers were recruited to form creative clusters influencing both design and marketing. Could the same also

take place in Mexico? The barriers are multiple, but the possibilities are there. Paradigm development falters as the patterns shift.

It is highly significant that potters usually are poor. Their wares sell well. Most seem to sell all that they can produce. But the income to the potter is very small. In effect, the success of craft industries is subsidized by peasants who work for abysmally low wages or commissions. It would seem, therefore, merely a matter of time until they will repeat the shift made by Danish potters at the turn of the century. They will abandon ceramics in favor of employment in other sectors of a growing industrial economy. Those who remain will be the very few who earn well from their ceramics work. A few individuals out of several hundred is what we anticipate will survive, but no more.

Will the folk art of Tonalá survive in this manner? Again, Denmark offers a basis for estimating probabilities. Whether conservative or subject to innovation and distortion, both black and glazed pottery survive in Denmark as fossils. Traditional ceramics are unimportant as a part of current ceramic activities in the nation as a whole.

It seems likely that the same will take place in Mexico. The present position of peasant potters is stronger in Mexico than was the case for peasant potters in Denmark several generations ago. Modern commerce is more active and successful. Even so, the few potters who may persist will surely not hold center stage as they do today. They will become producers of fossils. Center stage will be taken by ceramists out of the elite, international cultures that produced Wilmot, Bustamante, Edwards, Chiappone, and Rowe. The future belongs to trained designers working in modern factories. It belongs also to studio ceramists, a creative elite privileged by values they can articulate and live by. Thus the lines of the paradigm bend or are broken by the paradigm shift. The preservation of the production folk art, in these instances throwing and firing pots, as a general occupation for villagers condemns the majority to low hourly wages for repetitive piece work. It sentences families to poverty. This is hardly the romantic ideal we have when we pick up and enjoy a piece of pottery in Jalisco, initialed by an unknown potter.

The conversion of peasant skills toward more gainful employment through participation in a thriving economy, while supporting the preservation of the old folk art techniques and designs as specialized skills rather than mass duplication of products with limited use, could be a

basis for national policy in the arts. At the same time, the encouragement of talent and creativity through the modern Danish paradigm could sustain the flow of innovation as well as preservation. That paradigm incorporates elements of the Royal Copenhagen Paradigm and those of the Studio Potter by encouraging design and experimentation while adapting modern technology to new and economically viable products. This paradigm links the past to the present and the future by strategically preserving the traditions of the potters of the past and protecting those potters who practice in traditional ways. This paradigm would exclude sustaining the non-strategic practices of whole villages competing to produce trivial and low quality ceramics for tourists at prices that do not reward the potter's work with a living wage.

We turn once again away from Mexico to the milieu of studio potters on Bornholm to probe into their persistence and resilience despite the competition of mega-factories with industrial resources. The existence of the studio potters, we believe, is partly a functional consequence of, and resistance to, the Royal Copenhagen Paradigm.

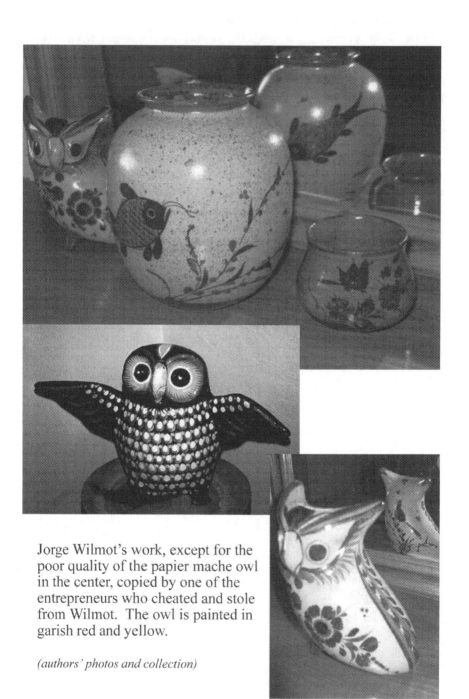

Jorge Wilmot's work, except for the
poor quality of the papier mache owl
in the center, copied by one of the
entrepreneurs who cheated and stole
from Wilmot. The owl is painted in
garish red and yellow.

(authors' photos and collection)

Above: Tonalá street market with lots of pottery.
Below: a boy painter at El Palomar. *(authors' photos 1975)*

Chapter Ten
In Denmark a New Paradigm Evolves

The inadequacy of the purely purpose-oriented form is revealed for what it is—a monotonous, impoverished boring practicality.
—Theodor Adorno

Growth of Independent Studio Entrepreneurs

The success of the Royal Copenhagen Paradigm appears to have contributed to the demise of folk pottery in Denmark. Certainly, industrialism did, but if the Paradigm has been harmful for traditional crafts, it has been beneficial for creative developments. It is associated with a new phenomenon–the appearance of the commercial studio potter, that is, the modern ceramist who works in a small, privately operated *etalier*. It would be simplistic to say that the one was the cause of the other. Modern potters are found in industrial nations throughout the world today as artists and craftspeople who produce fine wares to supply a market that has grown with a growing middle class. Yet, the appearance of the studio potter in Denmark is, at least in part, a functional consequence of implementation of the factory paradigm. Before we can explore that interpretation, however, we need to describe the setting and identify the actors.

Bornholm—a Perfect Place for Potters

Studio potters are presently found in every region of Denmark. Probably most are rural or semi-rural, even though the two largest concentrations cluster around two big cities, Copenhagen and Aarhus. We visited several urban shops, but elected to do our systematic interviewing in a rural environment. We concluded that it would be particularly instructive to talk to potters who now live and work in

the countryside, since our ultimate reference in this investigation is to peasant potters.

Just as importantly, however, we chose an area that currently enjoys a reputation, which in a sense is comparable to that of the Guadalajara region of contemporary Mexico, or the Sorring area of Denmark a century ago. Bornholm was well known in the nineteenth century as a center for folk and factory ceramics. That reputation has metamorphosed in recent years. The island, still known for its factories, is now also known for intense activity and high quality in studio production. As a net result, no other part of Denmark comes so readily to mind now either for Danes or for foreigners when ceramics are under discussion. *(The exception may be Silkeborg on the Jutland Peninsula.)* The actual number of potters may be greater in the urban regions mentioned above, but those areas are each large in land mass and population density. Potters there are nearly lost in an urban sea. On Bornholm, in contrast, they are highly visible.

The island is not large. Roughly trapezoidal in shape, its longest axis is 43 km (26 miles). The road system is excellent; almost no part of the island is more than an hour away from wherever you may happen to be. It is a beautiful place, in which neatly tailored, rolling fields alternate with expansive forests of beech trees and a rocky coastline that looks out on all sides to the moody Baltic Sea. In addition to the small city of Rønne, a scattering of very small towns can be identified. Many of these small towns serve as harbors for fishing fleets. The island is known in many parts of the world for its fine smoked herring. Other towns are located inland where they serve a farming population. Occasional hamlets and solitary farms lie cozily sheltered in fields or at forest's edge. So lovely and uncontaminated is the scene that it beckons hoards of tourists in the summer when the climate is mild and the sun dependable. Danes, Swedes and Germans, in particular, are attracted. They boat and fish at the coast, hike in the forests, and sight-see in the settlements. They also come to visit potters in their studios, and there combine tourism with a search for gifts and souvenirs.

Bornholm potters reside in every part of the island. Some live in a harbor town. Svaneke is such a place. It rises steeply from the harbor with its anchored boats, docks and fish-processing facilities to a small, oddly shaped square encircled by old farm buildings that look inland

to fields and forests. Six pottery shops are part of its touristic attraction. Gudhjen is another such center with another five shops. Other coastal towns, including Rønne, have a shop or two, as do a number of the inland towns. Many of the potters are located in small villages and hamlets. Three, for example, live in a small fishing village near Hasle where the former homes of fishermen-farmers now serve as combination studio-dwellings. Not a few have taken over old farmsteads isolated in their fields. In all, approximately thirty studios are scattered across the island. Often a husband and wife share a studio (in one case, a mother and daughter), so that the total number of potters is about forty. Of these, we interviewed thirty-three working in twenty-six studios.

Professional Pioneers

Let us return now to an interpretation of the recent history of the island. The proliferation of studio potters appears to constitute a functional consequence of factory growth patterned on the Royal Copenhagen Paradigm. Studio potters on Bornholm are recent, even though the island has long attracted artists and writers. The earliest of the new breed of ceramists established studios in the late 1950s. By that time the old folk potters were long extinct, and the only significant ceramic activity on the island was in Rønne, where the four factories were in full operation.

It is significant that, so far as we know, these first potters were all professional artists. Nis Stougaard earned his living for years as a painter before he established a small ceramics studio in Rønne. Knud Basse came to the island as a sculptor trained at the Academy of Art. Arne Ranslet is also a product of the Danish Art Academy while his wife Tulla Blomberg-Ranslet was trained there as well as in the Art Academy of Oslo. She was born in Norway and is primarily a painter. All but Stougaard were academy-trained in ceramic design. Thus, the institutions of advanced training which then as now contribute to the Royal Copenhagen Paradigm trained not only designers for the factories, but these Bornholm potters as well.

In 1961 the Stougaards moved to Svaneke, where they acquired an abandoned schoolhouse as home and studio. They enjoy a view across the sea to the tiny island of Christiansø, long sought out by painters because of its extraordinary light. The Stougaards transformed

part of the schoolhouse into a dramatic dwelling dominated by a large, high-ceilinged living room in which a steel circular staircase leads majestically to an upper floor. Now over seventy years old, Nis Stougaard leaves ceramics to his much younger wife while he paints in his studio overlooking a part of the harbor and that old mecca of landscape painters, Christiansø.

Unlike any other potter on the island, Nis and Birthe Stougaard in their studio developed a factory style of production; although they did not follow the Royal Copenhagen Paradigm. Tiny in comparison even to the smallest of the Rønne factories, the enterprise employs five people and two medium-sized kilns to maintain a steady volume of production. These products include a series of souvenir plaques portraying the tourist sights of Bornholm. Created by Mr. Stougaard, they required no significant artistic ability to originate and even less to reproduce. Hired assistants paint stacks of them to supply an insistent market. Some of the stoneware products of this tiny factory are quite good, however, including pieces that are outstanding as utilitarian art.

Arne Ranslet came to Bornholm to set up his own studio in 1954. Nevertheless, for five years (1958-1963) he served as chief engineer at Søholm. A specialist in the chemistry of glazes by virtue of training in the Polytechnic Institute, Ranslet guided the factory over difficult years when they made the shift away from lead glazes. After that was done he preferred not to remain at the factory. Instead, he returned to his farm-studio. There he specializes in human-scale ceramics and, incidentally, undertakes no farming. (None of the Bornholm potters farm, and only one fishes for a living.) Although he liked his work at the factory, Ranslet prefers to specialize in large ceramic sculpture. He continues to be available as a consultant to the Søholm factory when a special need arises, but he limits that contribution to the technological realm. Uninterested in creating designs for mass production, Ranslet explains that the prospect never appealed to him because, "A design loses all personality when it goes through so many different hands."

Others have not agreed with him on this. Stougaard was quite content to design for Søholm. So is the present artistic director, a newcomer to the island, Haico Nitzsche. We have not included Nitzsche in our statistics on studio potters because he is employed at the factory. Yet he does studio work in his free time and sells through a shop in Gudhjen

that he shares with his wife, a weaver. Born in East Germany where he was also trained as a ceramist, he was attached to the Gustavsbergs Porcelain Factory in Stockholm for a total of four years before he came to Bornholm to take his present position at the Søholm factory in 1974. Some of the vase and plate designs now in production are his. He is better known by far, however, for ceramic sculpture that, like that of Arne Ranslet, has the dimensions of human beings. Surrealistic in style and didactic in intent, he has experimented with truncated human torsos in *charmotte*, quite naturalistic except for a zipper that runs up the abdomen. One major piece in his one-man show at the Bornholm Museum the summer we interviewed him consisted of a table set for dinner with a pair of fat hands poised to eat. That piece was an intended commentary on the materialism and gluttony of contemporary Westerners.

From Nis Stougaard through Arne Ranslet to Haico Nitzsche, the Sóholm factory has engaged professional artists who used their skills as designers to create ceramic studios on the island. The Hjorth Factory also has contributed. Two of the leading island ceramists are Marie and Ulla Hjorth. As with Nitzsche, we have not included them in our statistics because they are full-time employees of a factory. Yet they exhibit with studio potters and share their interests. The Hjorth family also produced the most well-known of the Bornholm ceramists, Lisbeth Munch-Petersen, the aunt of Ulla and Marie and the daughter of Hans, who first brought stoneware to the factory at the turn of the century. Munch-Petersen is widely acclaimed for her ceramic reliefs, some the length of a large room. At present she also produces designs for stained-glass windows in collaboration with her husband Paul Høm, a well-known painter. Mrs. Munch-Petersen never worked in the Hjorth factory, but she was trained as a potter in the family tradition. She, too, ranks as a pioneer of studio art on the island.

A New Wave of Bornholm Artists

The ceramists who inaugurated the studio tradition on Bornholm in the late 1950s, then, were all professionally trained and directly shaped by local factories, specifically Søholm and Hjorth. A decade later, the island still supported only a few studio potters. Perhaps only eight or ten. By the time of our arrival two decades later, however, the

number was large, as we have seen. How did so many become part of the tradition whose recent origins we have just described?

Some, like Haico Nitzsche, came with experience as designers in factories. Gerd Hiort Petersen and Hans Munk Andersen, who now live with their small children on a farm isolated in its fields, first met while working in the design studios of the Royal Copenhagen Porcelain Factory. For the first five of her eight years at RC (1965-1973), Ms. Hiort Petersen found her work pleasurable and rewarding. With time, however, she became increasingly conscious of the difficulties of her position. "You have to keep continuously in mind that each minute of production time costs money." What does that mean? "It means that ten extra strokes of painting in a design motif cost extra to manufacture, and that puts you under pressure to change your designs for purely commercial reasons." She appreciated the fact that she had lots of help from chemists who worked with her to develop clays and glazes. She learned a lot. But she felt the urge to be what she terms an "all-around" ceramist, to do everything herself. Her husband, who spent three years in the same capacity at RC (1968-1971), agreed. They came to Bornholm to turn their occupation more into a way of life.

Gerd Hiort Petersen and Hans Munk Andersen feel that it is personally rewarding now to be ceramists. They work much harder, but they work together and find it more satisfying. It was advantageous at the factory to have technical assistance. Doing everything themselves now and having direct contact with consumers is also very satisfying, however, and they love living on Bornholm instead of in the large city of Copenhagen.

Bo Kristiansen first came to our attention in the display rooms of the Royal Copenhagen Factory in Copenhagen. His faience pieces, carefully decorated with lines of printing in subdued colors, had been accorded special display space during an early summer of our investigation. From that time we became increasingly aware of the prominence enjoyed by Bornholm potters and specifically by Bo Kristiansen. A year later we found our way to his barn-cum-studio-home in Gudhjen. No longer married to Julie Høm, the daughter of Lisbeth Munch-Petersen, he presently works alone in his studio. On retainer to Royal Copenhagen, he won the commission to do their annual mug for 1978. He was

also struggling to modify his printing designs so that they could be produced on an assembly line.

Bo Kristiansen, too, is a product of formal training in ceramics as well as experience as a designer for a factory. He held a special surprise for us, however. Given the mistaken notions that anthropologists only study seemingly exotic peoples in far-away places, it is not uncommon for Danes to ask jokingly if we consider them "primitive." To that we may respond, also jokingly, "Yes, of course." But with Mr. Kristiansen, the full cycle was completed, for at the very end of our long interview we learned that this "savage" informant is the son of Palle Kristiansen, an anthropologist on the faculty of the University of Copenhagen and an old acquaintance of ours. Since no people can objectively be described as culturally primitive, this revelation made us appreciate the wisdom of a practice we have always subscribed to as professional scholars: never use the term "primitive" or "savage" to describe a society. You may find that it applies to your own society and that of your children or your friends!

Journeymen Potters

Of all of the ceramists on Bornholm today, only the few mentioned above worked as specialists in factories. Others, however, came as journeymen potters, and thus clearly are products of the factories in which they apprenticed. In addition to four of the above designers (Bo Kristiansen, Hans Munk Andersen, Gerd Hiort Petersen, and Lisbeth Munch-Petersen), seven of the thirty-three interviewed were trained under a state authorized program which requires four years of apprenticeship as well as class-room training. All but one of these possess journeyman papers as master potters or ceramic throwers. The one exception is Tonna-Elisabeth Kjaersgaard, who apprenticed in a variety of shops and factories in France and Spain as well as Denmark, including two places that have particularly concerned us in this investigation, the shop of Knud Jensen in Sorring and the Kähler Factory in Naestved.

Self-taught Potters

Somewhat more than half of the Bornholm potters are professionally trained. It is surprising to learn, however, that 14 of our 33 interviewees are self-taught. Is it really possible to achieve excellence without

proper training? Evidently it is. While the work of some seemed quite pedestrian to us, that of others was of top quality. Of seven islanders who met jury standards to have their works sold in Den Permanente, five are self-taught. Illums Bolighus, the largest and most prestigious store in Copenhagen, fronts on Copenhagen's most famous shopping street (Strøget). It is the nation's most prominent store for the sale of household furnishings in modern design. Of four Bornholm ceramists who currently have wares on sale in that store, three are self-taught.

It is evident that self-taught artists can produce extremely fine work. But how do they learn? Most commonly, they learn at least the rudiments by spending some time working in the studios of other potters as in the old days of apprenticeships. Eleven out of 14 fit this pattern. One of these eleven, Jørgen Lai, is aberrant in that he potted for years as a hobby before he gave up his work as an advertising man in 1970 to turn professional. During his hobby years his friends included a number of qualified potters. He is among those whose works are sold in Den Permanente.

Self-taught potters also rely heavily upon published books that explain procedures. Seven of our interviewees learned primarily in this manner and nearly all have at one time or another used books for reference. The contrast with peasants is very great in this regard. It points up the significance of an excellent program of public education and library resources in providing options for individuals with artistic talent or ambitions. These options include a cultural flexibility or loosening of restraints. Their models for style and technique are international rather than parochial. The people we talked with were influenced by books from as far beyond Denmark as the studios of Hamada in Japan and Beach in England.

The Bornholm Style

Recruitment and training encourage variety and differentiation. Any one potter may be very repetitive within his or her own style, however. Many produce a limited selection that changes little from one year to the next. Most work in stoneware, although three prefer low-fired earthenware, and two produce faience — specializing in porcelain or *chamotte.*

A few devote themselves to sculpture rather than pots. One of these ceramist-sculptors is Finn Carlsen, the Don Quixote of Bornholm. Carlsen lives with his wife, Meta Høm, also a ceramist-sculptor. With their daughter they inhabit an old herring smoke-oven with its single large room and giant chimney. Finn trained for over three years at the Art Academy before dropping out. After some years of odd jobs interspersed with occasional work as a sculptor, he learned to sculpt in ceramic materials by working in a small factory. An iconoclast personally as well as artistically, he and his wife live poor in possessions but rich in fantasy. Very little comes out of their studio, but what does is usually highly imaginative, with mocking touches of humor. Much like Haico Nitzche, Carlsen uses his creations to criticize society. The 4th version of *Weilb achs Kunstnerleksikokn* (Mølleer,1994.) said of Carlsen:

> *"His important production is in ceramic sculpture where he had a penchant for large forms which favored surrealistic, fabulous themes, often with a marked gallows humor. His paintings, which show influences from Pablo Picasso and Fernand Legér, especially evolved in later years in a more naïve or primitive direction with motives that derive from a complicated interplay of religious and down-to-earth human reproductions."*
> *(Note: Carlsen died in 1996.)*

Also a sculptor is Ib Helge, whose figurines appear to take Henry Moore for inspiration. He is successful to the point of being sold in Illums Bolighus. Yet he is one of the few born on the island. He speaks with the strong accents that make the Bornholm dialect sound like a hybrid of Danish and Swedish. A journeyman potter, he supported his family for several years with wheel-thrown wares until a disabled shoulder incapacitated him for throwing. Overcoming several years of heavy discouragement, he taught himself to sculpt, and celebrated, the year we interviewed him, the simultaneous success of his new line of ceramic art and the birth of a son.

The most successful of ceramist-sculptors is Arne Ranslet. His large pieces designed to adorn buildings frequently take Biblical themes for their inspiration. During our visit he was assembling a large Jonah and whale. Tulle Ranslet, for her part, was working on a relief depicting the

Tree of Life. It is destined to grace the home of a German physician who visits their studio regularly on summer vacations. Unlike others who sculpt, Arne and Tulla also make stoneware plates and bowls, their style being dark, heavy and technically superb.

A number of potters produce small figurines, but most emphasize the manufacture of utilitarian pieces. If those of the Ranslets are dark and heavy, the porcelain of Hans Munk Andersen is exquisitely thin and pastel light. Between those extremes can be found as many varieties as there are potters. Most clearly are inspired by what others are doing in island studios, Danish factories, and foreign lands (particularly as known from books). Their work tends to be what may be ambiguously designated as "contemporary." Only a few show any direct influences from folk traditions.

Ties with Traditional Arts

The break with the Danish folk tradition of pottery is virtually complete. Only three of our subjects consciously imitate traditional styles. Lotte Mogensen and Poul Nielsen reproduce wheel-turned ceramics for tourist sales, modified from the past primarily in the application of a lead-free glaze. Nielsen (Tagora) has also imitated black pots since 1974. He throws them on the wheel and pre-fires them in his kiln, but finishes them in the old manner by pit-firing. His aim is to make them resemble antiques. The old-fashioned wheel-thrown pots of Peter Duzaine Hansen (Peter Duz) differ from those of Nielsen and Mogensen who work in earthenware. Hansen's pots are of stoneware. After many trial-and-error efforts he succeeded in developing a glaze that resembles closely the work of old town potters. Unlike the traditional wares, however, the imitations of Peter Duz are oven-proof.

Only two others draw heavily upon tradition. Tonna-Elisabeth Kjaersgaard is the only potter on the island who fires in a wood-burning kiln. She learned the technique as an apprentice in France, and gets a highly satisfying ash-glaze in that manner. Many of her forms are inspired by old pitchers and pots without being copies. Some are much larger than their prototypes that are generically peasant without clear ancestries. They were sold through Den Permanente in 1970.

Among the many creations of Nis Stougaard, who is a respected and talented painter and ceramist, are a few jugs and pitchers of stoneware also

211

inspired by historical forms, much in the manner of those of Kjaersgaard. Beyond these examples, any potter may occasionally throw a pot that resembles in shape a traditional form. Their inspiration, however, is uncertain. They are not prominent in collections. Overwhelmingly, imitation takes contemporary design as its object. The aim of the potter, however, is not to imitate, but to innovate. Cultural differentiation is the goal. It tends to work powerfully against the maintenance of historical continuity.

The New Paradigm

The life style of the studio potter may be seen as a new paradigm for creativity in ceramic design. It is defined by patterns for coping with three kinds of problems: training, sales and organization.

Self-teaching. We have already learned that the training of studio ceramists ranges from formal matriculation in the Art Academy through craft training in apprenticeship and schooling programs to self-instruction. It is the latter, minimal mode of instruction that defines the paradigm. Whether as a young person fresh out of public schooling or as a middle-aged or older individual seeking a change of occupation, it is possible to become an excellent potter without undergoing professional training.

This comes as a surprise to those who assume, and they are many, that education is the yellow-brick road to success. Training and re-training programs are founded on this assumption. Whether they are useful or not, needs careful examination. This seems a reasonable conclusion to draw from our finding in Bornholm. Conditions there, as well as throughout Denmark, make it possible for individuals to teach themselves a craft. What are these conditions?

One condition that makes self-training successful is unquestionably to be found in the educational infra-structure of the nation. To succeed in acquiring self-taught skills, potters need not merely to be literate, but to be experienced in using their ability to read as a way to gather information and apply it to the solution of problems. This is what educators mean by the inspiring but uncertain injunction not to teach facts in school, but to teach pupils to "learn how to learn." It is the implicit goal of a liberal arts education.

Even a couple of our interviewees who were low achievers in school acquired this capability. They were able through reading and through contact with working potters to learn in a manner that Foster found to be beyond the capabilities of the average potter of Tzintzuntzan. He concluded that background and education rather than genetic endowment were implicated. Our findings are consistent with his.

We should not exaggerate this capacity for self-instruction, however. It is equally facilitative that technology is simplified, a product of the success of contemporary industry and commerce. A Bornholm potter may construct his own kiln, but he may also purchase one ready-made. He may purchase a motorized throwing wheel. Clays and glazes may be purchased from factories. In short, the amount of technical knowledge is much smaller in its minimum than it is for a folk potter who must manufacture his own equipment and mix his own materials before he can even begin the process of making pots.

Sales Outlets. The first characteristic of the studio potter paradigm, then, is that the technology is simplified and can be self-taught. The second is that facilities for sales are available to the potter, or have been developed at the work site. Selling from one's own studio is customary. All but three of our subjects do so. The exceptions are sculptors who produce a small number of larger works, generally on commission. Part of the attraction for tourists is that they may browse in display rooms and visit with potters at their work. It is our understanding that the major source of income for most studio potters is summer sales achieved in this manner. It is also customary to sell through stores located in other parts of Denmark and abroad. The surplus at the end of the summer, or the products of winter work, frequently are sold to wholesalers. Most potters resist and resent this approach, however, since the additional markup of the jobber results in higher retail prices for their work but lower residual benefits for them. Many never sell to wholesalers or do so only as a last resort.

Most are able to sell the excess they produce directly to stores, and typically deal mainly with from one to five stores that handle their wares. The pots of Peter Duz, for example, are found in one shop in Copenhagen, one in each of two towns in the provinces, and two in Germany. Not infrequently, the stores include *Karamikstauen,* a chain of three souvenir shops located in town in Bornholm. Arrangements

with stores often are made through a representative who comes to the island for that purpose.

Although nearly every potter sells through stores, very few sell through Den Permanente, Denmark's cooperative for selling hand-crafted and industrial arts,. What are the drawbacks of Den Permanente from the point of view of potters? Many, it seems, have simply not given much thought to the matter. They sell all they produce through their own display rooms or to wholesalers and independent stores.

Those who have turned to Den Permanente report respect for the institution, but dissatisfaction. One who has sold through Den Permanente for eight years reports that they are now the only outlet that still expects wares be placed on consignment, without payment until a sale is made. Other stores purchase at a wholesale price, but with an immediate cash transaction. Den Permanente pays only if the goods are sold. Not only does that force the potter to wait for payment, but it may result in his receiving old goods back instead of money. Den Permanente is excellent, this potter insists, and he continues to send them goods, but the problem is persistent.

The other major complaint, reported by another potter, is that the jury system of selecting wares is too stiff or constrictive. The jury meets once a month, which is not often enough to prevent some delay in selections. In addition, there is the haunting question of whether the judgment of the jury is open and unbiased. This potter, whose work has been displayed on the shelves of Den Permanente for about three years, feels the jury process is valuable and that a jury system is necessary to maintain the exceptionally high standards that prevail. It leaves her, nonetheless, dissatisfied. Many, she might add, fear the jury since their sense of pride and identity is on trial with their ceramics. Some add that the jury system tends to discourage innovation beyond the limits of middle-class tastes.

A final outlet may be found in exhibitions and museums. Exhibitions of various kinds provide not only an opportunity for artists to get recognition, but also to sell their wares. Museum programs to encourage arts and crafts are useful in this way. Major museum displays discourage many from attempting to participate because it takes added time to produce the especially fine wares such displays require. The threat of rejection is difficult for many to accept. Minor displays are therefore

easier. They may occur when a bank or department store devotes a window to local potters. One of the best ways to sell grows out of the custom of factories to form art associations that may organize exhibitions of various kinds. Factories do this more in Sweden than in Denmark, but the practice is growing.

Voluntary Associations and Cooperatives: The Danish Mafia

To achieve their goals, potters found it helpful to organize themselves in certain ways. The establishment of two voluntary associations was their response, the one an island chapter of a national association, the other, a purely local society. Let us examine the local society first.

SBK, the Union of Bornholm Ceramists, appears at first approximation to be a success. Thirty-two of thirty-eight eligible workshops are members. It began its formal existence in 1975 when a number of potters met informally to discuss a dispute with the authorities over the right to place signs in public places. In the time that followed, potters used the power of organization to achieve other goals as well. The most useful is to publish each summer a map made freely available to vacationers. It locates on the road system the studios of members, and is effective in encouraging consumers to search out and visit places they might otherwise miss. This activity alone provides justification for the association in the eyes of many members. Even two dissident potters, deeply suspicious of any form of organization, volunteer approval of this service. In the words of one, "It is not the map, but the association that I am against."

The second successful function is to offer winter courses on ceramic technology. Many feel that they have no need for such instruction, but others find it useful. During the winter of 1976-1977, a course was offered that covered the complete ceramic process from the preparation of clay and the making of glazes through kiln construction and use to work habits and business practices. Meeting once a week, three hours at a time, the course recruited twenty-two students. The cost was modest, since enough participated for the program to qualify for state support under a program to encourage workers of all kinds to improve their skills. Planned by members of the association and coordinated by an enthusiastic and active president, Peter Duz, skilled professionals from the island and beyond come each week to teach their area of

special strength. It is not possible to predict future course offerings and outcomes.

Peter Duz is currently making efforts to help members obtain unemployment insurance. His involvement, as president of the association, consists mainly in talking with members and providing them with brochures. The scheme was set up for self-employed people by the national government. Peter Duz hopes to find other ways as well in which the association can serve its membership by channeling information that they might not otherwise receive.

The map, the winter course, and the passing on of information constitute the present success of the "union." Every other effort at cooperative action has failed. The hope that members might obtain the economic advantages of cooperative buying of clay and glazes was unfulfilled. This, in fact, was the major reason given for establishing the association in the first place. It proved impossible to get people to unite. Finally, the decision to make each member order a year's supply of clay and glaze, and pay for it in advance, was the "deal-breaker."

Almost nobody was willing to make such a commitment. Cash liquidity was at issue. Very few possess enough ready money to pay for a year of supplies in advance. Even more emphatically, almost no one was willing to commit themselves to the use of certain amounts and types of glaze and clay for a whole year, since it reduced their flexibility in experimenting and developing new products. Finally, they could not agree on what to stock, since they differ widely in the combinations of clays and glazes that they use. If a solution to these dilemmas exists, it is unknown of this time. The effort to function as a buying collective is presently in abeyance.

It is difficult for us, based on our work to date, to evaluate the failure of cooperative buying. Did the effort fail mainly because the purely commercial problems are refractory? Or, did it fail mainly because of social considerations, an inability to subordinate egoism to the common good? Of course, failure may have resulted from a combination of both. It is clear, however, that a second effort of the association failed directly because of egoism.

The map, a big success, was a product of serendipity. It represented a minimal strategy that the members were able to agree upon in the effort to develop a cooperative approach to selling. The association hoped to

establish a store that would display and sell the wares of all members. Not enough were willing to invest labor, wares and money in a store, however, even though all agreed that they were not happy to see their work sell consistently in private businesses for 50% to 100% more than they received for it themselves.

We detected, in our interviews, an element of mutual suspicion regarding cooperative plans. One of the two non-members we interviewed spoke openly of his suspicion that if money were involved, someone would take advantage of the others. No others, however were that outspokenly mistrustful. Rather, there was a tendency simply to fear that some would profit more than others, as when people standing in line worry that if they are not alert someone will slip ahead of the others. These subtle fears revealed themselves most clearly in a recent effort to achieve a kind of sales cooperation that might lubricate the process of getting wares into independent stores.

Under present arrangements, stores send representatives to the island to contact potters and arrange for shipments. Illums Bolighus, the most sought after outlet, does this annually when their buyer comes for a short stay. He spends his time driving around the island, so rushed that he can spend only a short time with a few ceramists. It seemed a good idea, instead, to arrange a temporary exhibit in which all members might display their wares. The Illums representative would be able to use his time much more effectively, and all who wished could be included. Other buyers might also take advantage of the opportunity. The benefit would be a fairer, more open system. Nevertheless, it failed. People feared that they might lose rather than win in systematic comparisons of their work with that of fellow members.

These fears and worries of mutual distrust are even more apparent as concerns the Bornholm chapter of the Danish Arts and Crafts Association. As we learned increasingly more about this association, we began to pick up references to monopolization by the "Mafia."

The old Danish National Association of Artistic Handcrafts endured for seventy years until it was dissolved in 1976, the victim of conflicts of interests that pitted the sponsors of industrial arts against the creators of handcrafted arts. As concerns handcrafters, the old association was replaced by the Danish Arts and Crafts Association, which consists of

seven regional groups, each largely autonomous. Bornholm is one of the regions.

To establish the Bornholm chapter, the new national office sent letters inviting members of the defunct association to reorganize. Ten islanders qualified to become founding members of the new group. Eight of the ten were ceramists; the other two were a silversmith and a textile weaver. The ceramists represented local elite. Five were members of the Hjorth family, either by descent or by marriage, all well known in national circles, including two newcomers to Bornholm who were formerly designers at the Royal Copenhagen Factory. The founders met the highest standards of ceramic excellence. They felt that these standards should distinguish all who might belong to the new association.

Under the original charter the founding group was free to organize as they chose. Each region followed its own lead in structuring their chapter. Some opted to be quite open and democratic. Others imposed strong central control. The Bornholmers preferred the latter approach. The way they went about it led outsiders to designate the controlling elite as "the Mafia." Yet their motives could be justified, because they felt that for the association to be effective it had to limit its membership to artists of excellence. The first ten gained their membership automatically by virtue of belonging to the old association. That procedure, they felt, gave them the right to evaluate additional candidates.

The issue came to a head over the first major activity of the new association. The purpose was to make the public aware of the skills of their members. Since the future of the new association is necessarily uncertain, they decided to organize a national exhibit to be hosted in the Industrial Arts Museum in Copenhagen in the summer of 1977.

Positive reviews of the exhibit, so their thinking went, would strengthen the association. It became a matter of serious concern that the works displayed be of top quality. Each regional association had to organize its own part of the exhibit and decide whom to include. Only the South Sjælland chapter allowed every member to take part. All of the others utilized some technique for eliminating inferior work. The Bornholm chapter created a jury to act as censors.

Because the island group was being organized at the same time the Copenhagen Exhibition was being planned, selection for the exhibit became synonymous with election to membership. By lot, the ten

founding members chose a jury of five to evaluate submissions. All of the original members passed this censorship. Decisions on others, however, led to disagreements and ill feelings.

Above all, many islanders identified the charter members as an inner clique, and resented the idea that they should submit to them for evaluation. Some felt, perhaps unfairly, that the inner group did not adequately advertise the existence of the new association in the hope, it was claimed, their hegemony would not be threatened. (It is true that some artists did not even know in advance about the exhibit.) Above all, however, it simply seemed arbitrary to many that five people should suddenly materialize as judges of their worth. They refused to submit, and were not included in the show.

The inner group did protect their privileged position. One island ceramist, a native Bornholmer, submitted his work only to be rejected arguing that he was a sculptor rather than a potter. The decision was patently unfair, since he is a journeyman potter who formerly made utilitarian objects. Moreover, the acknowledged doyenne of the association rarely makes pots, but creates sculptured relief work. Her son-in-law, who has probably never made a pot in his life, had his sculpted reliefs prominently displayed in the Copenhagen exhibit. Sculpture pieces by this woman's daughter were also accepted. Is it any wonder that others on the island felt that the process was unfair and even humiliating?

As this evidence built up it caused potters in various places to refer to the inner membership of the new association as a Mafia, as we have previously mentioned. Yet, the intentions of the "Mafiosi" were defensible, since they believed that they were supporting standards of quality. Nor were they at ease with the situation as it developed. Another native Bornholmer, a rare but tough breed among island potters, refused to submit his work for evaluation but insisted on exhibiting. The association gave in. The jury accepted others who finally submitted work. They were admitted both for the exhibit and for membership.

This resulted in a growing membership that decided to change the selection procedure. They agreed that chapter as a body would evaluate new members,. Certain of the newer people, and especially a couple who were universally respected as artists and as individuals, patiently pressed for a more open policy. It took patience because the procedure

was one of open voting, and because the debate became one between open membership versus the maintenance of high standards.

The contenders for openness temporarily won the day. It began to appear that most ceramists on the island would belong. In 1978, however, the inner clique resigned in an open split. The advocates for comprehensiveness had won a pyrrhic victory. Even though Denmark has enviable success in its cooperative organizations, the potters of Bornholm failed in cooperating. We cannot say the Bornholm studio potters provide a practical model for the folk potters of Mexico.

Non-folk Artisans: A New Breed with International Influence

Bornholm studio potters are a relatively new phenomenon in Danish ceramics. They live on farms, in fishing and farming villages and in harbor towns scattered across the island. Yet, they have very little connection with the now extinct folk potters of the island. Only a minority were born there. Only a couple perpetuate folk styles of pottery or folk techniques of production. Rather, studio potters represent a new breed of ceramists oriented to international styles of modern design who are able to exist because the training and technology that they depend upon was developed by ceramists organized in terms of the Royal Copenhagen Paradigm.

But while studio potters may be described as a functional off-shoot of the factory paradigm, they are not themselves shaped by it. Theirs is a new paradigm, characterized by training to be carried out on a do-it-yourself basis, by sales through their own studios, commercial outlets, exhibitions and sellers cooperatives, and by voluntary associations established to organize their effectiveness. Underlying the success of this paradigm is the infrastructure of an industrial nation with an effective system of public education. These potters illustrate a way in which peasant and folk arts is supplanted. On the surface, they look like a survival or revival, but in fact, they are essentially a new creation.

In the next chapter, we assess the effort to bring these two disparate countries into parallel paradigms with respect to their production of ceramics as folk art and as modern adaptations of an old utilitarian craft transforming folk skills into attractive and desirable contemporary arts. Is it all an exercise in futility for many? Is it a pattern of survival only for the clever entrepreneur? What is to happen to the poor of the poor,

the peasant whose artistic skills and knowledge of traditional forms and patterns, is exploited by entrepreneurs for a tourist market of romantic collectors? Is there a goal to be imagined with benefits and success for all involved?

Chapter Eleven
What Makes the Wheels Turn—Ideals or Profit?

It is frequently the tragedy of the great artist, as it is of the great scientist, that he frightens the ordinary man.
—Loren Eiseley, *The Night Country*, 1971

People committed to working out a paradigm typically provide elaborate justifications for what they do. This tendency to explain and defend activities and involvements constitutes rationalization, the last of the five essential components of the paradigmatic process (Wallace, 1972, 471). In examining this component, we shall include as relevant our own interpretations of findings. Our conclusions function now as rationalizations alongside of those of others.

Cultural Uniformity is Misleading—Nonconformity is the Norm

It is a characteristic of group life that individual conformity to group norms was always limited or incomplete. Anthropologists, before the *Post-Modern* turn, often described cultures as though this were not so. This resulted in characterizing whole societies as though all behavior in them was based upon a single shared pattern when in fact they are shot through with deviations from the supposed standards. It is for this reason that we employ here the method of balanced comparison, since one error, resulting from the formerly unexamined assumption of cultural uniformity, was assuming that select institutions or practices of an advanced industrial nation were typical of that nation. Further, the error identified less admired traits as typical of a developing nation. We want to provide a more accurate interpretation of reality. More precisely, we want to define the Royal Copenhagen Paradigm as a developed

achievement in Denmark, but as an achievement only incompletely and imperfectly worked out, even in Denmark itself.

The Royal Copenhagen Paradigm—Commitment to Aesthetics in Industrial Art

As we turn now to a rationalization of that paradigm. We find that here, too, it is misleading to describe a single set of explanations as though all concerned Danes subscribe to a single philosophy of modern design. Rationalizations can be identified, but so too can conflicting points of view.

The basic idea behind the Royal Copenhagen Paradigm is a commitment to the concept of industrial art. According to this aesthetic, high volume production does not need to preclude the presence of artistic values in resulting artifacts. The ideal is beautiful, but the reality can be less than perfect. For one, the ideal clashes with the need to make a profit. Cost considerations can influence design decisions about which raw materials to use and the amount of artistic work to be invested that may alter the designer's original intention. Again, one encounters limitations of machinery. Often deleterious changes result when committees and production belts separate the creator from the product. Finally, insensitivities and fickle loyalties in the aesthetic preferences of the consuming masses can be influential. In these and other ways, pressures on factory management cause compromise with the ideals of industrial art.

One way in which they compromise is to produce handcrafted items destined for buying elite. They return, in effect, to an older paradigm, that of the craftsperson producing a small number of expensive items for a consumer aristocracy. The Royal Copenhagen Porcelain Factory and Bing and Grøndahl do this by setting up small departments in which individuals such as Gerd Hiort Petersen and Bo Kristiansen produce unique items or short series in stoneware or faience. These companies are, in effect, attempting to resolve a contradiction between two rationalizations for utilitarian art; the one which favors industrial art versus the other which argues for a return to individual artisanry. They subscribe to both at once, but to some extent the result is deceptive. Large factories tend to establish and maintain their reputations by producing some excellent works, which are hand-crafted and exhibited, while most of their sales and income derive from mass-produced wares

characterized by redundancy, even though the designs may be well conceived. Finally, the first justification of the Royal Copenhagen Paradigm a dedication to the ideals of industrial art, but not a complete abandonment of handcrafted, unique products.

The second justification of the Royal Copenhagen Paradigm is that it is rational or planned. The basic intent is to bring together individuals to form a creative cluster of highly skilled and specialized innovators. This eliminates kinship, friendship, or chance as the major determinant in selecting personnel. More, it acknowledges limitations in what to expect from each central individual. The artist is not skilled in business. The chemist is not skilled in design.

Reality Departs from Ideals

Above all, factories overall are committed to financial viability as an ultimate purpose and necessity. They seem reluctant or unable to invest adequately in designers. They prefer to arrange artistic work to be done on an individual, temporary contractual basis, or they depend for design upon lesser-qualified individuals. This deprives the professional designer of that on-going, intense involvement that gave Arnold Krog the opportunity to shape and strengthen the Royal Copenhagen Factory at the turn of the 20th century. It also makes it difficult for all but a small number of designers to support themselves well enough to continue their artistic careers. The same is true of chemists and other technicians. In short, the stated goal is that production should be rational, but it is easy for emphasis to shift to a competitive reason for their existence — how to make a profit. Artistic investments ultimately may get short-changed in the process.

A third rationalization for modern design is that it results in objects that function well when put to their intended use. At its best, Danish design can be superbly functional in this sense. Yet, often, other values such as color, line, or shape subordinate function and dominate design considerations. Danes seem particularly addicted at times to colorful flights of fancy, and this alone may justify products. Most of the work of Bjørn Wiinblad fits this pattern. A stunning decorative effect may be taken in itself as sufficient *raison d'être* for a work of art and its mass production.

A fourth expressed value is honesty in design. The natural qualities of the raw materials are to be built upon rather than distorted, misused, or hidden. Even plastic, so difficult to work with in this way, can become beautiful and yet remain plastic in the hands of an Erik Magnussen. Consistent with this, earth colors are preferred in objects made of wood, wool or clay; but intense, bright, basic colors may be best for objects of plastic.

Honesty in design is often characteristic of Danish work, but it is not universal. Deviations from this commonly expressed norm are particularly characteristic of factories thought by all to be quite undistinguished. Some manufacture faience made to imitate porcelain. Others produce miniatures of Danish antiquities as tourist items. Small bronze-age-style shields of ceramic are perhaps the epitome of the commercial mentality whose only rationalization is that sales are the primary goal of business. The Danes we have been interested in generally are "honest" in design, but they do co-exist with less committed producers.

El Palomar: Mining Tradition for Gold

Rationalizations by, or for, the best of the Mexican factories are largely different from, but in not inconsistent with, those of the best factories in Denmark. Nothing in their stated goals conflicts with an adoption of the four basic principles of the Royal Copenhagen Paradigm: (1) industrial art, (2) rationality (planning), (3) functionalism, and (4) honest design.

El Palomar was founded to produce aesthetically attractive ceramics that would join the Mexican peasant heritage to an advanced stoneware technology. Making a profit was also a founding goal. This included a conscious calculation in which the peasant potters of Tonalá figured prominently. They were capable of exquisite ceramic painting. They would work for very low wages. In the last few years, as the cost of labor has skyrocketed, another rationalization, one formerly little thought of, has become dominant: the desirability of achieving high cost efficiency in the operation of the plant. There is nothing inherent in these rationalizations to prevent the Royal Copenhagen Paradigm from being a guide. To do so would be fully consistent with their stated goals. However, the paradigm is unknown to El Palomar.

The Paradigm of Family Factories: Fight and Fission
The family owned and operated ceramics factory is relatively common in Denmark. The practice is defended on the grounds that it allows an organization to perpetuate high standards of excellence known to have characterized a particular family in the past. It is also felt to bring to the business world some of the valued qualities of successful family life; pride, mutual reliance, and security.

Since family members tend eventually to fight and fission; the selfishness or shortsightedness of particular individuals often, or usually, will keep a family from holding together. The rationalization of the family paradigm is thereby ambivalent. People seem to admire and idealize it, but also to reject it, as a model.

We found in the ceramics industry that the family model could be joined to the Royal Copenhagen Paradigm. The greatest obstacle in a hybrid of this sort concerns rationality. The selection of personnel based on objective, performance-based criteria goes contrary to establishing relationships through descent and marriage. Indeed, it is because of this contradiction that the family paradigm ultimately seems to fail, even though it may implement well the Royal Copenhagen Paradigm for a time. Eventually every family organization whose history we explored fell into decline because family ties, rather than demonstrable excellence, persisted or re-emerged as the basis for recruitment.

The Peasant Potter Paradigm: Romantic Rationalization, Economic Despair
In both Denmark and Mexico, the peasant approach to production is justified on economic and humanistic grounds. The economic rationalization is the more insistent of the two. When the greater part of the population is a preindustrial peasantry, it becomes imperative to find ways to adapt their technology to modern market conditions. Peasants lack machinery and technological skills. They are a large resource in labor, and are thought to succeed best in labor-intensive occupations. The investment of their time and energy is valuable in an emerging economy.

Yet, the belief that labor-intensive occupations are beneficial is precisely what hurts the peasant the most. To be labor-intensive results in paying labor poorly. Time and energy cannot be reimbursed richly when there is so much of it, and when its value is not multiplied by

means of machinery. In concrete terms, this means that the peasant potters of Denmark and Mexico were and are poorly paid.

Neither efforts on their own behalf nor the well-intentioned efforts of planning agencies succeed in making peasant pottery truly competitive on the modern market. Efforts succeed, overall, only so long as potters remain poorly paid. Despite this, however, efforts to support and encourage peasant industries continue. Beyond the economic rationalizations are two more related to humanistic values. These rationalizations include romanticizing or denigrating peasant life, as well as romanticizing the old traditional peasant products.

According to a rationalization of the peasant way of life, efforts to harness it to the modern economy, would provide a family and community style of living that has much appeal. The peasant is thought to pursue a specialization that is more than just an occupation. It is a way of life. The worker lives with or near his or her family. The microcosm of the village provides a wholesome environment. However, this is the rationalization, generally of outsiders.

To the insider, peasant pursuits are the ways of the poor, the defenseless and the despised. Peasants are not admired, they are denigrated. Peasant potters are, in general, not respected. They are dismissed as uninteresting and unimportant. Neglect or pity are common attitudes. Ideas of this sort lie behind the fact that peasant potters leave their craft without regrets the moment they have adequate opportunity to earn more in other kinds of labor. Few are the exceptions to this rule.

Another rationalization for peasant crafts is that they ought to be preserved because they perpetuate the true traditions of a nation. The idea is romantic. Indeed, it derives at least in part from nineteenth century philosophical ideas characterized as romantic. It derives also from contemporary ideology, as an acknowledgement that ethnic minorities, racial groups, and developing nations need symbols of unity and purpose. In addition, and quite aside from romanticism and ideology, the specter of universal cultural homogenization stimulates in many the wish to retain old customs, even though they also wish to modernize in order to achieve the advantages of highly industrialized societies.

William McCord deals with this dilemma in commenting, "This is the first challenge: to construct a society receptive to modernization

without utterly destroying traditional civilizations." In identifying this challenge, however, McCord recognizes that destruction or transformation are predictable outcomes. It is desirable to retain old customs, he believes. "Nevertheless, certain social changes put in motion by education, persuasion, the law, or simply economic evolution itself must accompany the creation of a politically free, economically vigorous society." (McCord, 1965, 10.)

At this point, we introduce a rationalization based upon the present investigation. We find that peasant arts survive in a rather questionable manner if they do not become extinct. They may, as in Denmark, persist or revive as no more than resuscitated fossils. Alternatively, as in Mexico, they may lose their identification with peasants and localities. This occurs when villagers manufacture whatever will sell, without regard for origin, quality, or meaning. The notion of peasant arts becomes particularly ambiguous when the wares offered originate as copies, often inferior, of products created by individuals who belong to the international elite of modern designers. We conclude, then, that the potential survival of peasant arts as such is largely a delusion. Perpetuating preindustrial arts as authentic art, may also perpetuate the powerless and impoverished culture that sustained it. No one wants that, and perhaps for that reason, people close their eyes to an incongruity that ought otherwise to be blatantly apparent to anyone.

The effort to support peasant arts as such is ultimately destined to fail, we believe, for economic as well as for artistic reasons. Certainly, peasant pottery became extinct in Denmark despite last-ditch efforts to survive. Denmark seems in the large to predict the fate of peasant artisanry in Mexico. Yet, anthropologists overall have been especially prominent in rationalizing the value of perpetuating peasant industries by adapting them rather than replacing them. In part, we subscribe to this idea ourselves. Until other opportunities for employment open up (or can be created) it is better to improve what is there than to disregard it. However, we need to recognize that our efforts to help peasants in this way will be transitional and ameliorative if the goal is to achieve a level of economic well-being comparable to that of leading industrial nations. Peasants in such nations will survive and thrive as individuals. However, they will not survive as peasants, since peasant culture is only truly viable in a preindustrial society. To the extent

that our aims include support and encouragement of arts and crafts, we need to respond to this criticism. In focusing so heavily upon the study of peasant culture, how can we justify our neglect of cultures that also produce aesthetically valuable products? Why do we not concern ourselves more with the study of elite and aristocratic cultures? Why do we not give more attention to the culture of the middle class? Enter on stage: studio potters.

Studio Potters—Making a Life While Making a Living

It is striking that humanistic virtues thought to justify efforts to help peasant potters adapt and survive are precisely the virtues that provide a rationale for the new breed of studio potters. Economically, these ceramists acknowledge the need to earn enough from their wares to live well. Humanistically, they see the ultimate justification of their craft in non-economic values. They justify what they do as a whole way of life. This rationalization may include living on a farm or in a harbor town. It includes the pleasures of working with clay. Often these potters are relatively poor. They compromise their economic goals because they feel that they achieve the larger goal of living as potters. However, though poor, they are not despised. Achievement in the international arena of modern design is respected and encouraged by the society in which they live. Essentially middle-class in family style, education and aspirations, we expect these potters to survive. Some will be excellent, creative and happy. Should not anthropologists give attention to populations such as these? Is it not important to learn as much about them as we can?

Designers: An Artistic Elite—a Resource to Nourish

Finally, we turn to designers as such. They can be part of the Royal Copenhagen Paradigm, but they may also operate as independent entrepreneurs; they may be engaged in integrated roles as designers and producers. We return to them here because we want to stress that they, too, warrant anthropological attention. Like studio potters, they want economic viability. (Their aspirations, in fact are generally higher in this regard.) They also see their occupation as a way of life. Yet only a few can support that way of life by designing for factories. Using their skills for product development in a wide range of materials helps. Government and foundation grants are also supportive. Teaching positions provide alternatives for some. A few, especially people like

229

Wilmot and Bustamante in Mexico and Wiinblad in Denmark, establish their own small factories. On the whole, however, many talented and potentially creative individuals receive inadequate societal support.

Barriers to individual success are rationalized, often by the belief that the best will succeed. According to this belief, room at the top is limited and cannot admit everyone. We believe, however, that these rationalizations are inadequate to justify perpetuation of the system as it is. What a better system should be, we do not know. But in order to find out, it would be helpful to examine in more detail how designers are trained and employed. We argue, in short, that here too, anthropologists need to allocate attention to a neglected segment of the population.

In this case, whatever the social origins of the individual, we are talking about an elite. They constitute an artistic elite. Small in numbers, they exert a powerful influence on the lives of us all, for they shape and color our environment. Our psyches are the ultimate raw materials of their craft. They have nothing to do with peasants, yet we anthropologists have invested most of our research energy of the last two decades in the study of peasants. Anthropologists and social researchers may do well to re-examine these priorities. We need to trace the paths out of the peasantry into other levels of society where peasant roots may blossom as transformed life styles. Talent often lies dormant among the uneducated and poor who live in rural poverty and city slums; it also lies dormant among the unromanticized middle classes. That, at least, is the final argument of this investigation. What we believe we found in common among those few successful operations moving from folk art to modern design was the importance of the exposure of the artist/ craftsperson to literacy and a wider world view. We identify that, but above all we propose it. This should be no surprise. It is not a new idea. Julian Steward argued along these same lines more than a quarter of a century ago (Steward 1953). We have made the effort ourselves in earlier work (Anderson, 1971, 1-8, 1973, *passim*, 1975, *passim*). Only recently, however, has the idea caught on.

We see in Denmark almost no potters who are peasants, and yet there still are people throwing pots and people buying what is thrown. We see peasant-era designs modified for contemporary pleasure and use. We see the products of new industries replacing the handmade utilitarian wares of a previous age, while perpetuating a human touch

on the earth's clay. If nurturing the artistic creativity of peasant potters is the goal, then the Danish paradigms provide models for successful application in Mexico. Education, mentoring, apprenticeships, and combinations of creative clusters with management skills, sensitivity to people and cultures, and artistic talent are at the core of the paradigm transformations to be implemented.

EPILOGUE
A Thin Thirty-five Year
Retrospective, 1975-2010

So much of our time is preparation, so much is routine,
and so much retrospect, that the path of each man's genius contracts itself
to a very few hours.
—Ralph Waldo Emerson

Ultimately, our most valuable achievement as cultural anthropologists is
that we document how people lived their lives while we were with them.
In that way we create contemporary descriptions that eventually become
historical treasures, irreplaceable archives of the past.
—Robert Anderson, MD; *The Back Door to Medicine* (2010)

The Artist Ceramists of Mexico

Reluctantly we had to give up plans to return to Denmark and Mexico to reconnect with the artists and factories we visited over three decades ago. However, an update on some of the people and enterprises we describe in this book was limited largely to Internet searches and personal communications. In that way we were able to follow up on Jorge Wilmot, Ken and Jackie Edwards, Sergio Bustamante, Arthur Kent, José Bernabe, and Dolores Chiappone in Mexico as well as on Kai Bojesen, Henning Koppel, the Royal Copenhagen Porcelain Factory, the *Bing og Grøndahl* enterprise, the Georg Jensen silver designs, and the Holmegaard factory.

Recent (2010) pictures of
Sergio Bustamante, Ken Edwards,
and Jorge Wilmot, all three continue to
create art in new adventuresome ways.

Photo of Wilmot, by Kinich Ramirez
2006

Jorge Wilmot

Now over 80 years of age, Wilmot still lives in Tonalá surrounded by his books. On occasion he offers workshops at the school for arts he founded. "When I was working," he told one reporter, "I never thought of it as creating a piece of art. I was doing what I wanted to do and what I could do and I organized other people to do it." On another occasion he recalled, "I am from Mexico, but it is like [being] from another country that no longer exists" (From the Web, 2010).

Jorge Wilmot now is one of the treasures of Mexico, one of its greatest ceramic artists. He has been honored with many awards including the *Premio National en Artes y Tradiciones* and an award by the *Fomento Cultural Banamex*. Wilmot was deemed "Creator Emeritus" by the National System of Creators of Art (SNCA) in 1994 for his contribution to Mexico's cultural legacy as well as to the development of other generations of artists) . He created the National Ceramic Museum in his former house in Tonalá.

In 2009 and 2010, a series of exhibitions in homage to Wilmot's work were held in various parts of Mexico. The exhibitions were sponsored by the Museum of Popular Art (MAP) in Mexico City. The exhibitions feature more than five decade's of Wilmot's pottery and ceramics as well as photographs, memorabilia and Wilmot's forays into other crafts such as glassmaking and jewelry design.

In interviews with reporters, Wilmot talks about change: Tonalá's population expanded from about 11,500 in 1950 to 337,150 at the turn of the 21st century. He no longer has a ceramic factory and is reluctant to speak of his achievements. He says of his work as an artisan, "I dedicated almost 40 years of morning, day and night to it — it was an obsession." He speaks of his passion and determination to achieve a Chinese blue glaze without using cobalt: "... it took me 30 years, but I did it." With thousands of objects related to ceramics, his interest ended and it became to him like closing a circle. He is now more interested in bread making. The dough of bread and the clay for pots have much in common, but Wilmot says you can feed the world with bread.

Ken and Jackie Edwards

Jackie Edwards died in 1995, but Ken is still making pottery, and teaching others his methods in Guatemala near Lake Atitlan. In his

80s, he appears vigorous and articulate in a recent interview posted on YouTube. He has a small "family" of potters who produce his ware and work on their own designs. He still keeps a workshop in Tonalá and his fame has spread widely through the years. His dinnerware and ceramic pieces have grown in popularity over time and are now highly collectible. A quick look at E-Bay will bring many examples of work for sale with his trademark.

Sergio Bustamante

Now considered a major Mexican artist of international renown, Sergio's work may be found in boutiques, specialty galleries, and shops throughout the United States and in many parts of the western world. Since our interviews early in his career, he has continued to develop as an artist of whimsy, magic, and mysticism with commercial success beyond his own imagination. While Bustamante's works initially focused on painting and paper mâché, in the mid-1970's his talents led to the creation of sculptures in wood and bronze, many reflecting animal themes. 1979 marked the inauguration of innovative furniture designs in wood and glass with bronze accents, which are currently available in distinctive patterns and motifs.

The creation of ceramic sculptures in the mid-1980's provided avenues for the use of color and form in ways not previously explored. In 1992, the initiation of an extensive line of exquisite jewelry in bronze, gold and silver, many pieces set with precious and semi-precious stones and, again, often reflecting animal themes, marked a new and expansive direction for his creations.

In this same year, he introduced a new series of paper mâché sculptures. In the new millennium, Bustamante continues to explore uncharted paths for the further expression of his uniquely imaginative and gifted talents. The original Sermel shop he founded is still listed as a ceramics shop in Tonalá. In Tlaquepaque he founded The Sergio Bustamante Gallery. He has exhibited his work in Mexico City, New York, Washington, D.C., Montreal, Switzerland, Japan, Russia and throughout Mexico. He seems to be enjoying both artistic and commercial success.

Arthur Kent, José Bernabe, and Dolores Chiappone

The partner and supporter of Ken Edwards in developing the El Palomar factory, Arthur Kent first went to Mexico in the 1960's having retired at 60 with heart problems. He continued to work for years as the factory began to thrive. His involvement was crucial to its success. Kent died in 2001 having lived to the age of 102. At about this time, in the aftermath of the 9/11 attack on the World Trade Center, the export trade took a blow and El Palomar began to experience hard times. However, the factory workshop and salesroom are still in operation, with Kent's widow, Bertha Perez Kent, involved in its daily operation.

José Bernabe Campechano, initially employed by Ken Edwards at El Palomar, now is the most well known maker of *Petatillo* pottery in Tonalá. No longer working for El Palomar, he has his own family workshop offering classes to other potters in this difficult cross-hatched painting style now a family tradition for four generations. Now 73 years old (2010), he continues this intensive and difficult ceramic work.

A recent Web Site celebrated his work and his 70th birthday:

> The Bernabe family has been producing ceramic items for more than 200 years. More than 40 years ago they began to specialize in the demanding technique of the "petatillo". Nowadays their masterpieces are representing a unique synthesis of tradition and innovation. Don José uses white, black and beige-coloured and red clay and very special ceramic glazes, some of which he is making himself. Preparing the "petatillo" the blank pieces get a bath of red clay from inside and outside. This is the basis to engrave the decoration with a special gouge. In combination with white glaze the netlike pattern is created, which is associated with the structure of the "petate" – the Mexican sleeping mat made from weaved reed. In days past, the enameling was done with greta, a mixture of oxides and water, but today lead-free enamels are used, especially if designed for export.
>
> José has received numerous awards and prizes over the years for his creative work. He is featured in the landmark book, Great Masters of Mexican Folk Art. In 1964 he was honored with the "Premio Jalisco", the most important and most desired award

for artists in the state of Jalisco. His pride and joy, however, is a letter of thanks for a gift in "petatillo"-style, sent from pope John Paul II. with his apostolic benediction.

*www.mexicoartshow.com/**bernabe**.html*
http://www.altamex.de/index.php/language/uk/cat/c25_Jos--Bernabe.html

Dolores Chiappone resides permanently in Carmel-by-the-Sea, California and continues an active professional life through paintings exhibited in galleries throughout the Carmel Valley and other areas in California. Her paintings may be viewed on the Internet.

Retrospective on The Lively Arts and Potters of Jalisco

Thirty years of change apparently has not brought a renaissance to the arts of Guadalajara that continues to play out of the old paradigm of copy and reproduce without substantive innovation. What appears to have happened has been an explosion of the population that has transformed the area of discrete neighboring villages into an urban sprawl with little demarcation between Guadalajara, Tlaquepaque, and Tonalá. Yet the reputation for pottery, painting, and other arts and crafts lives on lustily as streets are filled with new shops (alongside the old) selling newly made pieces with the old designs and patterns based on the work of their international stars—Wilmot, Edwards, Bustamante and a few local entrepreneurs. Potters and painters still produce goods for a tourist market that has diminished, and for a local market of urban international residents that has increased. No major new enterprises have emerged, supporting young artists for innovation, as did the once experimental embryonic factories of Wilmot, Edwards and Kent, and José Norman Palacio. Those exciting ceramic factories either no longer exist or, as in the case of El Palomar, are struggling to survive. The exception may be the international outreach of Bustamante, whose individualistic style drew him away from readily identifiable Mexican themes to designs filled with dreamlike fantasies reminiscent of the concepts of the Dane, Bjørn Wiinblad or the Russian-French artist, Chagall.

Many of the energetic key innovators, who represented the growing tip of development, as Maslow defined it, if still living have grown old

and retreated into shells of disillusionment or are pursuing different interests. It is true for Wilmot, Edwards, and Chiappone. Native painters such as José Bernabe developed local reputations for their high quality traditional work, but have had no impact on the economic status of peasant potter/painters. Alas, others seem to have disappeared from sight as flotsam in the river of time.

A Thirty Year Retrospective on our Danish Subjects

Beginning with Royal Copenhagen Porcelain, the leading Danish company and our early paradigm model, the story of the development of the Danish transition from folk art to modern design continues to unfold. In developing the theoretical concept we called the Royal Copenhagen Paradigm, we applied the ideas of Mead, Maslow and Wallace, noting how important it was to the success of the company to bring together a cluster of creative individuals with diverse skills, including artistic talent and focus, business management ability, and engineering knowledge. We used Maslow's concept of creative persons as non-conformists who need to be accommodated within a creative cluster. We used Wallace's list of essential components for success in paradigm development—innovation, core development, exploitation, functional consequences, and rationalization. We applied those framing concepts to identify a Royal Copenhagen Paradigm as a way to write about Danish porcelain companies, both large and small, as well as family enterprises. We did not apply it to the nation as a whole. In retrospect some aspects of the paradigm now apply across the nation. Greater clarity often comes with hindsight.

Mergers and Acquisitions:
Royal Copenhagen, Bing and Grøndahl, Georg Jensen, Holmegaard, Kähler

Wallace's functional consequences component draws attention to many companies as technology, competition in production and distribution, economic shifts, changes in social interest and market demands have had an impact on the prosperity of the organizations we studied earlier. Some of those changes are in an opposite direction from what we would have predicted. Royal Copenhagen Porcelain,

for example, once supplier to the Queen of Denmark, has shifted its identify and to some extent its purpose.

By the mid 1980s, Royal Copenhagen had acquired Georg Jensen and incorporated with Holmegaard Glass Factory and Bing & Grøndahl in 1987. In subsequent years, the buying and selling of parts of this collective have been mind boggling—almost too convoluted to track and follow. Today, Royal Copenhagen is a part of a group of Scandinavian companies known as *Royal Scandinavia*. Together with Georg Jensen, Royal Copenhagen for a time was owned by the Danish private equity fund, Axcel. The selling, acquisition, re-naming and re-bundling of these properties involved complex trading negotiations by stockholders far removed from folk art or production of modern design. In April, 2008 Royal Copenhagen reported that it was moving nearly all of its production to Thailand.

The reorganized *Royal Scandinavia* is now under long-term Swedish ownership of at least 20 percent. The majority owner Carlsberg (a Danish beer company) over time will reduce its investment in *Royal Scandinavia* in order to diversify the new company's ownership base. In addition to a listing on the Copenhagen Stock Exchange, *Royal Scandinavia* is also considering listing its shares on the Stockholm Stock Exchange.

According to a press release:

A coordinated presentation of these individually strong quality brands creates better resources and considerably strengthens export opportunities. With their unique Scandinavian design and fine craftsmanship, these products target the same quality-conscious consumers around the world. Royal Scandinavia Holding is controlled by Axcel and two of Axcel's shareholders, Danish pension funds PKA, and Lønmodtagernes Dyrtidsfond as well as their joint company Dansk Industri Invest. Carlsberg and RC Investments are minority shareholders and contribute to the financing of Royal Scandinavia via subordinated loans. Royal Scandinavia dates back to 1742, when the Kosta glassworks in Sweden were founded and The Royal Porcelain Manufacturer in Denmark was founded in 1775 at the initiative of the royal family.

Today, Royal Scandinavia is one of the leading industrial arts groups world-wide with a broad product mix and a number of strong international brands. Turnover for the most recent financial year amounted to DKK 2.6bn and the group employs more than 3,000 people.

The group consists of Royal Copenhagen, Georg Jensen, Orrefors, Kosta Boda, Boda Nova, Holmegaard, Höganäs Keramik and Venini— all well-known international brands within the product areas of porcelain, glassware, and cutlery as well as jewelry and accessories.

Another report from the Danish Ministry of Foreign Affairs states:

> In recent years, Royal Copenhagen acquired Georg Jensen in 1972, incorporated with Holmegaard Glass Factory in 1985, and finally Bing & Grøndahl in 1987. Today, Royal Copenhagen is a part of a group of Scandinavian companies, Royal Scandinavia, together with Georg Jensen, and is owned by the Danish private equity fund, Axcel. Following Axcel's acquisition of Royal Scandinavia, Holmegaard Glasværk was sold in a MBO and a controlling interest in the Swedish glass works Orrefors Kosta Boda was sold to New Wave Group. In April 2008 it was reported that Royal Copenhagen was moving nearly all of its production to Thailand.
> *(http://www.denmark.dk/en/servicemenu/News/BusinessNews/ RoyalCopenhagenToThailand.htm. Retrieved 2010-07-19)*

We now turn away from our paradigmatic model, Royal Copenhagen, to review what has happened with some of the other artists and companies we studied so many years ago. Although not a potter, we will start with the *avante garde* silversmith and wood turner, Kay Bojesen.

Kay Bojesen

In chapter two, we described the work of then contemporary artists who were leaders in shaping the direction of Danish design in the arts. We wrote, in the late 1970s, of visiting the store and workplace of Kay

Bojesen, whose wooden monkey was copied without copyright until it is now ubiquitous and common. Bojesen died August 28, 1958, at the age of 72. However, his shop in Copenhagen, founded in 1932, operated until the nineteen-eighties. Following his death, his widow Erna Bojesen maintained the store until her death in 1986. At the time of our original writing, Erna Bojesen often worked in the store. The wooden toys we bought for our collection over the years have been played with by many of our grandchildren resulting in breaks and toddler crayon marks, and some were given away as special gifts. For some reason, we never bought a monkey. The Bojesen monkey was expensive at the time, and cheap copies from Thailand were available on the street as tourist items. We chose to purchase other wooden toys designed to stimulate a child's imagination including a "conversion" car in a wooden box that served as a garage. The "car" holds a driver and can be changed into a truck hauling wooden planks, a fire truck with ladder, a truck with a hoist, and a bus. Despite the overwhelming production of mechanized cars, hot wheels, and plastic robotic transformers that modern children covet through TV advertising, the plain unfinished wooden "conversion" car in its convertible wooden box still fascinates a preschool child, boy or girl, at least for a short while.

Before his death, Bojesen enjoyed widespread recognition and appreciation. He was named an honorary member of the National Association of Danish Arts and Crafts, and was recognized for his toys by the Danish National Committee of the OEMP (World Organization for Early Childhood Education).

Henning Koppel

Henning Koppel, another leading designer we visited, admired, and described in chapter two, died in 1981 at the age of 63. By that time, he had created an astonishing range of work extending from stainless steel cutlery such as *New York* that found its way into the homes of millions; to magnificent one-of-a kind signature pieces such as the silver and crystal chandelier he designed in 1979 to celebrate the 75th anniversary of the Georg Jensen enterprise.

He won many awards during his lifetime including the Milan Triennial, the International Design Award, and the Lunning Prize. Accolades are important, but what means even more is that people

still choose to wear a Henning Koppel watch or to serve coffee from one of his pots. The integrity and appeal of his designs remain vital and undiminished. The creativity and innovation he applied so independently, and with such apparent disregard for practicality, did not impede the appeal of his designs. In even the briefest of searches on the internet for his work, hundreds of the objects he created are pictured and are available for purchase.

Another Era Ends

Thus, we have learned of the end of Danish ownership and identity as the four giants of innovation and industry (Georg Jensen, Bing and Grøndahl, Holmegaard, and Royal Copenhagen) merged into a conglomerate focused on the bottom line of a business model for profit. As production continues for old Royal Copenhagen products in Thailand, the product line has taken a turn away from modern design and appears to have turned back to the popular designs of cobalt blue and floral ware that were novel centuries ago and that live on romantically in the public mind as precious pieces of history. The fresh, contemporary innovations brought to Royal Copenhagen by Jean Gauguin and by various other talented ceramists appear no longer to attract buyers. The plank of the RC Paradigm that provided space for *avant-garde* artists, as well as providing limited production for experimental wares and show-room space for new non-traditional and non-folk art designs has been abandoned. No signs of hand-thrown pots or stoneware now appear in advertising.

Thus, it seems that Royal Copenhagen, the dinnerware of Danish Royalty, has become a factory/museum to feed the fantasies of customers who collect reproductions of items representing a past glory even though produced in efficient factories of the 21st century, located, it seems, in Thailand. The efforts of Royal Porcelain and Bing and Grøndahl, to create and innovate for a modern populace while continuing the porcelain-ware designed for an earlier age appears to have failed. This paradigm shift leaves no clear model for Mexico.

Kay Bojesen in his studio. His "Conversion" car in a wooden box; his famous hanging monkey.

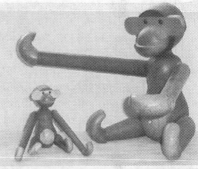

Below: Edna having coffee and chocolate covered "crowns" on the Royal Copenhagen patio, a favorite morning place. The shop (first floor) can be seen through the window. (1976)

Arne Ranslet, Tulla Ranslet,
Arne with daughter.
Haico Nitzche (left)
Henning Koppel (right) in

Den Permanente Is Bankrupt

In addition to the demise, or reconfiguration, of these companies, the effort to provide a store to display the wares of modern artists also has fallen to the fate of an economy that makes it difficult to meet the monthly costs of leasing a store on Strøget, the main pedestrian walking and shopping street in Copenhagen. The darkened windows *of Den Permanente*, whose founders included Kay Bojesen, display a "for lease" sign. The shop no longer provides a respected venue through which juried pieces may be presented for sale and their makers' reputations enhanced.

When we talked with artists in the 1970s, especially on Bornholm, we became aware that some problems were already threatening the operation of *Den Permanente* as a cooperative sales arena. Products sent for sale often were returned unsold, leaving artists without a way to reach potential connoisseurs.

At the beginning of the 1980s, *Den Permanente*, almost bankrupt, was taken over by Maki Koizumi, a Japanese exporter living in Denmark. The new management obviously was unable to change the fortunes of the store. Danes today tend more readily to associate *Den Permanente* with a very popular beach which carries the same name but is located near Aarhus on the Danish coast.

A description of the store *Den Permanente*, that obviously was written before its closure, provides an idea of how important this operation was to the Danish artists who enhanced their reputations by displaying there.

Founded in 1931, Den Permanente association is a cooperative of Danish artists and entrepreneurs that wish to enhance the image of small-scale know-how in the areas of design, furniture and interior decoration. The permanent exhibit of Danish art and craft industry (more commonly known as "Den Permanente"), based in the city of Copenhagen, attests to the dynamism of Danish creation throughout the XXth century.

Through a selection of kitchen utensils, toys, mirrors, lamps, jewelry, clothes, etc... that are shown to the public, the outlines of creation at the crossroads between art and consumption are

drawn, with reinforcement of the criteria for stylistic objects in the manner that the main representatives of this sector imagined them.

The first thing that distinguishes Den Permanente from other companies is the fact that Den Permanente is an association. The members are decorative art artisans who confide their productions to us for them to be exhibited and sold. The committee censors, judges ... which objects are the ones that, from an artistic point of view and also in terms of quality, have the required guarantees to be deemed worthy of representing Danish art at Den Permanente. Moreover, it has played an important role for the whole of both the craft industry and decorative arts since, throughout the years, it has set a standard for quality.

(http://www.ina.fr/fresques/europe-des-cultures-en/notice/ Europe00015/danish-design-den-permanente) 26-06-1961

The very modern department store, Ilums Bolighus, is still prospering a few doors down the street on Strøget, selling a wide variety of artistic goods made not only in Denmark but also throughout the world. As a business, it is succeeding, but it is not succeeding as a resource for Danish artists.

New stores, of course, have entered the arena such as DMK and Klassic, and tourists are finding their way to the doors of new shops to discover a different scene from earlier years with less emphasis on Danish and more emphasis on Modern Scandinavian.

The Kähler Factory—Like Phoenix Rising from the Fire

On the other side of the picture, however, two unexpected developments jumped out at us. First, the old Kähler factory, which under new management appeared to be in a dire difficulty, experienced an almost miraculous revival. Still using the mark of the original owner, HAK, the factory in Naestved on the Island of Sjaelland, constructed a new energized operation on the foundations of the old. All products are made by hand, thrown on the old style wheels or made by coil and hand crafting; all are fired in hand-fed kilns, and painted by individual artists.

Apprenticeships still take place in the Kähler workshop. Innovative artists, proudly advertised, are part of the stable of designers attached to the company. Beautifully and expensively established shops sell Kähler ceramics in Naestved and in Aarhus. Websites with videos presenting the history and contemporary work of the Kähler Company are available. A museum showing the works of Kähler founders and artists as well as works by other artists in Sjælland constitutes part of the Kähler company contribution to the city of Naestved.

Interest in Kähler products appears to have escalated as collectors buy and sell both old goods and new. As for the paradigm we used earlier, this factory is part of the family model that to its benefit adapted the RC model on a small scale. Although nearly moribund in the late 1970s, the new ownership appears not to have succumbed to the easy, cheap route of making thousands of inexpensive souvenirs and reducing its staff to a handful of painters whose skills are limited to repetition. Somehow, they have continued to search for and persuade ceramists with non-conformist talent to create art objects for production. They do not specialize in dinnerware or utilitarian goods, but remain loyal to the founders' model of artistic creation while marrying that production to a modern business sense of advertising and sales in their market niche.

On the surface what seems to behind the scenes of this glowing success story is, however, a tangled succession of years of struggle, failure, and attempted rescues. In 1974, Bøje Degener and his son Palle purchased the nearly moribund Kähler factory. They sold off a piece of the land to finance renovation. This provided a small window of opportunity for resuscitation. In 1977, the town of Naestved gave support to establish the Kähler museum. Thousands of old pottery pieces were collected for the museum, with about 3000 coming from the old Kähler family house. The descendants of Kai Nielsen, a renowned artist who was associated with the founders in the previous century, sued the factory for ownership of Nielsen's original molds. Although the family lost the lawsuit, most of the molds were destroyed.

By 1978, when we last visited the factory, Degener was failing financially. By 1980 the factory and its remaining lands were sold to Bøje Nielsen. According to Peder Rasmussen, (2002) Nielsen did not have the slightest understanding of ceramics, nor did anyone on his board of directors. Soon he, too, found the business unprofitable and in 1983

turned it over to his assistant, Nina Jørgensen. Rasmussen comments that the artists and the ceramic workers did what they could to make good use of the world famous factory place and keep it alive, including launching a small, but unsuccessful, boutique in Copenhagen. The ceramics produced in those years included a variety of types but none of very high quality. It was sad to see that deterioration of the HAK trademark, revered for so many years. In the meantime, another large piece of the park-like property at the front of the factory building was sold to developers who created a street lined with strip mall buildings for lease. The factory, which originally had occupied a beautiful setting at the foot of Kähler Hill, finds itself hemmed in—only a vague memory of its former greatness.

In 1984, a fire destroyed most of the factory. Fortunately, most of the outside walls, with their valued Reistrup decorations were saved. The owners rebuilt the factory, preserving the foundation and walls, but modernizing the production equipment. In 1993, the factory was sold again, this time to Inge and Knud Sørensen. The Sorensens had business and investing experience, but no experience in ceramic production or artistic design. They were committed, however, to the creation of a new enterprise organized on the old principles of handmade art pieces. They organized an artistic advisory committee and appointed personnel with ceramic experience and artistic talent. Rasmussen said, as he wrote of them at that time, "It is clearly difficult to transform what, for so many years had been going the wrong direction." Although he assessed the potential for success with "reserved optimism", his crystal ball appears to have been clear and accurate. The Kähler legacy has revived. In 2010, Kähler is strong, a tribute to what the protection of a mammoth conglomerate can accomplish.

Camilla Christensen, Project Manager of Danish Design Management, the Kähler Design division, sent us the reference to Rasmussen's work and gave us an update on Kähler that helped us interpret the renaissance we encountered on websites. She wrote that in 2007 the well-established Naestved company Holmegaard Glass took over Kähler hoping to bring it back into the front row of Danish ceramics. Unfortunately the financial crisis also hit Holmegaard (which had earlier been purchased by Royal Copenhagen Porcelain as noted above, and in September 2008 Kähler went bankrupt. The next month,

as if waiting in the wings, Kähler was bought by Mr. Frantz Longhi, a successful and ambitious architect who for more than 25 years has run his own business, Danish Management, with offices all over the world. When asked why Mr. Longhi was interested in the failed Kähler operation, and why she became Director of Kähler, Christensen replied:

"In regards to Mr. Longhi, the reason is actually quite simple; he has a strong passion for Danish design, and has for many years collected art pieces from Kähler, especially the Kai Nielsen figurines are of his big interest. But furthermore he couldn't bear that an old Danish cultural institution as Kähler should end it's days as a bankruptcy, so what was more natural than to buy it. I myself share the same interest in design and the old craftsmanship, so I'm of course very pleased that these interests can be united in my job as project manager working with product development and purchasing." *(private email July, 2010)*

The result, based on these reports and elegant website videos of artists at work in the Kähler factory, as well as a video tour showing the work and the vibrancy of the associated museum, appears to have brought Kähler back into prominence for high quality Danish design. Additional websites show a beautifully designed and stocked Kähler store in Aarhus, and an indication that one in Copenhagen is underway.

The early Royal Copenhagen Paradigm lives again in this fresh approach to reviving Kähler. The paradigm includes finding people with creative artistic talent as well as others with business and marketing expertise, and leaving decisions to responsible on-site management in collaboration with employees and expert artistic advisors as made possible by the Sørensens and Longhi.

Bornholm: Footprints Fading but New Signs of Energy and Art

In another part of Denmark, on the quiet Island of Bornholm, the passing of time brought unanticipated positive change. We could not have predicted an artistic explosion of this caliber by the turn of the millennium. First, we need to offer a brief reminder of the island's history.

Lying off the eastern coast of the main island of Sjælland that boasts the capitol Copenhagen, Bornholm was the victim of German occupation during World War II, and of Russian shelling in the days

following the liberation of Denmark. Fortunately, the unusual geology of Bornholm includes deep veins of clay that potters have appreciated for many generations. Since the 1700s, hundreds of island residents have produced large numbers of unusual pots, plates, and cups — many of which are whimsical and highly idiosyncratic reminders of another way of life. In 1858, a small-scale factory, Hjorth's Ceramics, was established. We have written about our visits to Hjorth in chapter four. We now return to Hjorth to see how the family factory has survived.

The Hjorth Family Factory—a Living Museum

Consistent with the family paradigm, our earlier writing described ceramists in this island community as educated and informed as well as independent and dedicated to the art and craft of ceramics. The need for commercial success coexisted with a high value placed on finding satisfaction with the successes of daily life and work. However, the paradigm of small family factories that excluded outsiders from adding new creative minds to the family mix worried us. We predicted eventual failure, because we could see the benefit of the Royal Copenhagen Paradigm that encouraged innovation by engaging non-family members in the enterprise.

The Hjorth family is one example on Bornholm that is now history. It closed in 1993. In chapter four, we foretold the possibility of that financial and artistic failure of the factory, but now we know that it struggled along for fifteen more years before the end came. Fourth generation Hjorths—Ulla and Marie Hjorth—took over the factory in 1982 after the death of their father Erik Hjorth. Both sisters produced innovative ceramics as well as tableware. Hans Hjorth's daughter, the widely acclaimed ceramist, Lisbeth Munch-Petersen, died in 1997; her artist daughter, Ursula Munch-Peterson lives and works on the island, enjoying her own reputation for high quality ceramics. (Ursula published an article in the *Scandinavian Journal of Design History, 2002*, "*Easier* Said Than Done: Draft, Design and Industry in the year 2001.") Neither Lisbeth nor Ursula, however, appears to have been involved in management of the family factory.

In 1995, a museum was established in the company's original factory, a solid building dating back to 1860. Inside, one encounters an intriguing hybrid of an art gallery with an industrial museum. On

display are the island's best examples of the dark-brown, yellow, and gray pottery that was produced in abundance beginning as far back as the 1700s, along with samples of the dishes and bowls made by the Hjorth company in more recent years, and some of the work of Bornholm's contemporary potters. At times during the year, several ceramic artists maintain studios inside, casting, spinning, or glazing pots in full view of visitors.

Joghus Closed

Joghus is another factory in the family paradigm, on Bornholm, described in chapter four. Founded around 1945, just after World War II, it finally closed in 1983. The Christmas plates, they produced for 30 years, are now collectors' items. This factory was similar in many ways to the mode of ceramic production we saw in Mexico. Established by two potter friends who had little or no experience in business and only minimal talent or sense of artistic design, and with no buyers beyond a tourist market, they used local unskilled labor to paint their clay forms. (The name Joghus was a combination made from the names of the two partners, just as Sergio Bustamante in Mexico combined his name with his partner's to create the business called Sermel.) When we visited Joghus in the 1970's it was losing momentum; but in contrast to Hjorth, which struggled on for many years, Joghus only held out for about five more years.

The A/S Andersen Factory Dying

The then thriving workshop of Michael Andersen is now all but closed, reportedly making only a few items. When we last saw it, more than thirty years ago, although we could see that it lacked the important organizational and business talent needed for continuing success. It had adopted a practice that we thought could save it from the fate of other faltering family factories — that of employing talent from beyond the family gene pool. The Andersen shop hired a talented artist, Marianne Starck. That was a wise choice, but Marianne could not save a business already paralyzed by family feuds. The director and talented artist, Michael Andersen, unable to work with the board of stockholders, bought out all their shares and regained control of the business. That resulted in stagnation not stability. Marianne's work

and some of Michael's are widely posted on collectors' websites and are highly regarded. Otherwise, the factory as a thriving entity has shriveled into its own history.

Søholm Closed: Renowned Artists Move On

The oldest ceramic operation on Bornholm was Søholm. When we last wrote of it in Chapter Four, we had reservations about the artistic quality of its output and about the fact that decisions regarding which items to produce were in the hands of a profit-minded management. Nevertheless we wrote positively of Arne Ranslet, Noomi Backhausen and Haiku Nitzsche whose talents lent vitality to this venerable old company, helping keep it youthful and vigorous. Despite our positive impressions, the factory closed in 1993.

Arne Ranslet already had turned from small pottery pieces to creating large sculpture. By 1978, he was devoting himself to casting large bronze sculptures with whimsical, humorous, even sardonic subjects both human and animal. After winning many international competitions and receiving prominent commissions, he and his wife, Tulla, moved to Spain with their children where they continue their respective artistic work and continue to win international recognition.

Noomi Backhausen continues to work independently as a Bornholm artist, predominantly painting ceramic tiles. Her paintings are whimsical, fanciful, and sometimes call to mind the images of Chagall or Bjørn Wiinblad.

Haico Nitszche left Bornholm in 1991, and now has international recognition. He currently lives and creates art in Drobak, a fishing village on Osloford, a few miles out of Oslo. He is an Associate Professor at the National Academy of Art and Design in Oslo. The following description is from an article about his work as it appears in the Bornholm Museum of Art.

Nitzsche is a sculptor, who allows ancient forces hidden in the plasticity and form of the clay and which are fused at the moment of firing to become elements of pictorial cultural history to antiquity, and, in a lesser perspective leads to childhood experiences.

Often his work portrays an illusory presentation of everyday things, but the interplay of the materials he uses leads surrealistically to an association with the best of American pop-art, and to artists such as Jasper Johns and George Segal. His work challenges the viewer to a reflection of the existential questions surrounding the folly of existence.

Bornholm Museum of Art, Lars Kærulf Møller

Thus, not only have the leading porcelain and ceramic operations in Copenhagen failed to sustain their independence and creative production, the old small independent established factories on Bornholm have also largely faded into oblivion. In both cases, footprints remain to remind one of the past and to guide today's new generation of artists to the future.

Bornholm a Beehive of Artistic Activity

Despite the demise of formidable old family factories, the community of Bornholm artists as a whole, has transformed this somewhat remote island setting into a beehive of creativity activity and is experiencing a surge of tourist interest.

The art association, organized decades ago through the unceasing efforts of Peter Duz (deceased), is now a flourishing organization with a website listing all island artists and continuing to provide an updated map locating studios. The island now boasts an art institute with a three-year degree program. The association, along with other organizations, sponsors an annual international arts conference.

The theme of the 2010 conference presents issues for discussion that are remarkably relevant to the story line of this book from decades ago. The very last question among the conference topics is: "Can a return to the traditions of the past be the way forward to the future?"

The issues and purposes of the 2010 Bornholm conference are stated clearly:

Ceramists as well as other craft practitioners have traditionally worked in strong collaboration with the industry, designing and developing products for industrial mass production. This collaboration between individual artists has played a historic

253

role when defining the identity of ceramics in Europe. The situation is different today, due to globalization and the changing economic situation.

Over the past many years, ceramic production in industry has been minimized to the point where it is almost gone in many European countries. Ceramic products are now being produced cheaply in the Far East or in smaller production units locally.

This conference aims to address and discuss how ceramists , as well as craft practitioners in general, are recognized as a part of the cultural and creative economy.

What do craft practitioners do when Industry closes and the historical and cultural links are broken?

In a time of economic change, is there another way forward for the Ceramic Industry?

Can a return to the traditions of the past be the way forward to the future?

*(source: http://www.europeanceramiccontext.com/events/ conference/) *edited with bold added*

Technology, Industrialization, Change—The Finale

In drawing to a close our retrospective look at the experiences of two nations as their folk art was incorporated into modern design or abandoned we had hoped to offer, through paradigm development, ideas that could lead to greater success and greater understanding of the components necessary for success both culturally and economically.

We chose the two nations in the study because of our familiarity with them, but also because the contrasts seemed clear and potentially useful. It seemed that Denmark had managed to incorporate elements of their folk art traditions into modern ceramics while, at the same time, moving their pottery into a milieu of modern production that served both utilitarian and aesthetic purposes. The artisans of Denmark were no longer paid as, or treated as, peasant potters. In contrast, the pottery in Mexico was crafted largely by unidentified peasants at low wages, who lived in poverty but carried on unwritten and undocumented traditional designs passed on from past generations. Entrepreneurs with international expertise initiated change in the peasant by devising ways

to use the potters' skills to create new objects for tourist consumption. The process was simple, labor was cheap, distribution and sales were local. Problems arose when a more ambitious vision of making sets of dinnerware, for international marketing, and establishing modern factories became a goal.

What we did not calculate in our initial inquiries was the future impact of modern technology and changing life styles on both of these societies. We especially failed to project the effects of globalization in both countries. We saw and wrote about Denmark and Mexico as separate and distinct from each other, without awareness of the hidden network of factors that would influence production and marketing internationally. The amalgamation of large Danish porcelain and glass factories into a conglomerate was not in the picture. The corporate buy-out frenzy of merge and acquisition that struck the western stock market in the 1980s was not a clear pattern in 1975. The effects of a world economy on tourism, as well as the cost and complications of delivery of goods across national borders, were not foreseen. The preemption of newer malleable materials such as plastics and metals into the production, not only of utilitarian goods but also into industrial arts was also not foreseen, even though the very birth of the Danish porcelain factories was a response to early awareness of the potential impact of industrialization.

What we did not miss, however, was the difference in cultural, social, economic, and political contexts in which our subjects lived, worked, and created their art. The importance of literacy, of more than minimal education, and of exposure to ideas across national borders is clear both for the potency of the art produced and for the power of the individual artist to protect himself and his family from outright poverty. Also clear was the importance of a visionary enlightened government in respecting tradition and supporting the arts while closing economic and technological gaps that impeded peasant artisans. This, we have seen, was not well done through the intervention of outside experts or government advisors taking charge of operations. A family of artists painting traditional designs on pots as piecework cannot survive in today's economic world. Traditional village ceramic production can no longer support talented potters, painters or other innovative artists.

In the end, we see the impact of change over time and we recognize the inevitable, perhaps unalterable, failures of hopes and dreams held impulsively or stubbornly by many of the subjects of this book. We must admit, we, too, deplore the loss of the individual artist, even those who held to folk traditions, in this process of globalization and mass production. However, we relish the fact that after three decades many of those we came to know through interviews succeeded in being steadfast in their art and have been recognized for their achievements. We revel in the belief that there is seriousness in today's interest in ceramic arts and other crafts; with continuing respect for individual creativity, and, among artists themselves, a willingness to risk and innovate that is not quenched by the tsunami of standardization, globalization and industrial/technological force. We are uneasy about the exploitation of artisans that continues without much change in Mexico despite individual stories of success, but we hope to see progress made with new policies and new programs. We are dismayed by the collapse of Royal Porcelain, Bing and Grøndahl, George Jensen, Kay Bojesen's shop, and the loss of Den Permanente, but we are excited to witness a Phoenix-like rise of Kähler in Naestved, and to learn of a fresh vibrancy on the island of Bornholm.

We do respond gently to the final question of the current Bornholm conference because it speaks to the heart of our original investigation: "Can a return to the traditions of the past be the way forward to the future?" It seems like nostalgic longing and naïveté in light of our retrospective. And yet, we have many platitudes to recall such as 'plus ça change, plus c'est la même chose' (the more things change, the more they remain the same), and "Those who cannot remember the past are condemned to repeat it." However, the time of the traditional illiterate and poverty-stricken peasant is past and should not be preserved as a model for the future. We remember that peasant life as one limited by hardship and provincialism. Preserving admired values of past traditions such as individual creativity, joy and reverence of life, curiosity and exploration, honesty, hard work, and community caring can be guides to a more humane future. But much in the traditions of the past was not humane or generous. We found, among those we interviewed, a delight in traditional patterns, skills, and products. We did not see great rewards for most of those who labored to perpetuate patterns of the past. We

saw the transition from useful folk wares, lovingly embellished, to non-functional faux folk art forms produced for a market of collectors.

We need not forget or dismiss the importance of folk art, but we need to move forward in support of artists as individuals. Peasant artists, as we have seen, were mostly anonymous workers living in poverty. Contemporary artists, who choose a simple way of life that resembles the peasantry, in general are privileged with modern education and technological amenities.

We leave it now to others to analyze our work, to re-examine the past as well as to blaze new paths for the future. In the meantime, we wonder what we did with all the pots we bought in the early years of this research, happily used, sadly broken, generously given away, but now kept and enjoyed with fresh appreciation knowing that they may be highly collectible. Nevertheless, wistful in also knowing that they were valued most after the artist's death. Alas, *Sådan er det så meget!* or, *Así es la vida!*—That's life!

REFERENCES

Acheson, James M. "New Directions in Economic Anthropology? A Comment on Kunkel." *American Anthropologist* 78 (2): 1976. 331-335.

Anderson, Robert. *Traditional Europe: A Study in Anthropology and History.* Belmont, California: Wadsworth Publishing Company, 1971.

Anderson, Robert. *Modern Europe: An Anthropological Perspective.* Pacific Palisades, California: Goodyear Publishing Company, 1973.

Anderson, Robert. *Denmark: Success of a Developing Nation.* Cambridge, Massachusetts: Schenkman Publishing Company, 1975.

Anderson, Robert. *The Backdoor to Medicine: An Embedded Anthropologist Tells All.* Bloomington, Illinois: iUniverse Publishing Company, 2010.

Banfield, Edward C. *The Moral Basis of a Backward Society.* New York: The Free Press, 1958.

Barnett, Homer G. *Innovation: The Basis of Cultural Change.* New York: McGraw-Hill Book Company, 1953.

Bodelsen, Marete. Tradition og stilskifte i dansk stentøj. In M. Bodelsen, *et al,* eds., *Dansk Keramik.* Copenhagen: Gyldendal, 1960. 43-88.

d'Azevedo, Warren L., ed. *The Traditional Artist in African Societies.* Bloomington, Indiana: Indiana University Press, 1973.

Diaz, May N. *Tonalá: Conservatism, Responsibility, and Authority in a Mexican Town*. Berkeley: University of California Press, 1966.

Ehlers, Louis. *Dansk Lertøj*. Copenhagen: Thaning & Appels, 1967.

Foster, George M. "Peasant Society and the Image of the Limited Good." *American Anthropologist* 67: 1965. 293-315.

Foster, George M. "Contemporary Pottery and Basketry." *Handbook of Middle American Indians*, vol. 6. Austin: University of Texas Press, 1967a. 103-124.

Foster, George M. *Tzintzuntzan: Mexican Peasants in a Changing World*. Boston: Little,Brown and Company, 1967b.

Koppel, Henning. Web citation *(http://www.georgjensen.com/global/ Designers/Henning-Koppel.aspx)* date of access: August 20, 2010.

Kroeber, Alfred L. *Anthropology*. New York: Harcourt, Brace and Company, 1948.

Kuhn, Thomas. *The Structure of Scientific Revolutions.* Chicago: University of Chicago Press, 1962.

Kunkel, John H. "Opportunity, Economics, and Behavior: A Comment on Acheson and Foster." *American Anthropologist* 78 (2): 1976, 327-331.

Lewis, Oscar. "The Culture of Poverty." *Scientific American* 215 (4) 1956, 3-9.

McCord, William. *The Springtime of Freedom: The Evolution of Developing Societies*. New York: Oxford University Press, 1965.

Malinowski, Bronislaw. *The Trobriand Islands*. E.P. Dutton & Co. Inc.:New York, 1915.

Maslow, Abraham H. *The Farther Reaches of Human Nature*. New York: Oxford University Press, 1971.

Mead, Margaret. *Continuities in Cultural Evolution*. New Haven: Yale University Press, 1964.

Mølleer, Lars Kærulf (L.K.M.) *4th version of Weilb achs Kunstnerleksikokn* (artist dictionary). 1994.

Newhall, Nancy, ed. *The Daybooks of Edward Weston. Vol. 1: Mexico*. Millerton, New York: Aperture, 1973.

Opler, Marvin K. "Schizophrenia and Culture." *Scientific American*. 197 (2): 1957, 103-110.

Papanek, Victor J. *Design for the Real World: Human Ecology and Social Change*. New York: Pantheon, 1971.

Pi-Sunyer, Oriol. *Zamora: Change and Continuity in a Mexican Town*. New York: Holt,Rinehart and Winston, 1973.

Price, John A. *Tijuana: Urbanization in a Border Culture*. Notre Dame: University of Notre Dame Press, 1973.

Rasmussen, Peder. *Kahlers Vrk: Om Familien Kahler Og Deres Keramiske Vrksted Naestved 1839-1974*. Copenhagen. Nyt nordisk forlag Arnold Busck, 2002.

Sten Møller, Henrik. *Dansk Design/Danish Design*. Copenhagen: Rhodos, 1975.

Sten Møller, Viggo. *Dansk Kunstindustri, vol. 1*. Copenhagen: Rhodos, 1969.

Steward, Julian H. (1953). Analysis of Complex Contemporary Societies: Culture Patterns of Puerto Rico. In Millard Hansen and Henry Wells, eds., *Puerto Rico: A Study in Democratic Development, The*

Annals of the American Academy of Political and Social Science 285: 95-103. Reprinted in Julian H. Steward, *Theory of Culture Change: the Methodology of Multilinear Evolution.* Urbana: University of Illinois Press, 1955, 210-222.

Stolmaker, Charlotte. "Examples of Stability and Change from Santa Martia Atzompa." In Scott Cook and Martin Diskin, eds., *Markets in Oaxaca*. Austin:University of Texas Press, 1976,189-207.

Toneyama, Kojin. *The Popular Arts of Mexico.* New York: Weatherhill/ Hiebonsha, 1974.

Wallace, Anthony F. C. "Paradigmatic Processes in Culture Change." *American Anthropologist.* 74 (3): 1972, 467-478.